UNFORGETTABLE
STEVE MCQUEEN

Copyright © 2008 by Verlhac Editions
Introduction © 2008 by Henri Suzeau

isbn 978-2-916954-04-2

Translated by Tammi Reichel for APE Int'l
Layout: RVB Studio

Printed in China

Distributed in the USA and Canada by powerHouse Books, Brooklyn, NY

Verlhac Editions
41 rue d'Artois
75008 Paris, France
www.verlhaceditions.com
contact@verlhaceditions.com

UNFORGETTABLE
STEVE MCQUEEN

edited by / édité par Henri Suzeau

V

VERLHAC
EDITIONS

© 2008

MARIA SHARAPOVA
TENNIS WOMAN | JOUEUSE DE TENNIS

He loved speed. He was strong-headed.
We could have gotten along well, I think.

Il adorait la vitesse et il était une forte tête.
Je pense qu'on se serait bien entendus.

LEWIS HAMILTON
FORMULA 1 DRIVER | PILOTE F1

Undoubtedly a perfect image
of male seduction.

Sans aucun doute, l'archétype de
la séduction masculine.

© 2008

UMA THURMAN
ACTRESS | ACTRICE

Extremely sexy, extremely wild
and extremely talented.

Extrêmement sexy, extrêmement sauvage
et extrêmement doué.

© 2008

KIMI RAIKKONEN
FORMULA 1 DRIVER | PILOTE F1

Steve McQueen gave a new meaning to coolness.

Steve McQueen a donné un nouveau sens au mot "cool"

PRIANKA CHOPRA
ACTRESS | ACTRICE

Ruggedly handsome, devilishly sexy and superbly talented !
An actor, race car driver, husband, father and inspiration to millions…
McQueen was the ultimate movie star !

Rudement beau, diaboliquement sexy et superbement doué !
Un acteur, pilote de course, mari, père, source d'inspiration pour des millions de gens …
McQueen était la star de cinéma suprême !

SEBASTIEN BOURDAIS
FORMULA 1 DRIVER | PILOTE F1

When he was driving as when he was acting, he gave the impression of coolness.
I always found him impressive and inspiring.

En tant que pilote et en tant qu'acteur, il donnait l'impression d'être cool.
Je l'ai toujours trouvé impressionnant et fascinant.

THE KING OF COOL

DESTIN DE STAR

by / par Henri Suzeau

A Romantic Life. A Tragic End.

Almost thirty years after his passing, Steve McQueen remains the quintessential superstar. Without question, he was one of greatest Hollywood, or the world, will ever know. Originating from America's deep South, he triumphed over adversity to become one of the world's most charismatic (and wealthy) actors. In that respect, his career is a perfect image of the American dream. Neither an ordinary man nor an ordinary actor, his steely gaze masked passion and rebellion, two characteristics that would impact his life inexorably. Steve McQueen's life led him to find the love he'd lacked in childhood in the worship of millions of fans.

A TROUBLED CHILDHOOD

The story begins on March 24, 1930, in Beech Grove, small city in Indiana a few miles from the Indianapolis Motor Speedway (host of the legendary Indianapolis 500 race). As the first days of spring brought the long winter to a close, Terence Stephen McQueen was born. Six months later, his father, Williams "Red" Mc-Queen, an aerobatic stunt pilot, abandoned the family; he would never see his son again. His teenage mother Jullian was unreliable and an alcoholic and had few resources to cope with her son, depending instead on the goodwill of her uncle (a farmer in the tiny village of Slater, Missouri) to raise him. But the young Steve suffered from dyslexia and hearing problems in the left ear, a result of mastoiditis (an inflammation of the temporal bone), and failed to apply himself at school. Instead, he preferred to hang out with other teenage layabouts. Meanwhile, his mother met a new man, another alcoholic, and went to live with him in Los Angeles. Steve followed them to California. There were increasing conflicts with his stepfather and the boy (now fourteen years old) ran away more and more often to join the suburban Los Angeles gangs and get involved in petty larceny. That ended the day his mother decided to place him at the California Junior Boys Republic, an approved school for delinquent teens.

For the young McQueen, the whole experience was deeply traumatic. Running away (which he did several times) was futile: every escapade ended in recapture and return. It was eighteen months before he finally left Boys Republic to return to his mother and the man who would become his new stepfather in New York. It would be many years before Steve McQueen realized that his experience in reform school had set him on the right course. At the height of his fame, he would often return to the California Junior Boys Republic. He even established a scholarship for the best student and left $200,000 to the school in his will. Meanwhile, during 1946, Steve's reunion with his mother Jullian was brief. He could not forgive her for abandoning him and he left at the first opportunity. That summer he fell in with two merchant marines who persuaded him to join them on the tanker SS Alpha. But McQueen quickly realized that work aboard ship disagreed with him and during a stopover in Cuba he left the ship. He lived in

Sa vie est un roman. Son destin, une tragédie.

Près de trente ans après sa disparition, Steve McQueen conserve l'image d'une Super Star. Sans doute l'une des plus grandes qu'Hollywood et que le monde connaîtront. Originaire du fin fond des Etats-Unis, il a triomphé de l'adversité pour devenir l'un des acteurs les plus charismatiques et les plus fortunés. En cela, sa carrière est le parfait reflet du rêve américain. Ni homme, ni acteur ordinaire, il dissimulait derrière son regard métallique révolte et passion. Deux traits de caractère qui marqueront inéluctablement son existence. Car la vie de Steve McQueen est celle d'un homme qui trouvera dans l'adoration de millions d'admirateurs l'amour dont il fut privé durant sa jeunesse.

UNE ENFANCE TOURMENTEE

L'histoire débute le 24 mars 1930, à Beech Grove, petite ville de l'Etat d'Indiana située à quelques miles de l'Indianapolis Motor Speedway, le circuit de vitesse où se court la mythique course des 500 Miles. Alors que les premiers jours du printemps mettent fin à un long hiver, Terence Stephen McQueen voit le jour. Son père, Williams « Red » McQueen, est pilote dans un show d'acrobatie aérienne. Mais, six mois après la naissance de Steve, il abandonne le domicile familial et jamais ne reverra son fils. Sa mère, Jullian, adolescente fugitive et alcoolique, n'a guère le temps de s'occuper de son fils. Alors, elle le confie à la bienveillance de son oncle, fermier dans la petite bourgade de Slater dans le Missouri. Mais, le jeune Steve, qui souffre de dyslexie et de problèmes d'audition de l'oreille gauche résultant d'une mastoïdite (inflammation de l'os temporal), manque d'assiduité à l'école. Il préfère fréquenter des bandes de jeunes adolescents également livrés à eux-mêmes. Durant cette période, sa mère rencontre un nouveau compagnon, alcoolique lui aussi, et violent, avec lequel elle s'installe à Los Angeles. Steve les suit en Californie. Là, les conflits avec son beau-père se multiplient. L'adolescent, alors âgé de quatorze ans, fugue de plus en plus souvent pour rejoindre les gangs de délinquants des faubourgs de Los Angeles et commettre de petits larcins. Jusqu'au jour où sa mère prend la décision de le placer au California Junior Boys Republic, une maison de redressement pour adolescents.

Ce châtiment est vécu par le jeune McQueen comme un véritable traumatisme. À plusieurs reprises, il s'évade. En vain. Il est repris et ramené après chaque escapade. Ce n'est que dix huit mois plus tard qu'il en sort définitivement pour rejoindre sa mère et l'homme destiné à devenir son nouveau beau-père à New York. Il faudra de nombreuses années à Steve McQueen pour reconnaître que son expérience en maison de redressement l'avait remis dans le droit chemin. Devenu célèbre, il reviendra souvent au California Junior Boys Republic. Il créera même une bourse pour le meilleur étudiant et léguera, dans son testament, une somme de 200 000 dollars à l'établissement.

En attendant, en cette année 1946, les retrouvailles de Steve avec sa mère Jullian

the Dominican Republic for a while, but was quick to return to the United States. There followed a series of odd jobs in various states until he finally decided to join the Marine Corps.

In April 1947, just one month after his seventeenth birthday, Steve joined his unit, where he became a mechanic. But he was far from a model marine. His refusal to obey orders and his frequent absences, as well as his interest in girls, earned him several visits to the cooler. McQueen made his reputation as a hooligan and devastating lady killer, roles he would later reprise on the big screen with great success. Nonetheless, during a disastrous exercise in the Arctic, McQueen regained the respect of his officers when, at great risk to his own life, he rescued five sailors from the icy water. This act of heroism earned him a place in the Guard of Honor for the yacht of Harry S. Truman (33rd president of the United States). Honorably discharged from the marines in April 1950, he left for Texas to work on an oil well. Afterwards, he went to Canada, where he learned to be a logger. Then it was back to New York, where he rented an apartment with no warm water for $19 a month. He ran through more petty jobs: driver-delivery man, show salesman, artificial flower salesman… until the day one of his girlfriends, an acting student, suggested he should try acting, too.

The idea appealed to him. He then invested most of his income in courses at that well-known school of the dramatic arts, Sanford Meisner's Neighborhood Playhouse, which he left in 1952 to study with Herbert Bergoff. McQueen displayed an irresistible thirst for learning and acting. So determined was he, that he was one of only two candidates chosen from two thousand applicants to join New York's famous Actors Studio. He made his theatrical debut in a revival of Peg O' My Heart and it was not long afterwards that McQueen's name hit the Broadway lights as he took the opportunity to replace Ben Gazzara in the leading role of A Hatful of Rain. This was the first important role of his young career and it was also the turning point of his life. He had also just gotten to know a young novice actress, Neile Adams, whom he married in 1956 in San Clemente, California.

THE GLORY YEARS BEGIN

Although still modest, McQueen's fame led him to Hollywood in 1956, where he made his cinematic debut in *Somebody Up There Likes Me*, directed by Robert Wise and starring Paul Newman. His own screen appearance as a billiards player was so minor that he did not even appear in the credits. As yet untried, confidence still eluded him and it he found it hard to believe in himself. In the beginning, the profession did not know whether to look on Steve as a possible hero or as a solitary psychotic. Indeed, the young man's desire to become an actor seemed a very odd choice of career to some. But he worked at it and two years later, in 1958, he began a series of roles in *Never Love a Stranger* and *The Blob* (a low-budget sci-fi film in which he took the lead). At the same time, he appeared in *The Great St. Louis Bank Robbery* and *then Never So Few* by John Sturges alongside Frank Sinatra, Charles Bronson and Gina Lollobrigida.

sont de courte durée. Il ne lui pardonne pas de l'avoir abandonné. Alors, il part à la première occasion. Durant l'été, il fait la connaissance de deux matelots de la marine marchande qui le persuadent d'embarquer avec eux sur le tanker SS Alpha. Mais rapidement, McQueen s'aperçoit que le travail à bord ne lui plaît guère. Lors d'une escale à Cuba, Steve quitte le navire. Pendant quelques temps, il vit en République Dominicaine. Puis, il ne tarde pas à regagner les Etats-Unis. Il enchaîne les petits boulots dans différents états. Jusqu'au jour où il décide de s'engager dans le Corps des Marines.

En avril 1947, juste un mois après son dix-septième anniversaire, Steve rejoint son unité. Là-bas, il devient mécanicien. Pour autant, il n'est pas un Marine « modèle ». Il se révèle rapidement réfractaire aux ordres de ses supérieurs et ses sorties répétées ainsi que son attirance pour les filles lui valent à plusieurs reprises un séjour au mitard. McQueen se construit une réputation de voyou et de redoutable tombeur. Des rôles qu'il incarnera par la suite avec succès au grand écran. Toujours est-il que, lors d'un exercice qui tourne mal en Arctique, McQueen regagne l'estime de sa hiérarchie en sauvant, au péril de sa vie, cinq marins des eaux glaciales. Cet acte héroïque lui vaut alors d'être choisi pour intégrer la Garde d'honneur du yacht de Harry S. Truman (33ᵉ Président des Etats-Unis). Libéré des Marines en avril 1950, il part au Texas pour travailler comme ouvrier sur les forages pétroliers. Ensuite, il gagne le Canada où il apprend le métier de bûcheron. Puis, c'est le retour à New-York où il loge dans un appartement humide en échange de dix-neuf dollars par mois. Il accumule de nouveau les petits jobs : chauffeur-livreur, vendeur de sandales ou de fleurs artificielles… Jusqu'au jour où l'une de ses petites amies, apprentie actrice, lui suggère de s'essayer lui–aussi au métier d'acteur.

L'idée le séduit. Il investit alors la majeure partie de ses revenus dans les cours de la célèbre école d'Art Dramatique - Neighborhood Playhouse - de Sarsford Meisner, qu'il quitte en 1952 pour rejoindre les cours d'Herbert Bergoff. McQueen montre une irrésistible soif d'apprendre et de jouer. Sa détermination lui vaut alors d'être l'un des deux candidats sélectionnés sur deux mille à rejoindre le fameux Actors Studio de New York. Il fait ses premiers pas au théâtre dans une reprise de *Peg O' my Heart*. Puis, le nom de McQueen ne tarde pas à s'afficher sur Broadway lorsque l'occasion se présente de remplacer Ben Gazzara dans le premier rôle de *A Hatful of Rain*. C'est le premier rôle important de sa jeune carrière et le tournant de sa vie. McQueen vient également de faire la connaissance d'une jeune actrice en devenir, Neile Adams, avec laquelle il se marie en1956 à San Clemente en Californie.

DEBUT DE LA GLOIRE

Bien qu'encore modeste, la notoriété de McQueen l'amène à Hollywood en 1956. Là, il fait ses débuts au cinéma dans *Marqué par la haine* dirigé par Robert Wise, où le rôle principal est tenu par Paul Newman. Son apparition à l'écran dans le rôle d'un joueur de billard est tellement discrète qu'il n'apparaît même pas au générique. Garçon encore discret, il éprouve encore des difficultés à faire confiance et à croire en lui-même. Lors de ses premiers tournages, le métier ne sait s'il doit considérer Steve comme un possible héros ou bien comme un psychotique solitaire… Que ce jeune homme veuille devenir acteur apparaît aux yeux de certains

However, it was his major role in the TV series Wanted : *Dead or Alive* that definitively ended his anonymity in 1960. Here at last was a role worthy of his talent: bounty hunter Josh Randall. By McQueen's rendition, Randall hovers between good and evil. He has no friends, unless you count his signature sawn-off Winchester rifle. The series ran for three years and the success that came with it gained McQueen entrée to the most famous production houses. His face became one of the best known in America. It was the start of a long and illustrious career.

From there, he won a crucial role in a new film by John Sturges, *The Magnificent Seven*, where he acted alongside Yul Brynner, Charles Bronson, James Coburn and Robert Vaughn. He followed that with *The Honeymoon Machine* (1961), then *Hell is for Heroes* (1962) and *The War Lover* (1962). McQueen was recognized as top of the bill in Hollywood. In 1963, the actor rejoined director John Sturges, along with Charles Bronson and James Coburn, in *The Great Escape*, a film that established his international reputation. A passionate biker, he himself suggested the idea of a two-wheeled escape from a prison camp and his famous jump over a barbed-wire fence to escape from Nazi soldiers. But it was his friend, biker and stuntman Bud Ekins, who actually performed the jump at the Swiss border. Incidentally, Steve rode another bike in the role of a German pursuer, a chase that became legendary.

It is notable that McQueen followed these with more subtle roles, including *Soldier in the Rain* (1963), *Love with a Proper Stranger* (1963), in which he acted with Nathalie Wood, and especially *Baby, The Rain Must Fall* (1965), in which he gave a forceful interpretation of a conflicted character, a dense rendition which comes closest to that abrasive side of himself that he still sought to hide. Unfortunately, these films were not well received. It didn't matter. The next year saw him in the role of poker player Eric Stoner in The *Cincinnati Kid* alongside the legendary Edward G. Robinson and Karl Maldon, which rehabilitated him with his public. It was a great success and the fans rushed back. McQueen returned to the Western in *Nevada Smith*. And then the actor rediscovered Robert Wise, the director of his youth, in *The Sand Pebbles*. For many of his admirers, Steve delivered one of his finest performances as a dramatic actor in the role of sailor Jake Holman. Indeed, the role earned him an Oscar nomination for Best Actor in 1967.

CULT FILMS

The following year, McQueen appeared in two of his most famous films. With the deliberation of a chess match, he played a steamy game of seduction with Faye Dunaway in *The Thomas Crown Affair* by Norman Jewison. As soon as he read the script, McQueen knew that this was the role he had been waiting for. Businessman Thomas Crown has a dull life until he organizes the heist of the century: robbing his own bank in broad daylight. Throughout the shoot, the actor worked as never before. Careful of his appearance, he wore the finest suits and chose his own ties. His habitual nonchalance and that touch of insolence, of the rebellious youth, left him for a while, retreating back to where they came from.

McQueen followed this with Peter Yates' *Bullitt*, an extraordinary film in which he plays a taciturn detective. The chase sequences in which McQueen's Ford Mus-

comme un choix de carrière étrange. Pourtant, McQueen persévère. Deux ans plus tard, en 1958, il commence à enchaîner les tournages : *Never Love a Stranger* (jamais diffusé en France), *Danger Planétaire*, un film de science fiction à petit budget dans lequel il décroche le premier rôle. Dans la foulée, il joue dans *Hold up en 120 secondes*, puis *La proie des Vautours* de John Sturges, aux côtés de Franck Sinatra, Charles Bronson et Gina Lollobrigida.

Pour autant, c'est son rôle majeur dans une série TV intitulée *Au nom de la Loi* qui le sort définitivement de l'anonymat en 1960. Il bénéficie enfin d'un rôle à la hauteur de son talent. Celui d'un chasseur de prime : Josh Randall. A l'image de McQueen, Randall se situe entre le bien et le mal. Il n'a aucun ami, si ce n'est sa célèbre Winchester à canon scié. Le feuilleton s'installe à l'écran durant trois ans et le succès qui l'accompagne ouvre à Steve McQueen les portes des maisons de production les plus renommées. Son visage devient l'un des plus connus des Etats-Unis. C'est le début d'une longue et prestigieuse carrière.

Dès lors, il obtient un rôle crucial dans un nouveau film de John Sturges : *Les sept Mercenaires (The Magnificent Seven)*, où il donne la réplique à Yul Brynner, Charles Bronson, James Coburn, Robert Vaughn. Il enchaîne avec *Branle-bas au Casino* (1961), puis *L'enfer est pour les Héros* (1962) et *L'Homme qui aimait la Guerre* (1962). McQueen devient une tête d'affiche reconnue à Hollywood. En 1963, l'acteur retrouve le réalisateur John Sturges, ainsi que Charles Bronson et James Coburn dans *La Grande Evasion*, film où il prend définitivement une dimension internationale. Passionné de moto, il suggère lui-même l'idée de l'évasion sur deux roues du camp de prisonniers et ce fameux saut au-dessus de la barrière de barbelés pour échapper aux troupes nazies. C'est son ami, le motard Bud Edkins qui réalise le saut à la frontière suisse. Pour le plaisir, Steve pilote une autre moto en jouant le rôle d'un poursuivant allemand. Une séquence devenue mythique.

Par la suite, McQueen se voit confier des rôles plus nuancés dans *La dernière bagarre* (1963), *Une certaine rencontre* (1963) où il joue aux côtés de Nathalie Wood et surtout *Le Sillage de la Violence* (1965) où il interprète avec force un personnage déchiré. Une interprétation étoffée qui touche le plus justement sa nature d'écorché qu'il a toujours voulu dissimuler. Malheureusement, ces derniers films ne font pas l'unanimité. Qu'à cela ne tienne, l'année suivante, le rôle du joueur de poker Eric Stoner dans *Le Kid de Cincinnati* aux côtés du légendaire Edward G. Robinson et de Karl Malden le réconcilie avec son public. Les fans se pressent dans les salles. Le film est un véritable succès. McQueen renoue avec le western dans *Nevada Smith*. Puis, l'acteur retrouve Robert Wise, le réalisateur de ses débuts, dans *La canonnière du Yang-Tse*. Pour nombre de ses admirateurs, Steve livre dans le rôle du matelot Jake Holman l'une de ses plus belles performances d'acteur dramatique. Une prestation qui lui vaut une nomination pour l'Oscar du meilleur acteur en 1967.

DES FILMS CULTES

L'année suivante, il tourne deux de ses films les plus célèbres. Le temps d'une partie d'échecs, il joue un jeu de séduction torride avec Faye Dunaway dans *L'Affaire*

tang (Frank Bullitt) and the killer's Dodge Charger pursue each other across San Francisco have endured as the most incredible of the time and in the history of cinema. These scenes alone stretched over three weeks of shooting and required two Mustangs and two Chargers. As for McQueen, he insisted on doing his own stunts for most of the sequences.

In 1969 he broke away from action roles and tried a completely new genre. Based on a popular novel by William Faulkner, the film *The Reivers* tells the story of Boon Hogganbeck. This young stable hand, both immature and irresponsible, borrows his boss's car for a joyride between whorehouses and racecourses, teaching the facts of life to two boys at the same time. Here McQueen reveals a true talent as a comedy actor. For that reason, perhaps, the film was not received very well. Two years passed and the actor tried to combine his love of speed and racing with the cinema in a film devoted entirely to the glory of car racing, *Le Mans*. McQueen invested himself and his personal fortune in the project, which, sadly, was not an immediate success. Only several years later would the film gain the recognition it deserved. To this day, racing professionals consider *Le Mans* one of the most realistic films of the world of car racing and the legendary Le Mans 24 Hour Race.

This disappointment was followed by the excitement of working with one of Hollywood's most controversial directors, Sam Peckinpah, whose last film, *The Wild Bunch* (1969), revived the Western genre. The film is still remembered for its climactic final gunfight, a dantesque massacre in which Peckinpah gave full rein to a rage that had been bottled up for too long. He and McQueen developed a certain complicity: together they shot *Bonner Junior* (1972), featuring a family of rodeo riders, then repeated their success with *The Getaway* (1972), in which McQueen easily slipped into the skin of a prisoner released in exchange for a bank robbery, who then fled across the United States with his wife and the stolen money. The film costarred Ali MacGraw, who would become his second wife. Both films were box office successes, as was *Papillon* (1973), the nickname of a French convict McQueen played alongside Dustin Hoffman. A little later, Steve McQueen rejoined Paul Newman in the disaster movie *Towering Inferno* (1974), which remains a model of its kind. The two superstars, McQueen and Newman, shared billing with an impressive list of other acting greats including Fred Astaire, Robert Vaughn, William Holden, Robert Wagner and Faye Dunaway. McQueen took the role of the San Francisco fire chief and does not appear on screen until the second half of the film, but in time to save the guests of a fundraising reception from the flames devastating a 138-story skyscraper.

Despite this renewed success, the actor set himself slightly apart from the profession. The constraints of shooting and the studios irked McQueen, a passionately free agent. So he decided to rein in his career and enjoy life more. Only in 1978 would he reappear, thickly bearded, in an adaptation of Henrik Ibsen's *An Enemy of the People* with Bibi Andersson. This environmentally conscious film denounced the polluting activity of a tannery contaminating a community's water supply. Unfortunately, it proved to be a commercial failure, and sadly, this was not the only bad news for McQueen that year. For some time now, the actor had been a mere shadow of himself and there were rumors of drug addiction. But

Thomas Crown de Norman Jewison. A la lecture du script, McQueen sut aussitôt que ce rôle était celui qu'il attendait. L'homme d'affaires Thomas Crown connaît une existence sans relief. Alors, il organise le hold-up du siècle : dévaliser en plein jour sa propre banque. Durant le tournage, l'acteur s'applique comme jamais. Soigne son apparence, s'habille des plus beaux costumes et choisit lui-même ses cravates. Son habituelle nonchalance et son rien d'insolence d'une jeunesse turbulente sont en passe de rentrer dans le rang.

McQueen enchaîne avec *Bullitt* de Peter Yates. Film mythique dans lequel il incarne un détective taciturne. Les séquences de course-poursuite à travers San Francisco, entre la Ford Mustang de McQueen (Franck Bullitt) et la Dodge Charger noire du tueur, demeurent pour l'époque les plus incroyables de l'histoire du cinéma. A elles seules, ces scènes se prolongèrent sur trois semaines de tournage et nécessitèrent deux Mustang et deux Charger. Quant à McQueen, il exigea de ne pas être doublé pour la plupart des cascades.

En 1969, il rompt avec les rôles d'action et s'essaie à un tout autre genre. Tiré d'un roman populaire de William Faulkner, le film *Les Reivers* relate l'histoire de Boon Hogganbeck. Ce jeune garçon d'écurie immature et irresponsable emprunte la voiture de son patron pour une balade entre maisons closes et courses de chevaux, durant laquelle il fait découvrir la vie à deux jeunes garçons. McQueen y dévoile un vrai talent d'acteur de comédie. Pour autant, le film ne rencontre pas un grand succès populaire. Deux années passent et l'acteur tente de lier son amour de la vitesse et des courses automobiles avec le cinéma dans un film totalement dédié à la gloire des sports mécaniques : *Le Mans*. McQueen y investit de sa personne et de sa fortune personnelle. Hélas, *Le Mans* ne connaît pas le succès escompté. Ce n'est que plusieurs années plus tard que le film obtiendra la reconnaissance qu'il mérite. De l'avis des professionnels de la course, *Le Mans* demeure encore à ce jour l'un des films les plus réalistes sur le monde de la compétition automobile et sur la mythique course des 24 Heures du Mans.

A la déception succède l'exaltation de travailler avec l'un des réalisateurs les plus controversés d'Hollywood : Sam Peckinpah, dont le dernier film *La Horde sauvage* (1969) renouvelle le genre du western. Le film est resté célèbre pour sa gigantesque fusillade finale. Un massacre dantesque où Peckinpah laisse exploser une rage trop longtemps accumulée. Avec McQueen naît une certaine complicité. Ensemble, ils tournent *Junior Bonner, le dernier bagarreur* (1972) mettant en scène une famille de cavaliers de rodéo. Puis, ils récidivent avec *Le Guet-apens* (1972), où McQueen se glisse facilement dans la peau d'un détenu libéré en échange du braquage d'une banque. Or, celui-ci va s'enfuir avec sa femme et l'argent volé à travers les Etats-Unis. Steve y rencontre surtout Ali MacGraw, l'actrice vedette, qui deviendra sa nouvelle épouse. Ces deux films sont des succès au box-office. Au même titre que *Papillon* (1973), surnom d'un bagnard français qu'il interprète aux côtés de Dustin Hoffman. Quelques temps après, Steve McQueen retrouve Paul Newman dans un film catastrophe qui demeure à ce jour un modèle du genre : *La Tour Infernale* (1974). Les deux monstres sacrés, McQueen et Newman, en partagent l'affiche avec une liste impressionnante d'autres grands acteurs : Fred Astaire, Robert Vaughn, William Holden, Robert Wagner ou encore Faye Dunaway. McQueen y incarne le rôle du chef des pompiers de San Francisco et n'intervient

they were badly off-mark. In fact, McQueen was ravaged with cancer. He shot his two last films, *Tom Horn* in 1979 and *The Hunter* in 1980. Both were the kind of solitary rebel role he had favored throughout his career. Of these, the bounty hunter Ralph "Papa" Thorson was more than a little reminiscent of the ever-celebrated Josh Randall, who, twenty years earlier, had introduced Steve McQueen to the public at large.

RACING IN HIS BLOOD

Trained as a mechanic during his service with the Marine Corps, a passion for engines and especially for racing defined Steve's life. With his first acting success, he acquired his first motorbike and regularly lined up at the start of the "desert rides." In that light, it was no accident that McQueen appeared handlebars in hand in so many of his films. His preference was for Triumph, much in vogue at that time in the United States, and it was a Triumph 650 cc TR6 Trophy disguised as a BMW that the actor rode in *The Great Escape*. Again in 1964, he rode the same model at the Six Days Trial in East Germany as a member of the US team. There was a dramatic accident at that event when McQueen's bike was catapulted into a ravine. By a miracle, he walked away with a few scratches, his passion for the sport as strong as ever. He would often visit Triumph's factories to check up on the production of "his" machines. Further, the rebellious mug shot from his arrest for riding under the influence is well known, the media seized on it. Steve also found himself on the cover of Life Magazine on a motorbike, and the poster for *The Great Escape* was sold in the hundreds of thousands.

Steve McQueen was equally passionate about cars. He owned some of the cream of sports cars. Among other glories, he had a fabulous Jaguar XK-SS, one of only eighteen ever built. He was also the owner of several Porsches and he wasted no time in racing them, making his first official start in 1959 in Santa Barbara at the wheel of a Porsche Speedster. He also raced Lotus and Coopers. McQueen acknowledged very few heroes during his life, but one of them was the British racing driver Stirling Moss. In March 1962, they shared the wheel of a Healey Le Mans at the Twelve Hours of Sebring. Unfortunately, after leading their category for the first seven hours, they had to drop out due to engine problems. This performance earned McQueen a job offer from the British Motoring Corporation, which sought to hire him as a professional racing driver, an offer the actor declined because of prior commitments. That same year, during the shooting of *The War Lover* in Britain, Stirling Moss suggested McQueen take part in a race at Brands-Hatch. Although his insurers deplored his practice of car racing, McQueen could not resist the opportunity to join the starting line at this race, and in fact, he came in third. McQueen thus earned the respect of other professional racing drivers of the time, such as Richie Ginther, Jo Siffert and Peter Revson. It was in Revson's company that McQueen chalked up his most remarkable result. With his left leg in a cast following a motorbike accident two weeks previously, he finished second at the 12 Hours of Sebring 1970 at the wheel of a Porsche 908, just seconds behind Mario Andretti in a Ferrari 512 S.

McQueen also dreamed of taking part in the 24 Hours of Le Mans. His insurers were officially against this, so the actor made a film about it, Le Mans, written by

à l'écran que lors de la seconde partie du film pour sauver les invités d'une réception à la merci des flammes qui ravagent une tour de cent trente huit étages.

Malgré ce nouveau succès, l'acteur prend quelques distances avec son métier. Les contraintes des tournages et des maisons de productions lassent McQueen, épris de liberté. Il décide alors de freiner sa carrière pour profiter de la vie. Ce n'est qu'en 1978 qu'il réapparaît, grossi et barbu, dans l'adaptation d'Henrik Ibsen *Un ennemi du peuple* avec Bibi Andersson. Ce film "environnemental" dénonce les activités polluantes d'une tannerie contaminant l'eau d'une commune. Malheureusement, cela s'avère un échec commercial. Ce n'est, hélas, pas la seule mauvaise nouvelle de l'année pour McQueen. L'acteur n'est plus que l'ombre de lui-même depuis quelques temps déjà. Des rumeurs rapportent des problèmes de toxicomanie. Il n'en est rien. En fait, McQueen est rongé par le cancer. Il tournera ses deux derniers films : *Tom Horn* en 1979 et *Le Chasseur* en 1980. Deux rôles de rebelles solitaires comme il les affectionna durant toute sa carrière. Dont celui du chasseur de primes, Ralph "Papa" Thorson, qui n'est pas sans rappeler le désormais célèbre Josh Randall qui, vingt ans plus tôt, a révélé Steve McQueen au grand public.

LA COURSE DANS LE SANG

Formé au métier de mécanicien lors de son service dans le Corps des Marines, sa passion pour la mécanique et plus encore pour les sports mécaniques jalonne la vie de Steve. Avec ses premiers cachets d'acteur, il s'offre ses premières motos et s'aligne régulièrement au départ des "desert rides". Dès lors, ce n'est pas un hasard si McQueen apparait au guidon de motos dans plusieurs de ses films. Sa préférence va aux Triumph, très en vogue à cette époque aux Etats-Unis. C'est d'ailleurs une 650 cc TR6 Trophy maquillée en BMW que l'acteur enfourche dans *La Grande Evasion*. Avec ce même modèle, il participe en 1964, comme membre de l'équipe des Etats-Unis, aux "Six Days Trial" en Allemagne de l'Est. McQueen y est victime d'un terrible accident. Sa moto est précipitée dans un ravin. Par chance, il en réchappe avec quelques égratignures. Pourtant, cela n'entrave nullement sa passion. Souvent, il se rend aux usines Triumph pour s'enquérir de la préparation de "ses" machines. En outre, l'image du rebelle casqué ivre de vitesse fait recette. Les médias s'en emparent. Steve à moto se retrouve en "Une" de *Life Magazine*. Le poster de *La Grande Evasion* se vend aussi à des centaines de milliers d'exemplaires.

Steve McQueen se passionne également pour l'automobile. Il possède ce qui se fait de mieux en matière de voitures de sport. Entre autres merveilles, l'une des fabuleuses Jaguar XK-SS construites à dix-huit exemplaires. Il sera également le propriétaire de plusieurs Porsche qu'il ne tarde pas à engager en course. C'est ainsi qu'il prend son premier départ officiel en 1959 à Santa Barbara au volant d'une Porsche Speedster. Puis, il pilote des Lotus, des Cooper. McQueen avait très peu de héros dans sa vie. Le pilote britannique Stirling Moss était l'un deux. En mars 1962, ils se partagent le volant d'une Healey Le Mans aux 12 Heures de Sebring. Après avoir mené le classement de leur catégorie durant les sept premières heures, ils doivent malheureusement renoncer à cause de problèmes de moteur. Cette performance vaut à McQueen une proposition du British Motoring Corporation

Harry Kleiner, produced by Jack N. Reddish, and directed by Lee H. Katzin, with an original score by Michel Legrand. Steve played the part of Michael Delaney, an American racing driver returning to the track after a serious accident. As a result of a dual with his rival, the German Erich Stahler, Delaney begins a love affair with the widow of a driver who had been killed the previous year in the same accident that had so nearly claimed Delaney himself.

Prior to this, the few films on motor racing, including *Grand Prix* (1966) with James Garner, had been unconvincing. Directors and actors as respected as Howard Hawks, John Frankenheimer, Paul Newman and Kirk Douglas had all addressed the genre, but none were very successful. McQueen wanted to show the reality of the 24 Hours of Le Mans, an authentic and realistic piece that paid homage to the drivers and their entourage of engineers, mechanics, etc. and also to those who lose their lives on the famous circuit.

To achieve this, McQueen collaborated with a number of professional racing drivers such as Jacky Ickx, Derek Bell, Jean-Pierre Beltoise, Gerard Larrousse, Henri Pescarolo and Jean-Pierre Jabouille, who acted as technical advisers. McQueen also wanted the stars of the film to be the real contesters in the race: the Porsche 917, the Ferrari 512, the Matra 650 and others. The first takes were scheduled for the spring of 1966, but Steve had to leave for Asia to make *The Sand Pebbles*, which lasted five months longer than anticipated. To generate authentic racing scenes from the 24 Hours of Le Mans 1970, the crew set up a car with the first onboard camera ever used. This Porsche 908, driven by Jonathan Williams and Herbert Linge, finished unclassified because it covered too little distance. Nonetheless, the racing scenes are luminously real. McQueen, who was more invested in this film than usual, was clearly driving one of the racing cars during shooting. It was also while shooting Le Mans that the actor wore the colors of the Swiss watchmaker Heuer and adopted his famous watch « Monaco », thus becoming one of the elite ambassadors of the brand. A veritable hymn to the 24 Hours, *Le Mans* is a masterpiece that comes across as extraordinarily lifelike and remains unequalled to this day.

At his death, Steve McQueen left behind 210 motorbikes, fifty-five cars and five planes, a testimony to the degree of his unbridled passion for all kinds of machine, just so long as they were synonymous with speed and excitement.

THREE MARRIAGES

Many women believed they could soften Steve's character and make him more civilized. None succeeded.

It was during his Broadway debut that Steve met the woman who would become his first wife. Like him, Neile Adams was a professional actor. Their marriage in 1956 resulted in two children: a son, Chad (born in 1960), and a girl, Terry (born in 1959), who would die tragically of complications from a heart transplant at the age of thirty-eight. After sixteen years together, the McQueens divorced on March 14, 1972.

qui souhaite l'engager comme pilote professionnel. Offre que l'acteur décline, car son emploi du temps ne le lui permet pas. La même année, lors du tournage de *L'homme qui aimait la guerre* en Grande-Bretagne, Stirling Moss suggère à McQueen de participer à une course sur le circuit de Brands-Hatch. Bien que ses assureurs n'apprécient guère sa pratique du sport automobile, il ne peut résister à l'envie de prendre le départ de cette course où il se classe finalement 3ème. Ainsi, McQueen gagne l'estime d'autres pilotes professionnels de l'époque, à l'instar de Richie Ginther, Jo Siffert ou encore Peter Revson. C'est en compagnie de ce dernier que McQueen signe son résultat le plus remarquable. Jambe gauche plâtrée suite à un accident de moto deux semaines auparavant, il termine 2ème des 12 Heures de Sebring 1970 au volant d'une Porsche 908 devancée de peu par la Ferrari 512 S de Mario Andretti.

L'acteur rêve également de participer un jour aux 24 Heures du Mans. Ses assureurs s'y opposant formellement, il en fait un film : *Le Mans* écrit par Harry Kleiner, produit par Jack N. Reddish et réalisé par Lee H. Katzin, avec une musique originale de Michel Legrand. Steve y joue le rôle de Michael Delaney, pilote américain de retour en course après avoir été gravement accidenté. Sur fond d'un duel avec son rival, l'Allemand Erich Stahler, débute une histoire d'amour avec l'épouse du pilote qui a péri l'année précédente dans l'accident dont Delanay a réchappé de justesse.

Jusqu'alors, les quelques films dédiés au sport automobile n'avaient guère convaincu. Y compris *Grand Prix* (1966), avec James Garner. Des réalisateurs et des acteurs aussi réputés que Howard Hawks, John Frankenheimer, Paul Newman ou Kirk Douglas se sont aussi attelés au sujet. Sans véritable succès. McQueen, lui, veut un film "vrai" sur les 24 Heures du Mans. Une œuvre authentique, réaliste qui rende hommage aux pilotes et à leur entourage : ingénieurs, mécaniciens..., et à ceux qui ont perdu la vie sur le célèbre circuit.

Pour parvenir à ses fins, il s'assure la collaboration de plusieurs pilotes professionnels comme Jacky Ickx, Derek Bell, Jean-Pierre Beltoise, Gérard Larrousse, Henri Pescarolo ou Jean-Pierre Jabouille, qui font office de conseillers techniques. McQueen veut également que les Porsche 917, Ferrari 512, Matra 650 et autres, qui ont réellement disputé la course soient les vedettes de son film. Les premières prises de vues sont programmées au printemps 1966. Mais Steve doit partir en Asie pour le tournage de *La canonnière du Yang Tsé* qui dure cinq mois de plus que prévu. Pour alimenter le film en scènes de course authentiques, la production engage aux 24 Heures du Mans (1970) une voiture équipée pour la première fois dans l'histoire d'une caméra embarquée. Cette Porsche 908 pilotée par Jonathan Williams et Herbert Linge finira non classée pour cause de distance parcourue insuffisante. Au final, les scènes de course y sont d'une éclatante vérité. McQueen, qui s'est investi comme rarement dans un film, a évidemment piloté l'un des bolides lors du tournage. C'est également à l'occasion du film *Le Mans* que l'acteur portera les couleurs de l'horloger suisse Heuer et adoptera sa célèbre montre "Monaco", devenant ainsi l'un des ambassadeurs cultes de la marque. Véritable hymne aux 24 Heures, *Le Mans* est un chef d'œuvre qui sonne incroyablement juste et qui demeure à ce jour jamais égalé.

On August 31, 1973, Steve married for the second time. This time, too, his bride was an actress: Ali MacGraw. The two had been madly in love since starring together in *The Getaway* the previous year. Drawn, perhaps, by Steve's beautiful eyes, Ali left Robert Evans, director of the film *Love Story*, of which she was the unforgettable interpreter. Alas, she quickly discovered that her new husband was incapable of having the least consideration for a woman, that his mother's abandoning him had left a terrible scar, and that he was ravaged with bitterness and pain. Powerless in the face of such anger and hostility, Ali realized that the marriage was a mistake. Later, she would argue that this psychological condition was the origin of Steve's cancer. Divorcing McQueen in 1978, Ali MacGraw left the world of cinema to drown in drugs and alcohol. Rehabilitated by a detox cure at the famous Betty Ford Center in California, she lives today in New Mexico, where she has found peace. Better still, at the age of sixty-eight, Ali has crowned her great theatrical promise on the Broadway stage in the 2006 play Festen.

It is also said that Steve was not always a model of fidelity, and that he had many mistresses during his life. Most of these were his partners on screen.

Finally, in Mexico, on January 16, 1980, Steve McQueen married his third wife, Barbara Minty, a young model of twenty-five who would remain with him until his death.

HIS BATTLE AGAINST CANCER

In 1978, after a medical checkup, Steve learned that he had a rare cancer, mesothelioma. This form of cancer is especially malignant and virulent. It affects the lining of the lungs or stomach, or the sac around the heart. It is usually caused by prolonged exposure to asbestos, and Steve had often been around this material during his life, not least on the many building sites he frequented as an itinerant worker. Asbestos was generally used in the insulation of boats built prior to 1976, and during his time with the Marines, Steve remembered being sentenced to six weeks of cleaning down the ship's engine room. The pipes were covered with asbestos, which the men had to tear off and replace. The air was so thick with asbestos particles he could hardly breathe. The material was also present on film sets and in racing car brakes, as well as in the drivers' leathers and crash helmets.

If the achievements of modern medicine now allow a reasonable prognosis, at the end of the sixties there was no hope. Treatments such as chemotherapy did not exist at the time and at Culver City, the senior physician's assessment of Steve McQueen's chances was grim.

The actor knew he was doomed, but like John Wayne, he fought with exemplary courage. He continued shooting *The Hunter* in Chicago. Sadly, the disease gained on him. McQueen learned that it was inoperable, but he clung to hope. In a last-ditch effort, he placed his hope in a private, very controversial Mexican clinic. He would endure three months of torture, receiving injections of animal cells and swallowing a hundred vitamin pills a day, but the disease continued to weaken him. It was there, in the private clinic of Juarez, that on November 7, 1980, at fifty years of age, Steve McQueen died of a post-operative pulmonary embolism following the removal of a stomach tumor. In accordance with his last wishes, his ashes were scattered over the Pacific Ocean.

À sa mort, Steve McQueen laissera 210 motos, 55 voitures, et 5 avions. C'est dire à quel point il vouait une passion sans borne à toute forme de machine, si tant est qu'elle soit synonyme de sensations et de vitesse.

TROIS MARIAGES

Bien des femmes ont cru pouvoir adoucir le caractère de Steve et le rendre plus civilisé. Aucune n'y est jamais parvenue.

C'est à l'occasion de ses débuts à Broadway, que Steve rencontre celle qui va devenir sa première épouse. Comme lui, Neile Adams exerce le métier de comédien. De leur union scellée en 1956 naissent deux enfants : un fils Chad né en 1960 et une fille Terry née en 1959 qui décédera malheureusement à l'âge de trente-huit ans des suites d'une transplantation cardiaque. Après seize ans de vie commune, le couple McQueen divorce le 14 mars 1972.

Le 31 août 1973, Steve se marie pour la deuxième fois. Là encore avec une actrice : Ali MacGraw. Ils sont épris follement l'un de l'autre depuis l'année précédente, lors du tournage de *Guet-apens*. Pour ses beaux yeux, Ali quitte Robert Evans, le réalisateur du film *Love Story* dont elle a été l'inoubliable interprète. Très vite, hélas, elle réalise que son mari est incapable d'avoir la moindre considération pour une femme. Que l'abandon de sa mère a laissé une terrible blessure en lui. Que Steve est dévoré par l'amertume et la souffrance. Impuissante face à tant d'animosité et de colère, Ali comprend que cette union est une erreur. Plus tard, elle avancera la thèse selon laquelle l'état psychologique de McQueen est à l'origine de son cancer. Divorcée de McQueen en 1978, Ali MacGraw quitte l'univers du cinéma pour sombrer dans ceux de la drogue et de l'alcool. Sauvée grâce à une cure de désintoxication au célèbre Betty Ford Center en Californie, elle vit aujourd'hui au Nouveau-Mexique où elle a retrouvé la sérénité. Mais surtout, à l'âge de 68 ans, Ali a effectué ses grands débuts au théâtre sur la scène de Broadway en 2006 dans la pièce *Festen*.

On prête également à Steve de n'avoir pas toujours été un exemple de fidélité et d'avoir eu, au cours de sa vie, de nombreuses maîtresses. La plupart parmi ses partenaires à l'écran.

Enfin, le 16 janvier 1980 au Mexique, Steve McQueen épouse sa troisième femme, Barbara Minty, une jeune mannequin de vingt-cinq ans qui l'accompagnera jusqu'à son dernier souffle.

SA LUTTE CONTRE LA MALADIE

En 1978, à la suite d'une visite médicale, il apprend qu'il est atteint d'un cancer rare : le mésotheliome. Cette forme de cancer est particulièrement maligne et virulente. Elle affecte le revêtement des poumons, de la cavité abdominale ou l'enveloppe du coeur. Il s'agit du cancer causé par une exposition prolongée à l'amiante. Or, au cours de sa vie, Steve a souvnt été en présence de ce matériau. Notamment lors de sa vie de travailleur itinérant qui l'a amené à fréquenter de nombreux chantiers.

L'amiante était couramment utilisée dans l'isolation des bateaux construits avant 1976. Or, de son passage chez les Marines, Steve se souvient avoir été condamné à six semaines de nettoyage dans la salle des machines d'un navire. Les tuyauteries

EPILOGUE

Three years later, at the reform school he had attended as a youth in Los Angeles, a new building was dedicated: the Steve McQueen Recreation Center. A bronze memorial plaque bears this moving dedication:

"Steve McQueen came here as a troubled boy but left as a man. He went on to achieve stardom in motion pictures but returned to this campus often to share of himself and his fortune. His legacy is hope and inspiration to those students here now, and those yet to come."

étaient recouvertes d'amiante que les hommes devaient arracher et remplacer. L'air était si épais avec les particules d'amiante, qu'on pouvait à peine respirer. Cette matière était également présente sur les plateaux de tournage, dans les freins des voitures de course, les combinaisons et casques de pilote.

Si les progrès effectués par la médecine permettent aujourd'hui un meilleur pronostic vital, à la fin des années soixante dix il n'en est rien. A l'époque, les traitements curatifs comme la chimiothérapie n'existent pas et le chef de la clinique de Culver City émet un pronostic plus que réservé quant aux chances de Steve McQueen de s'en tirer.

L'acteur se sait condamné. Pourtant, à l'instar de John Wayne, il va se battre et faire preuve d'un courage exemplaire. L'acteur poursuit le tournage du film *Le chasseur* à Chicago. Malheureusement, la maladie est plus forte. McQueen apprend qu'il est inopérable, mais il veut croire en ses dernières chances. Il tente un ultime baroud d'honneur en confiant ses derniers espoirs à une clinique mexicaine très controversée. Il va endurer trois mois de torture, supportant des injections de cellules animales et absorbant, chaque jour, une centaine de cachets à base de vitamines. Mais, la maladie ne cesse de l'affaiblir. C'est là, dans la clinique de Juarez que, le 7 novembre 1980, âgé de cinquante ans, Steve McQueen décède d'une embolie pulmonaire post-opératoire (suite à l'ablation d'une tumeur à l'abdomen). Selon ses dernières volontés, ses cendres seront dispersées dans l'Océan Pacifique.

EPILOGUE

Trois ans plus tard sera inauguré, au sein de l'établissement de redressement qu'il fréquenta plus jeune à Los Angeles, le *Steve McQueen Recreation Center*. Sur une plaque en bronze dédiée à sa mémoire, on peut lire le plus bel hommage:

"En entrant ici, Steve McQueen était un enfant à problèmes. En sortant, il était devenu un homme. Il a trouvé gloire et fortune dans le cinéma. Mais, il est souvent revenu chez nous. Il a donné de sa personne et de sa fortune. Il demeure pour toujours un exemple, une source d'espoir et d'inspiration pour tous nos étudiants, présents et à venir."

IN MY OWN MIND, I'M NOT SURE THAT ACTING IS SOMETHING FOR A GROWN MAN TO BE DOING.

STEVE MCQUEEN

AU FOND DE MOI, JE NE SUIS PAS CERTAIN QUE LE METIER D'ACTEUR SOIT POUR LES ADULTES.

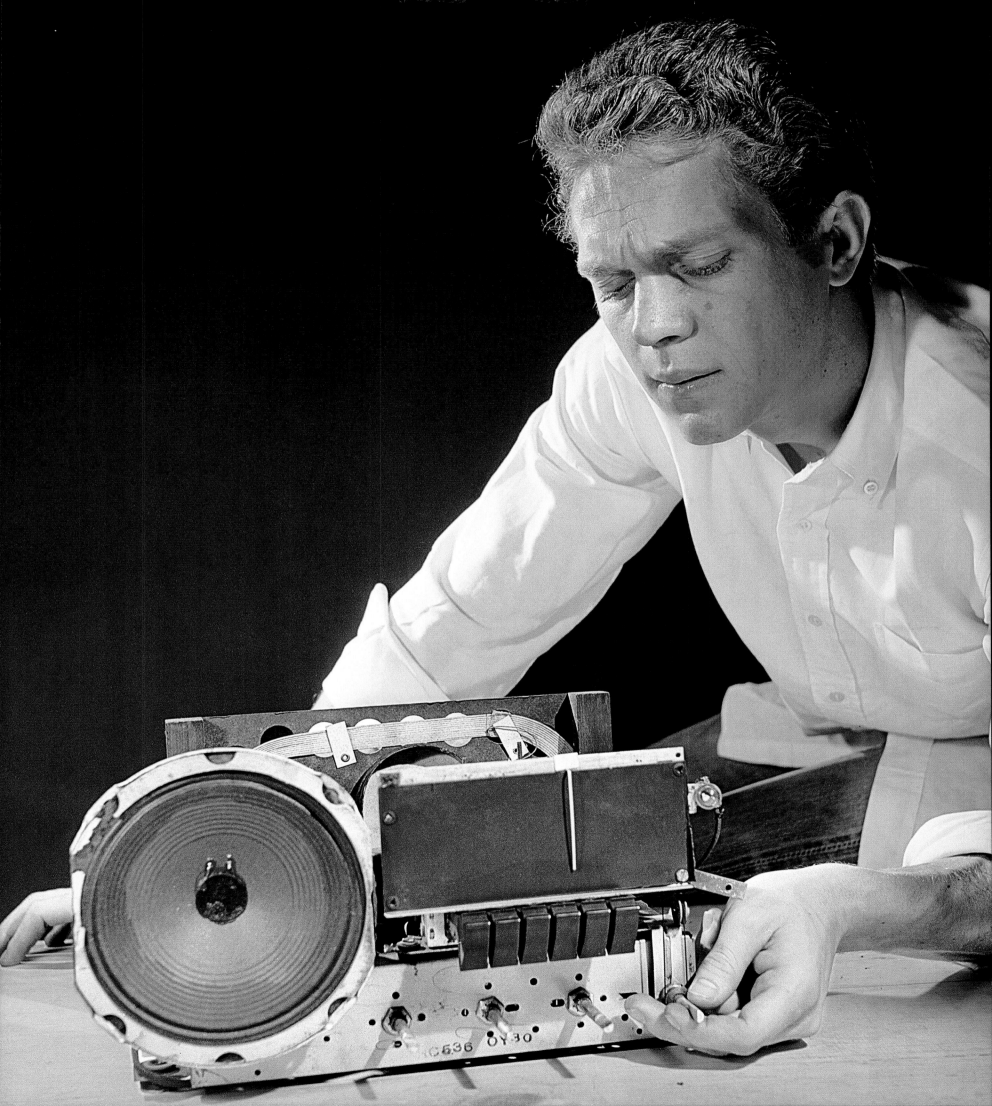

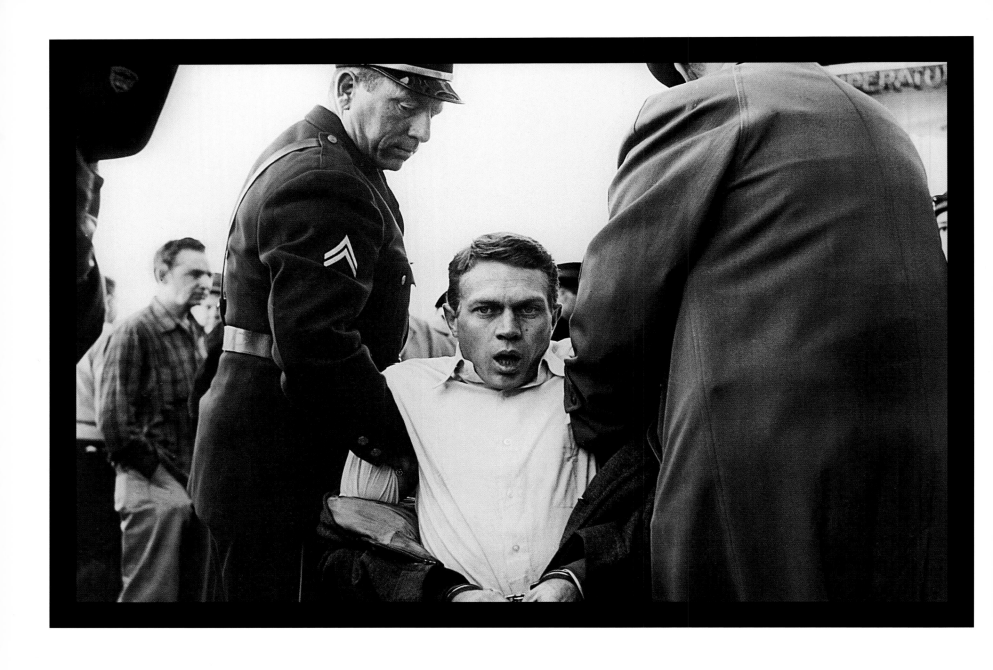

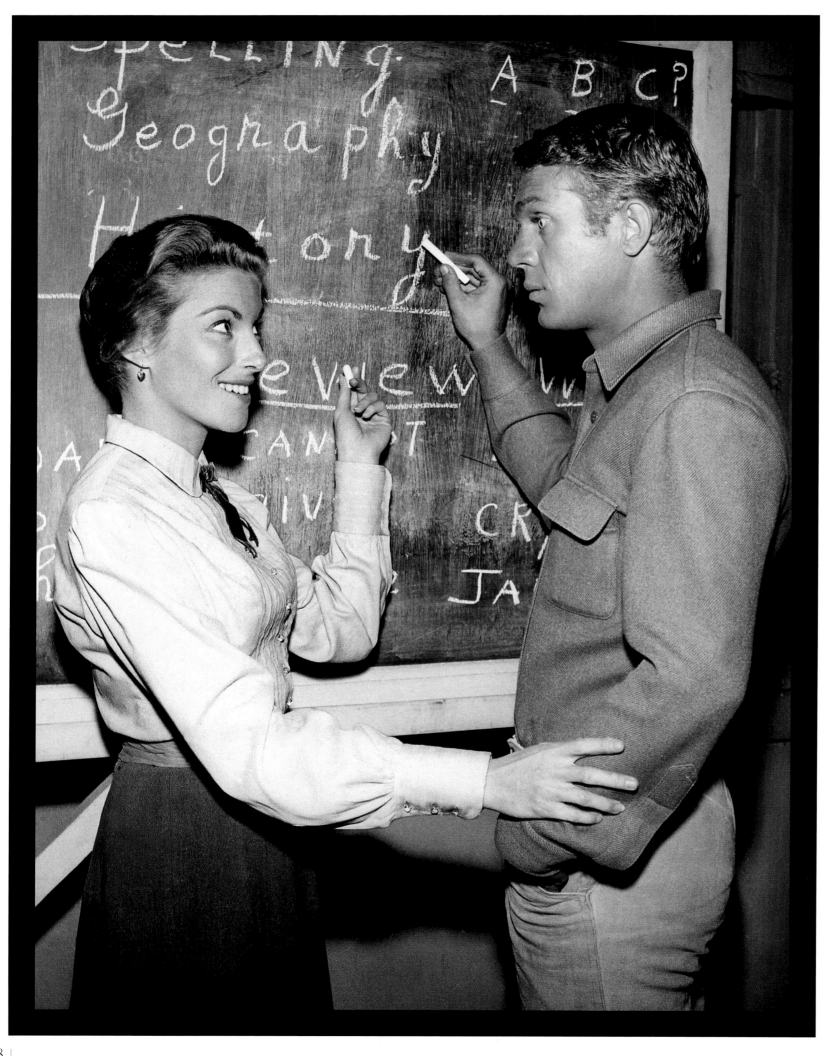

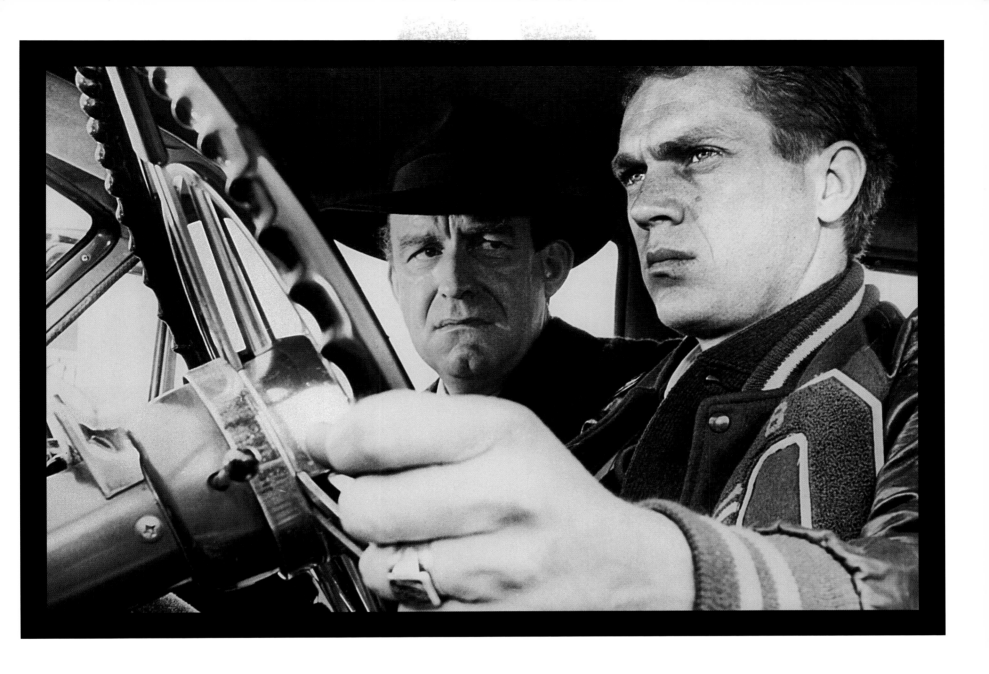

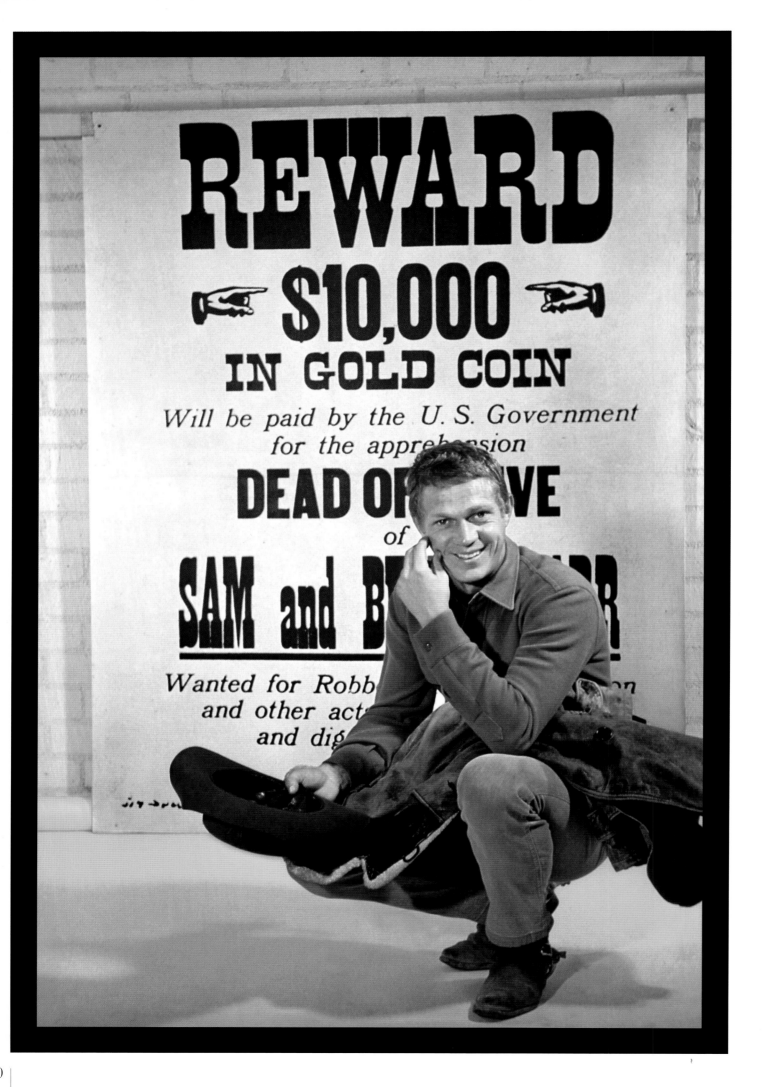

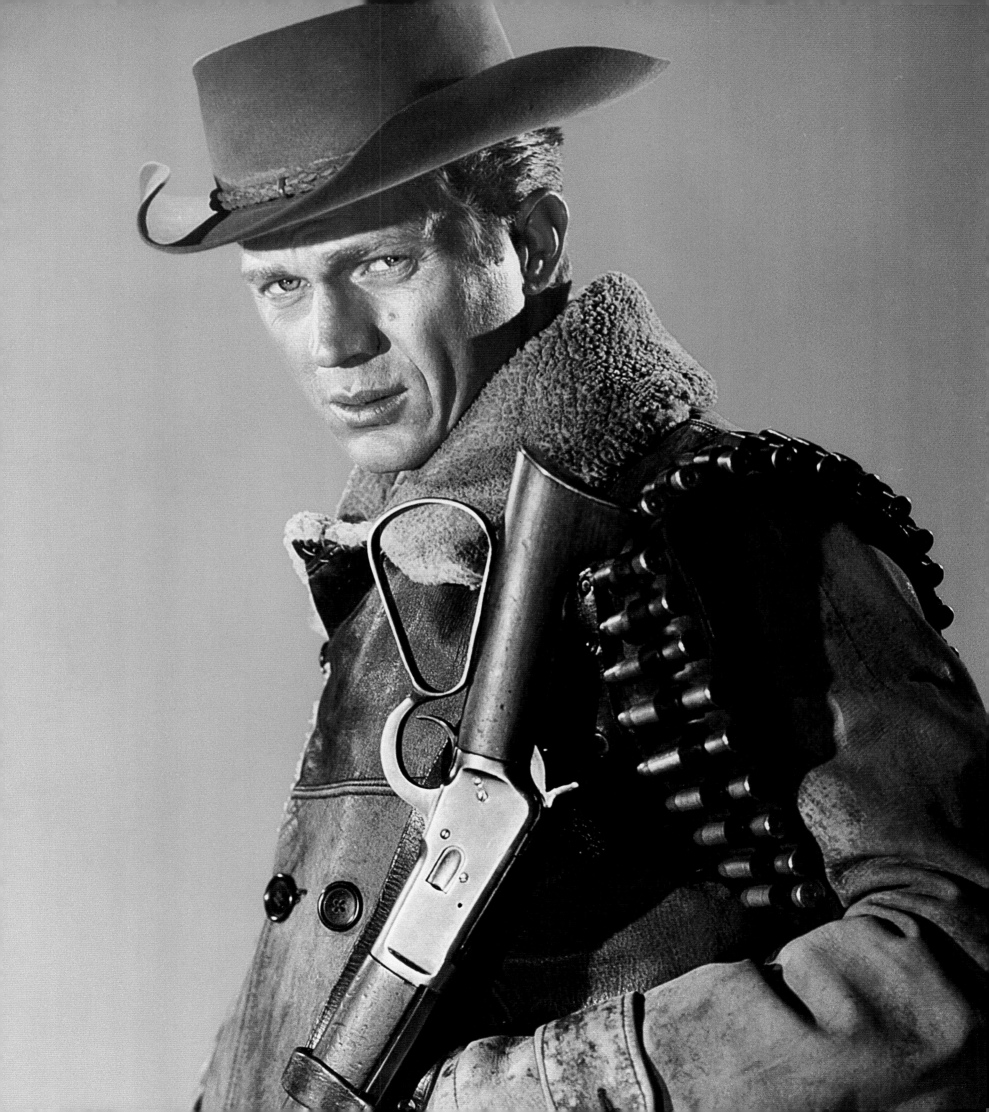

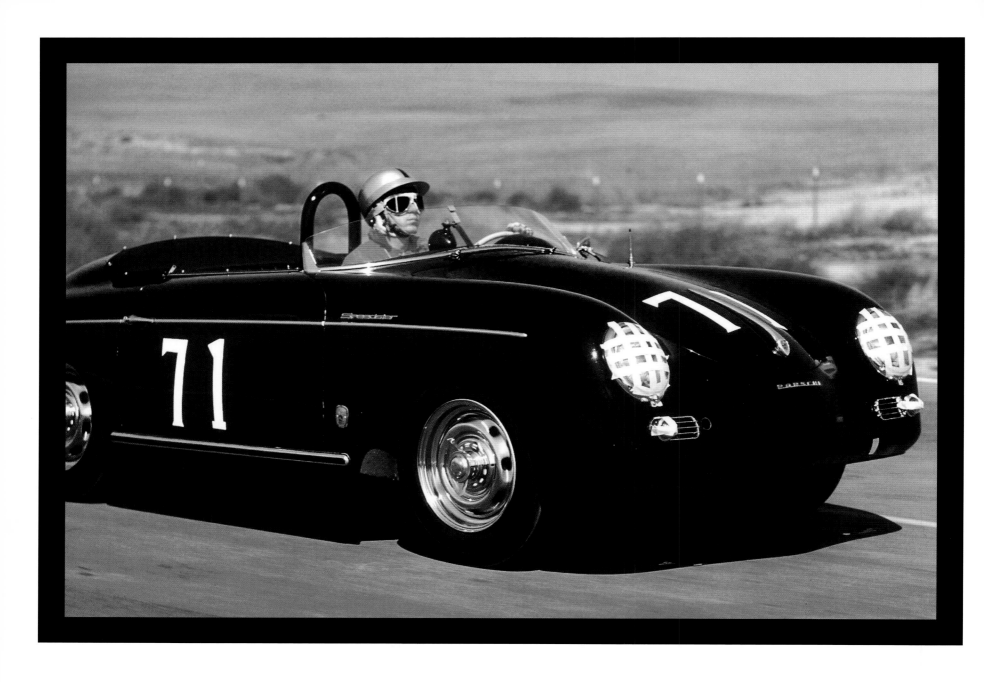

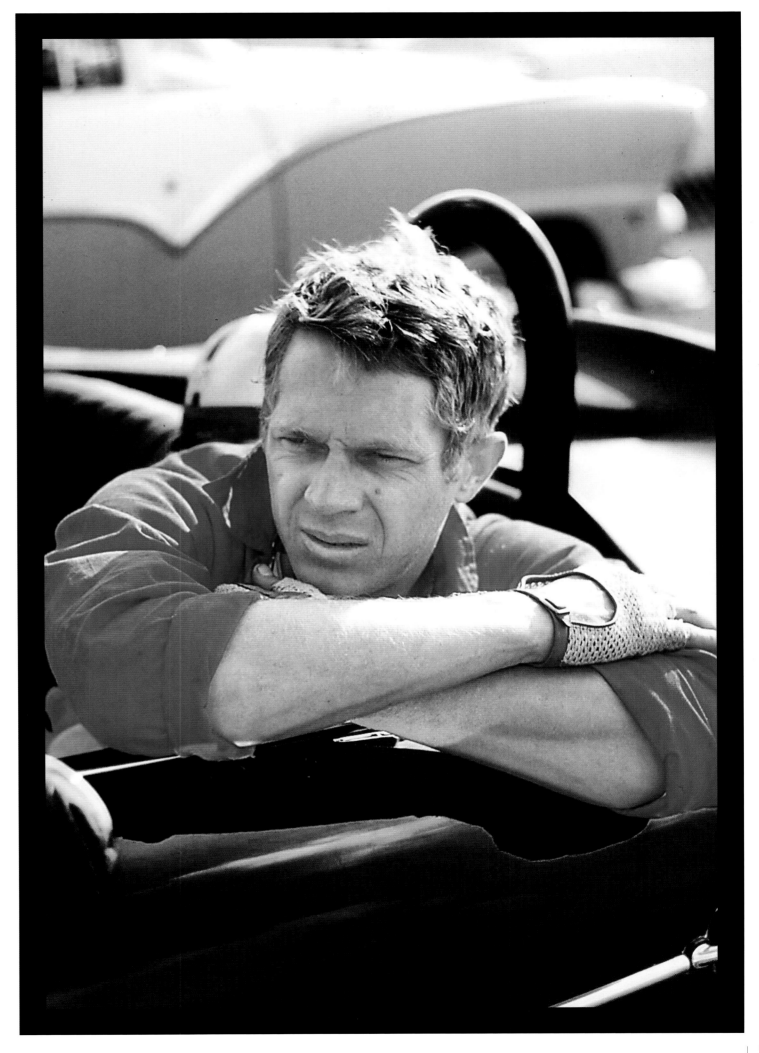

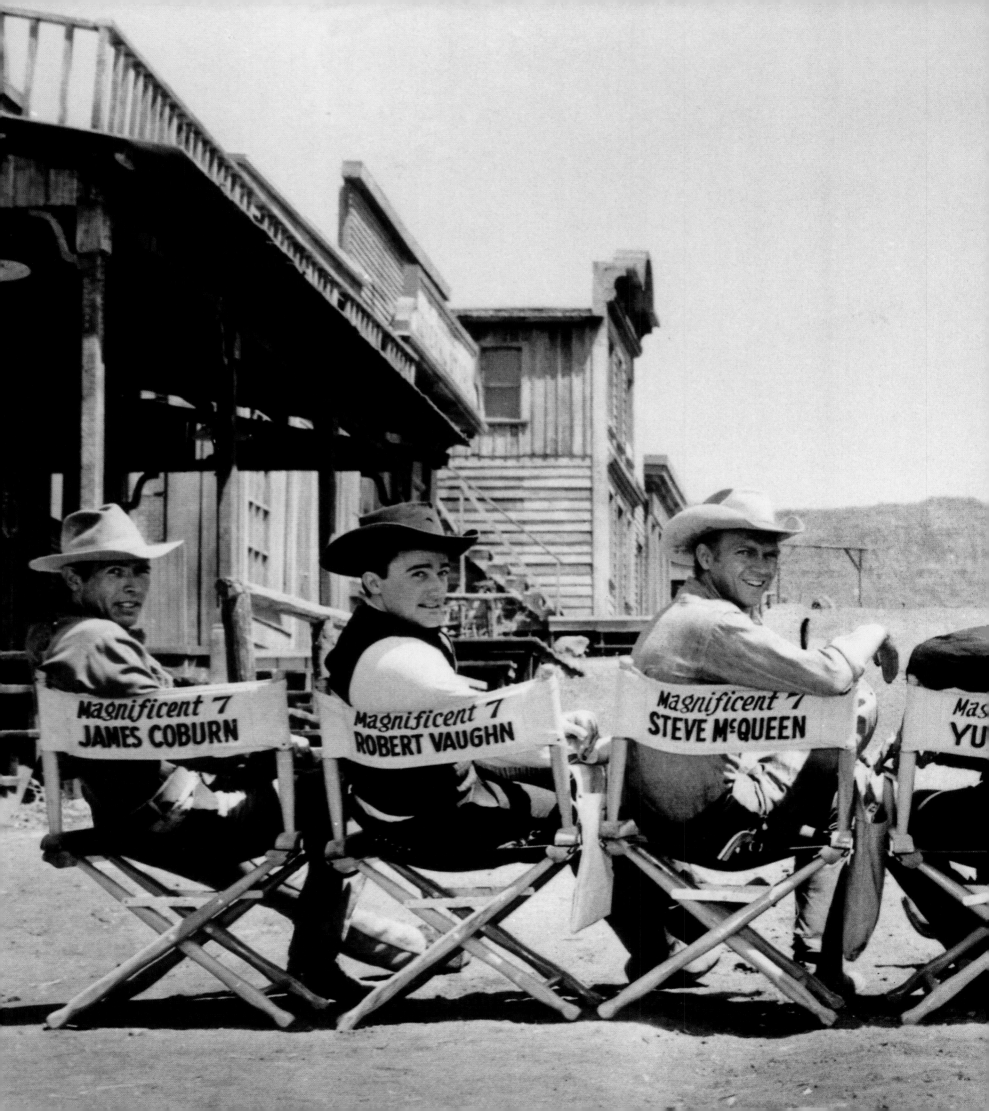

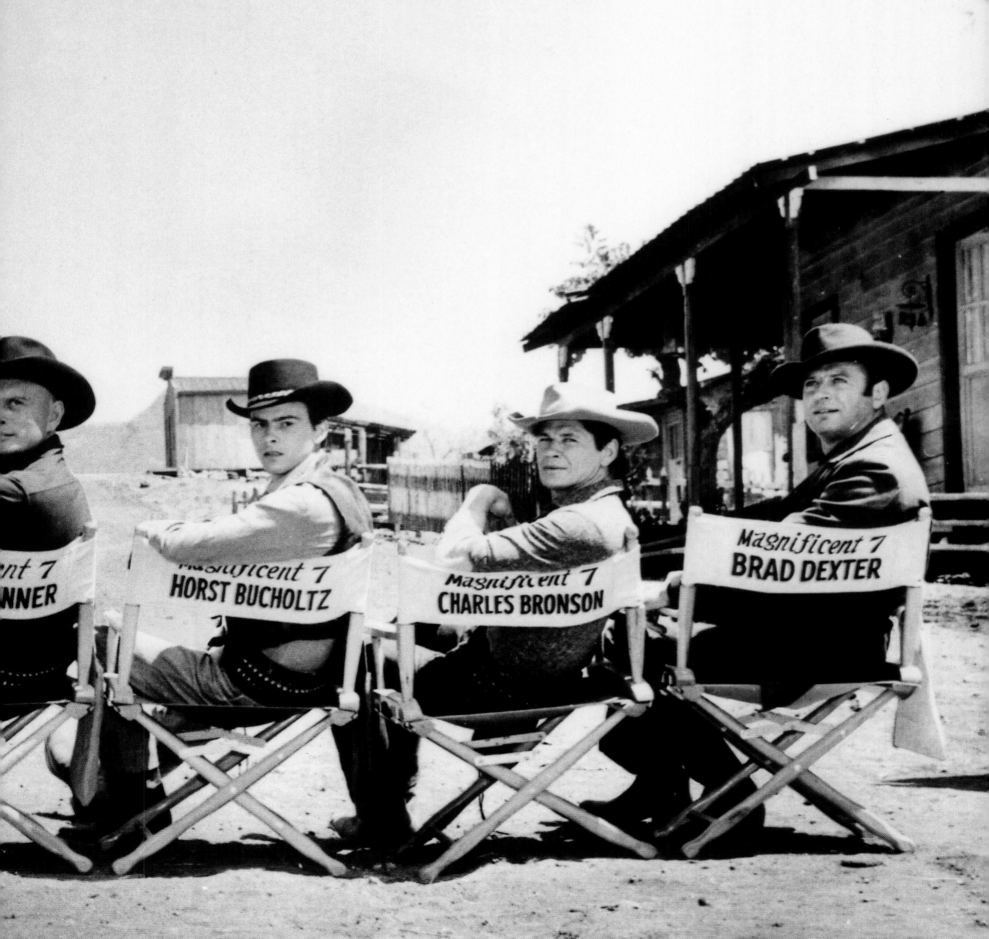

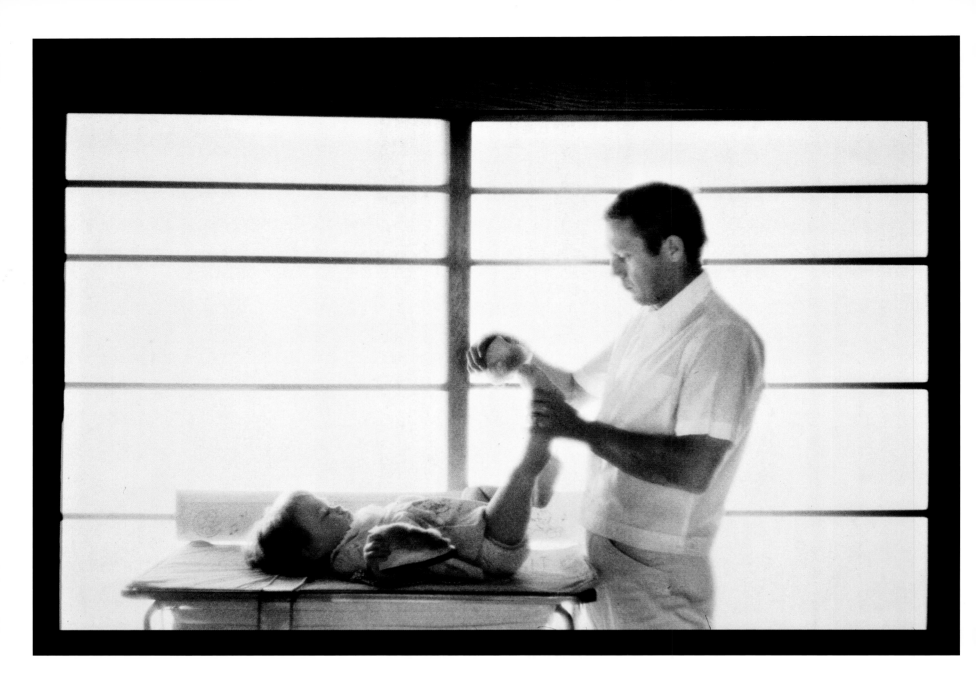

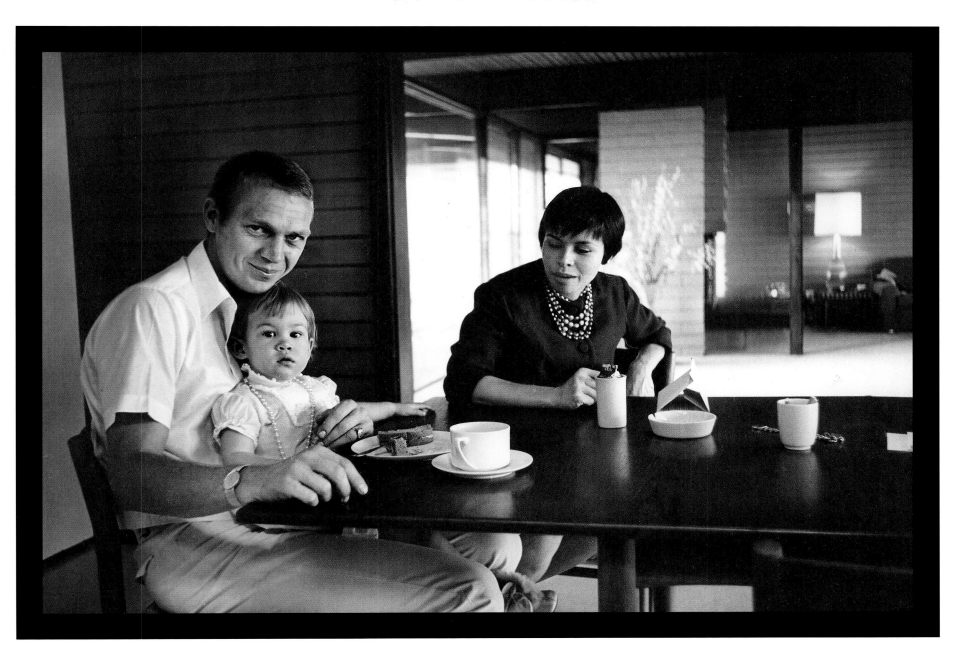

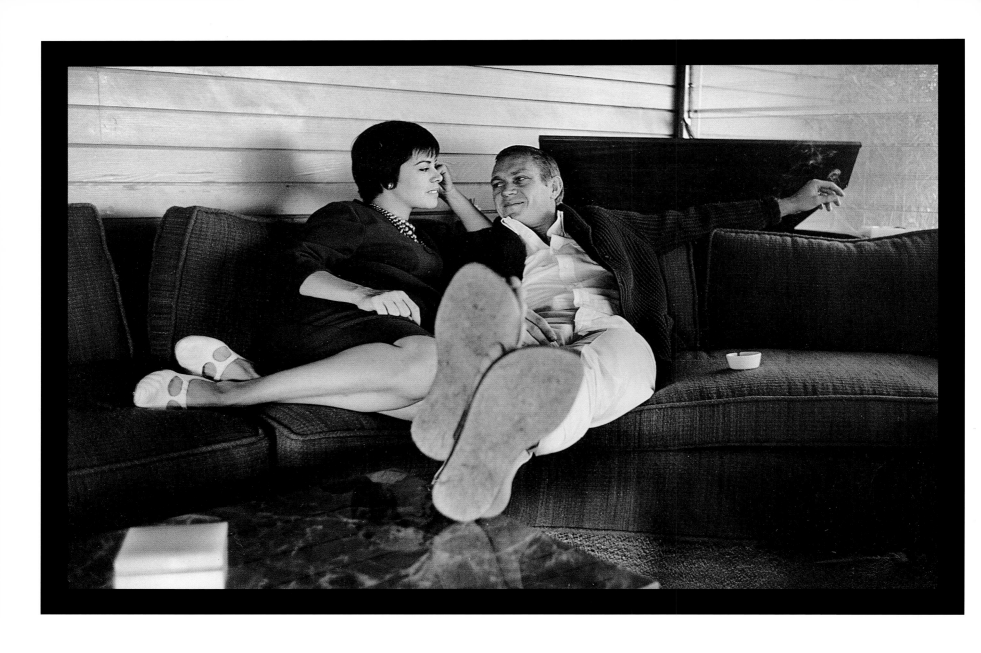

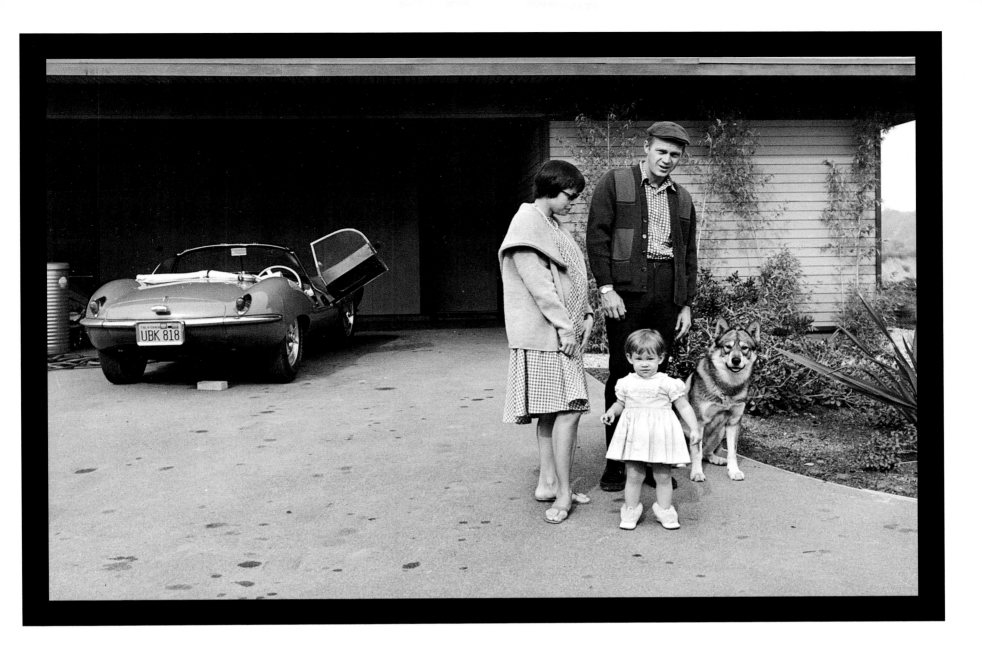

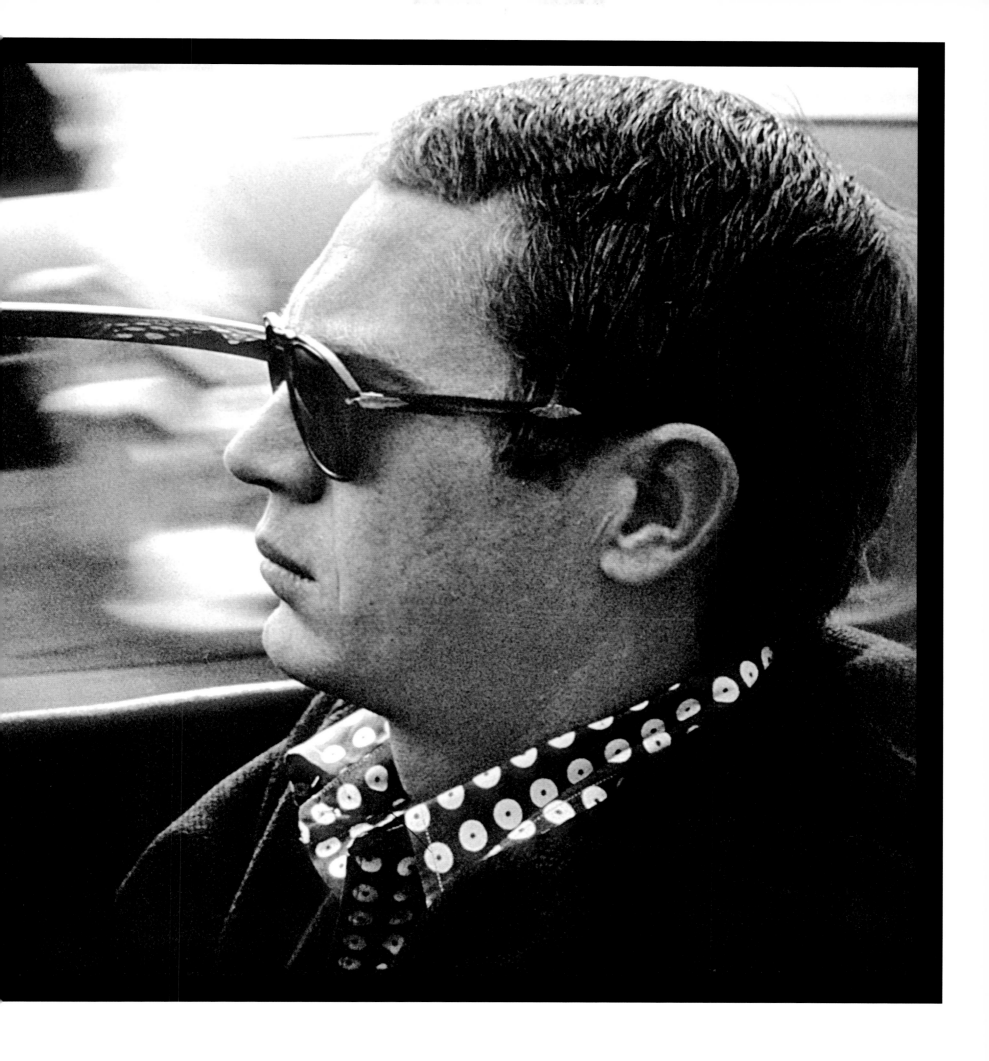

THERE'S SOMETHING ABOUT MY SHAGGY-DOG EYES THAT MAKES PEOPLE THINK I'M GOOD.

STEVE MCQUEEN

A CAUSE DE MON REGARD DE BOBTAIL,
LES GENS CROIENT QUE JE SUIS UN GENTIL.

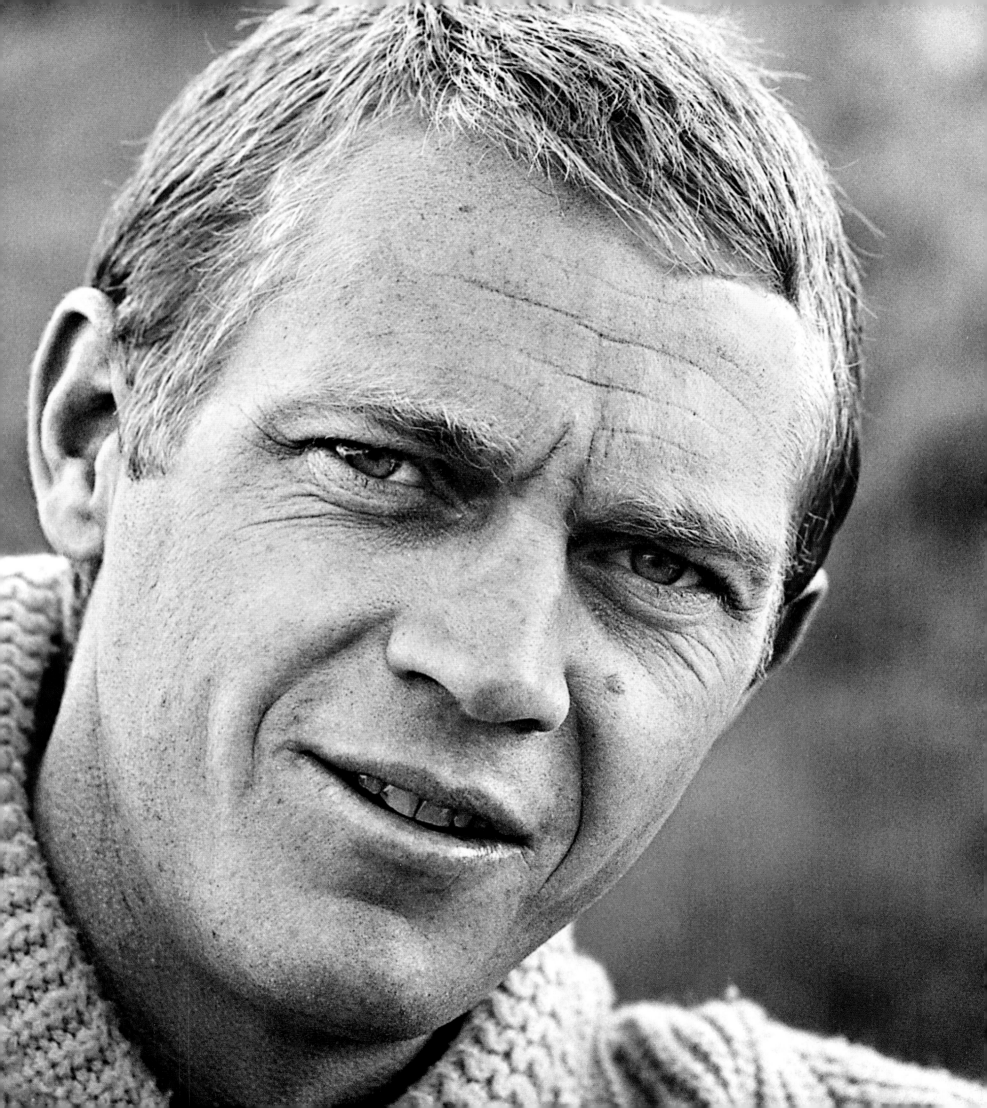

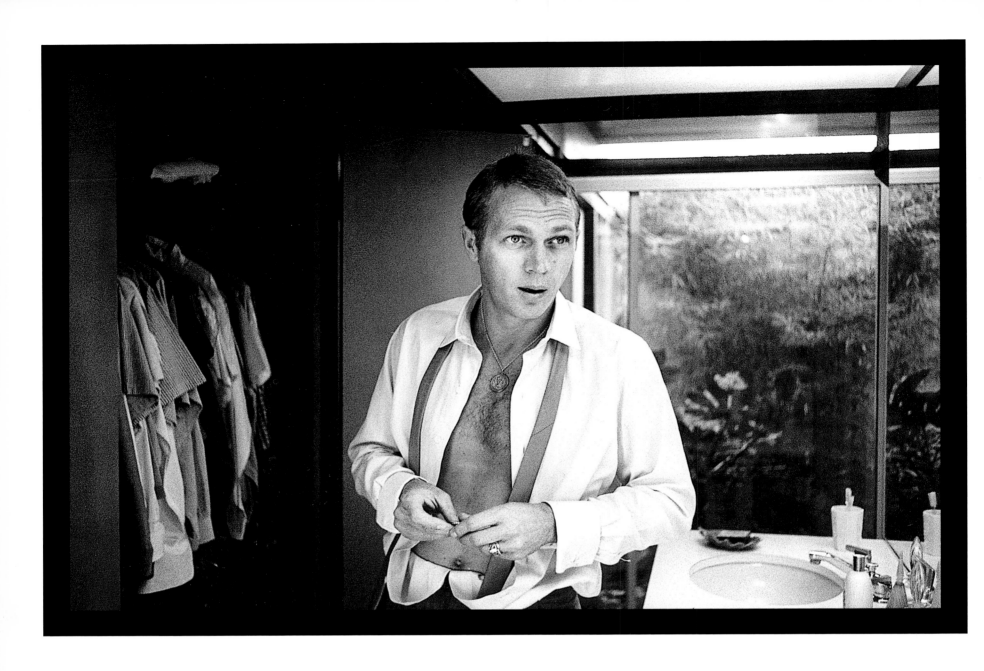

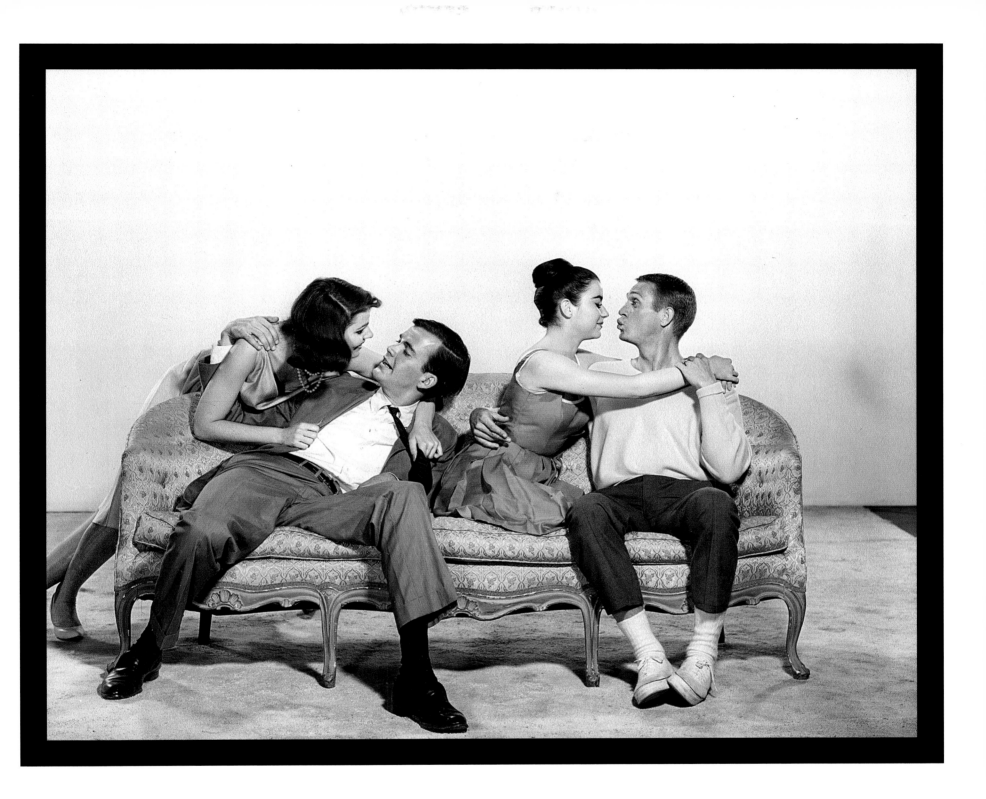

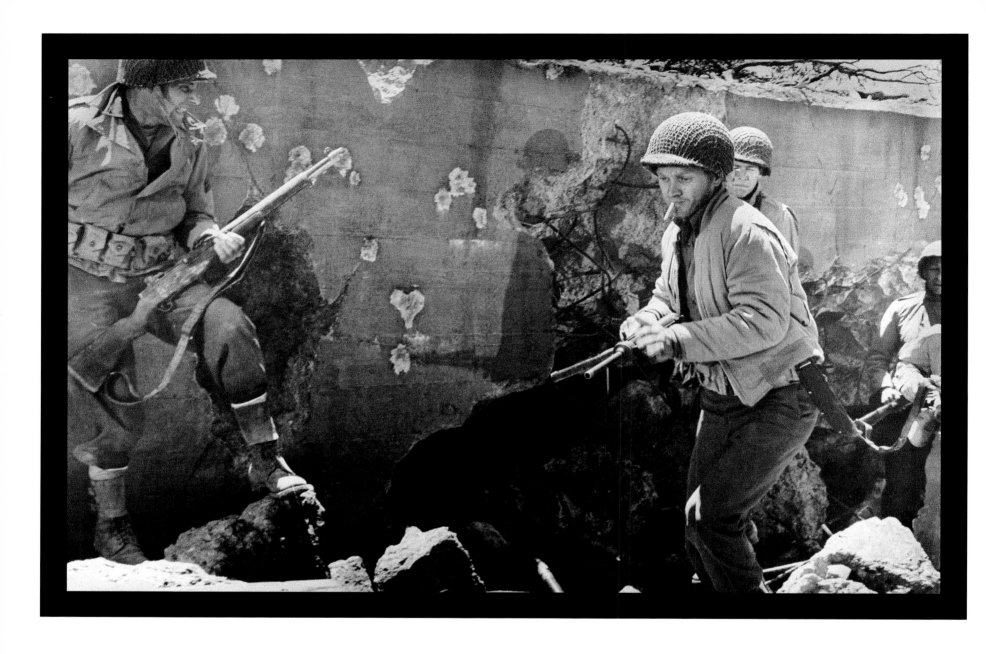

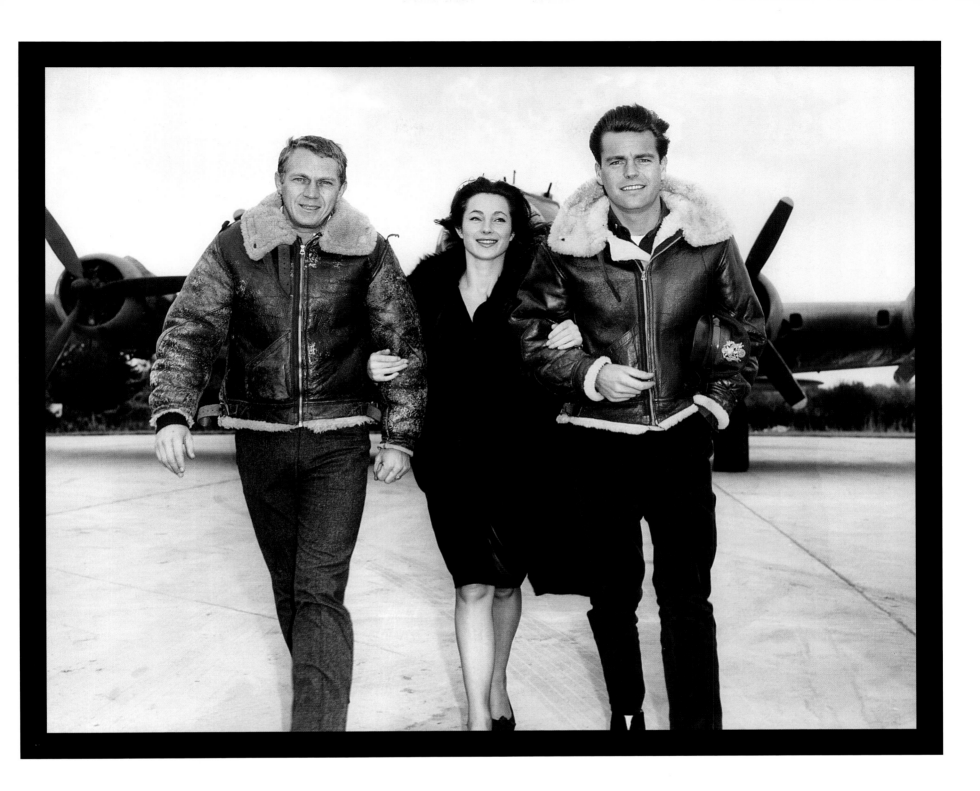

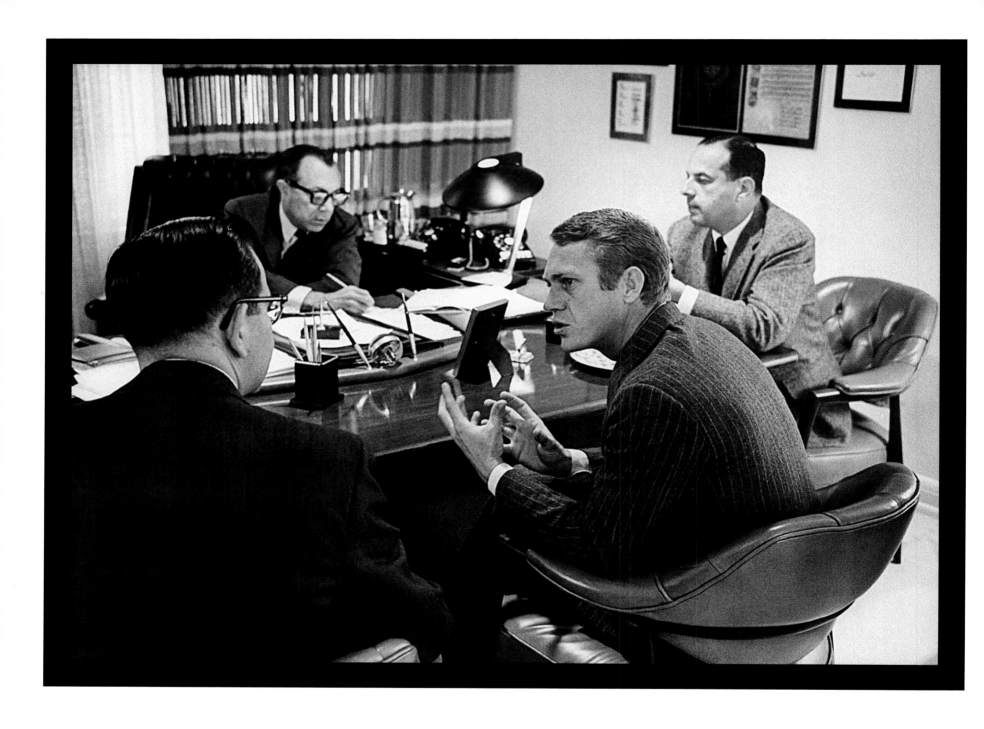

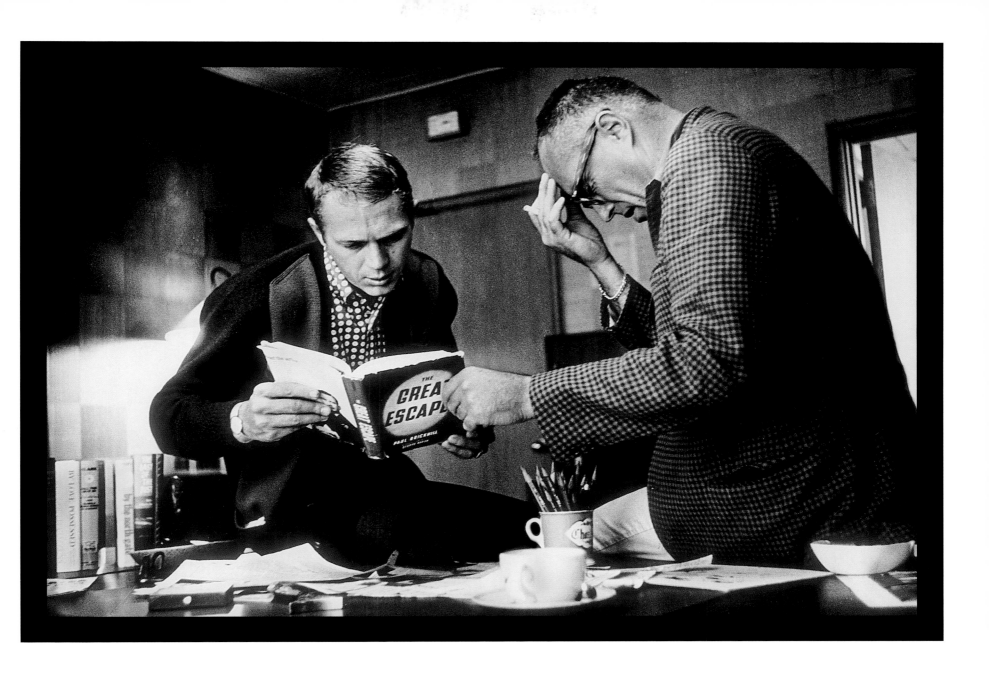

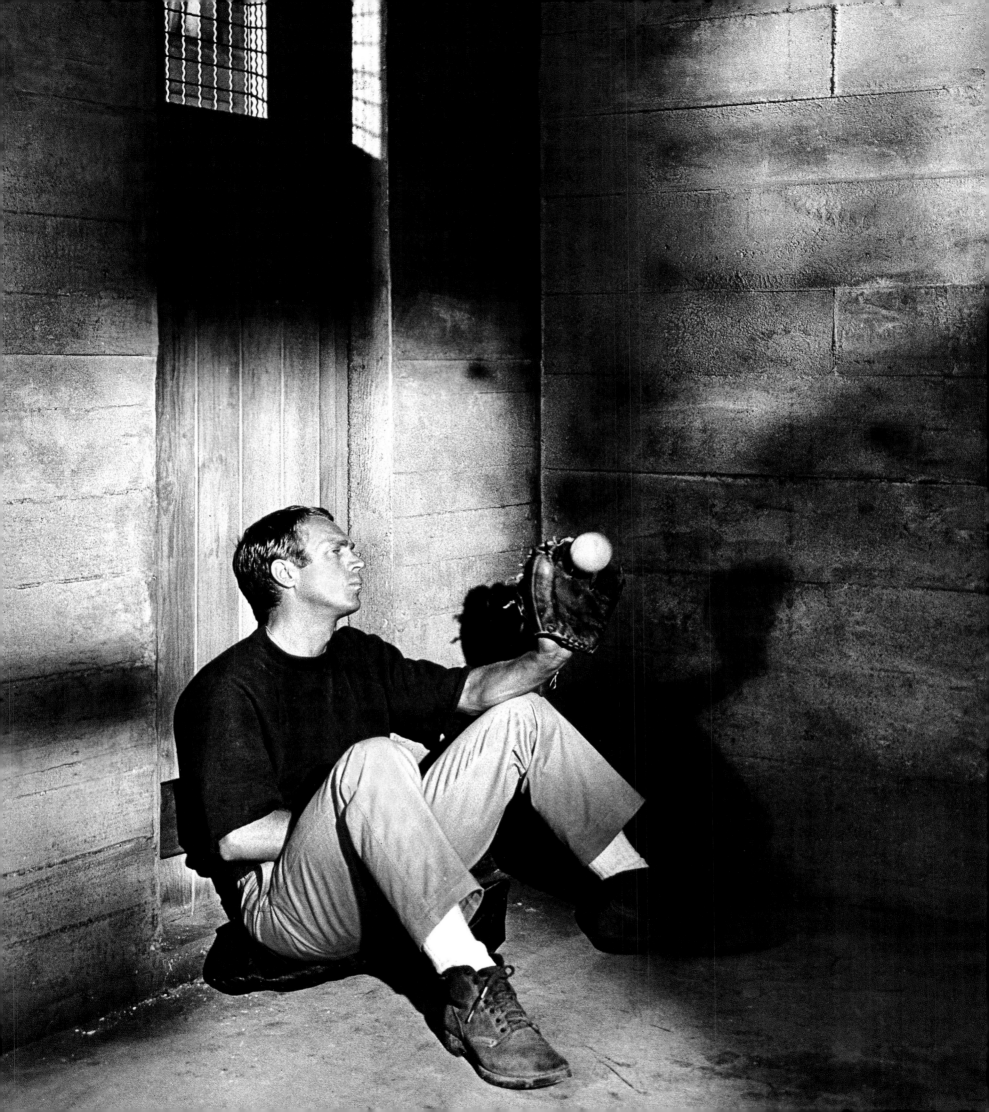

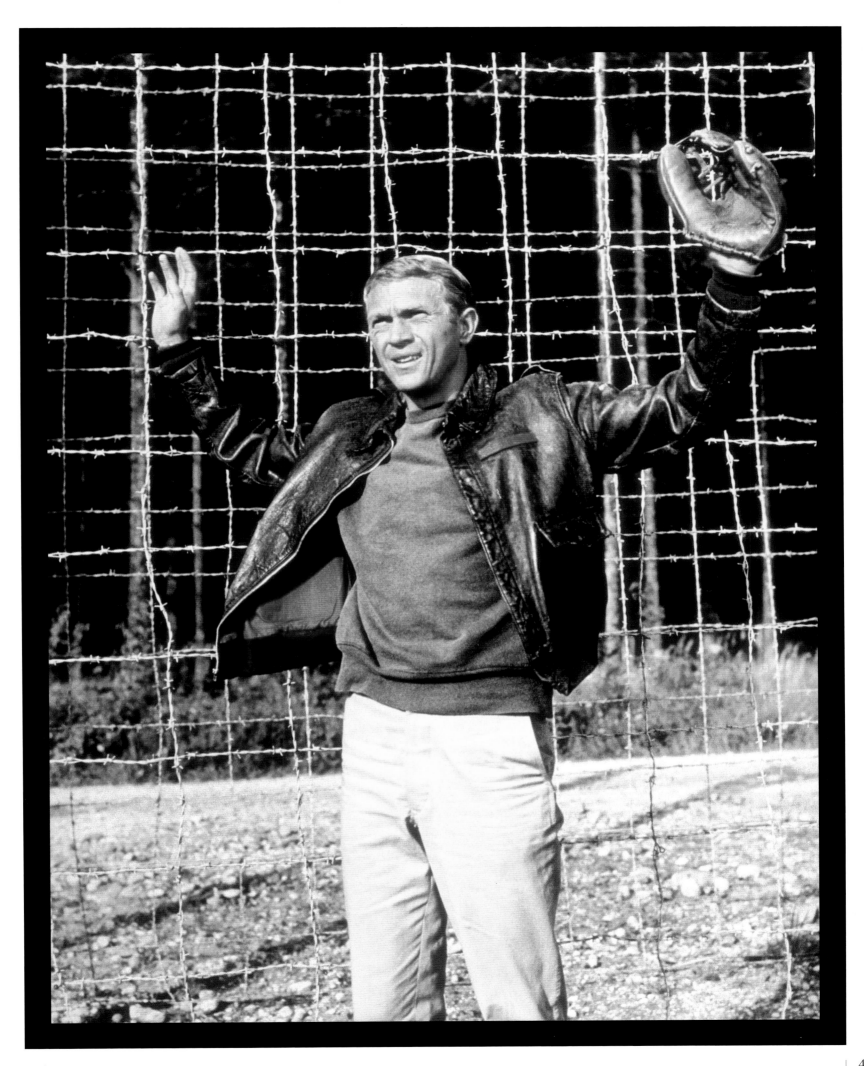

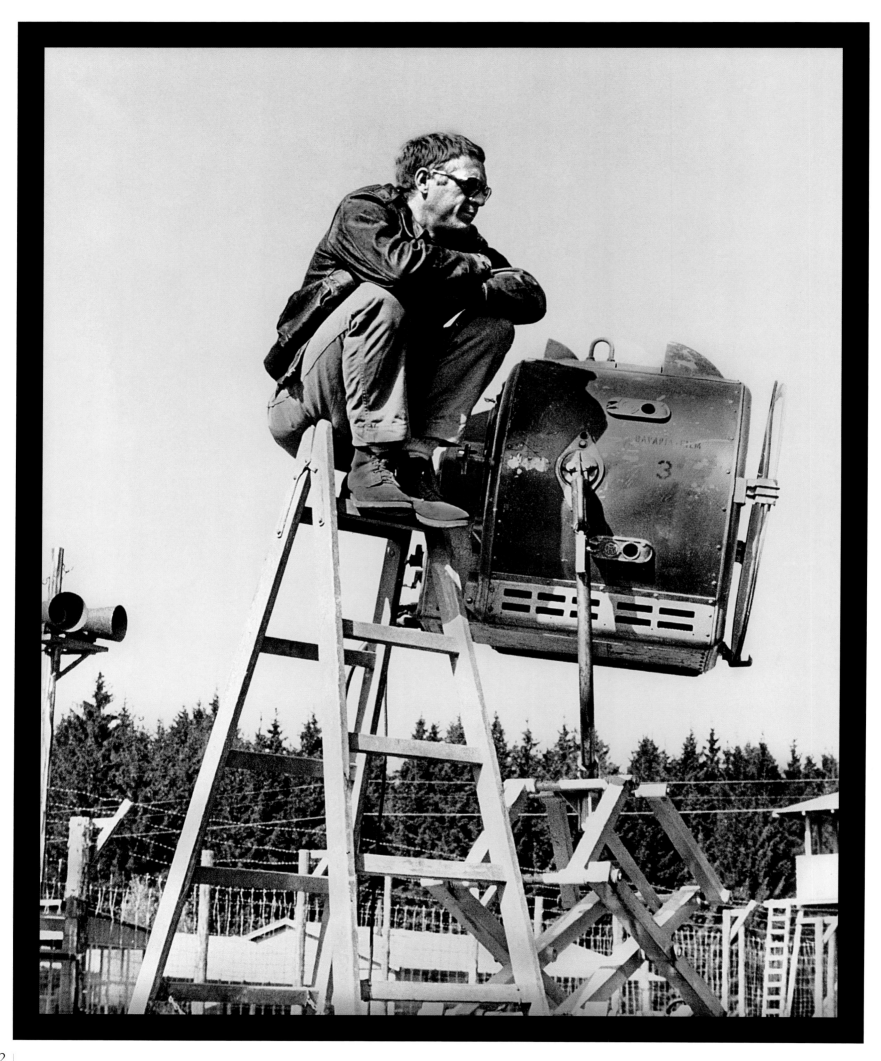

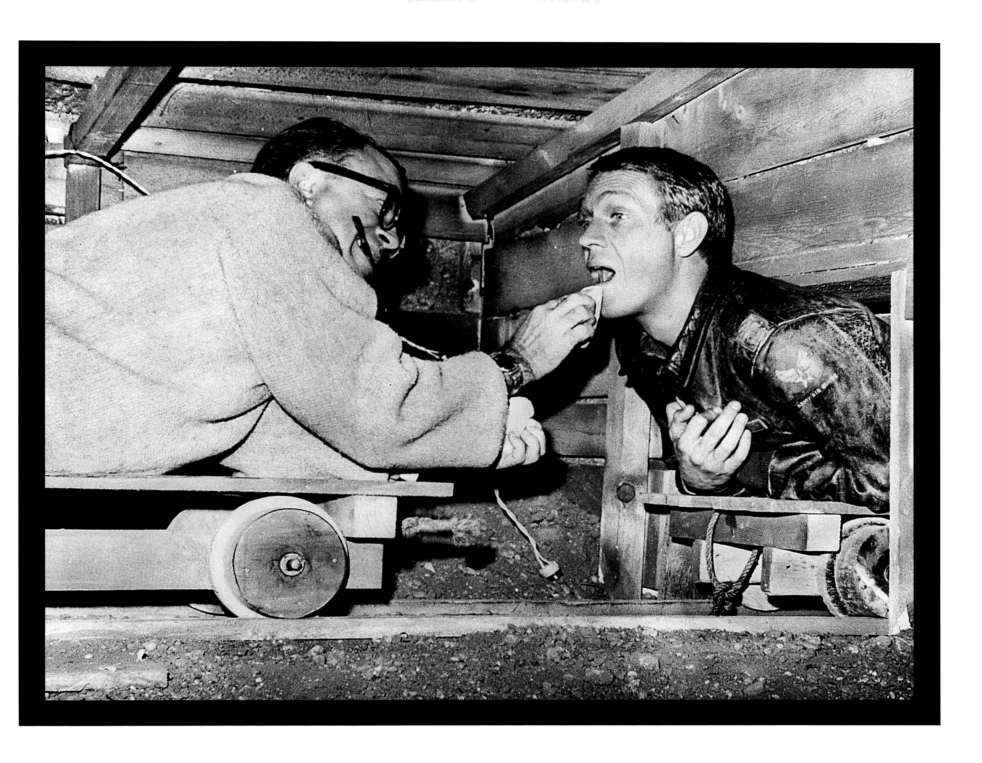

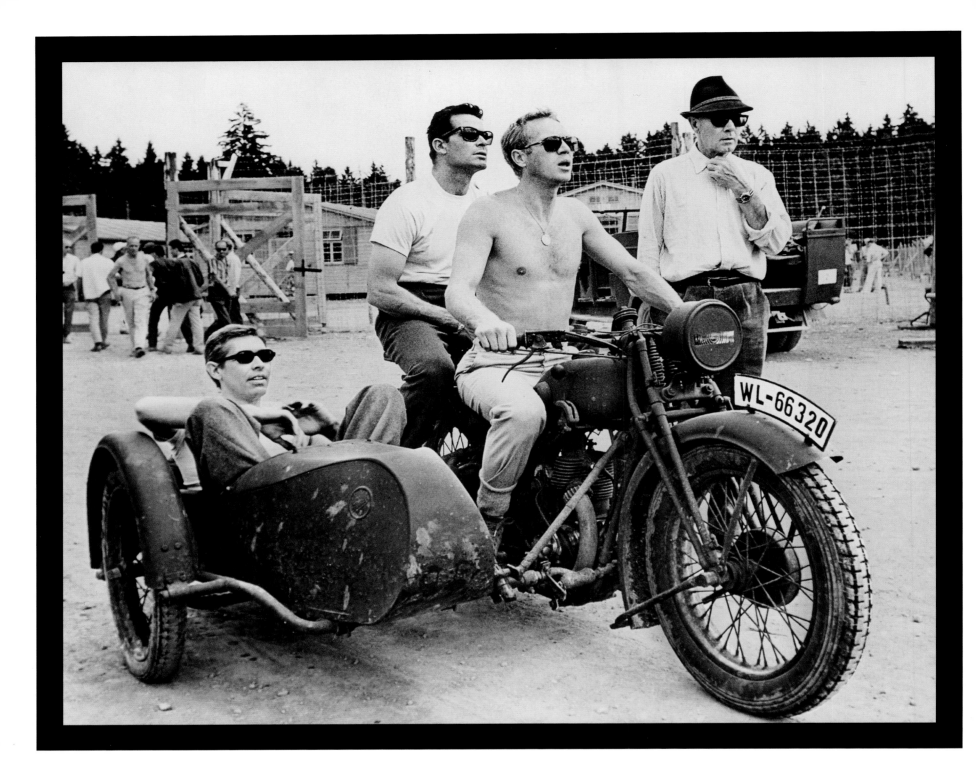

44

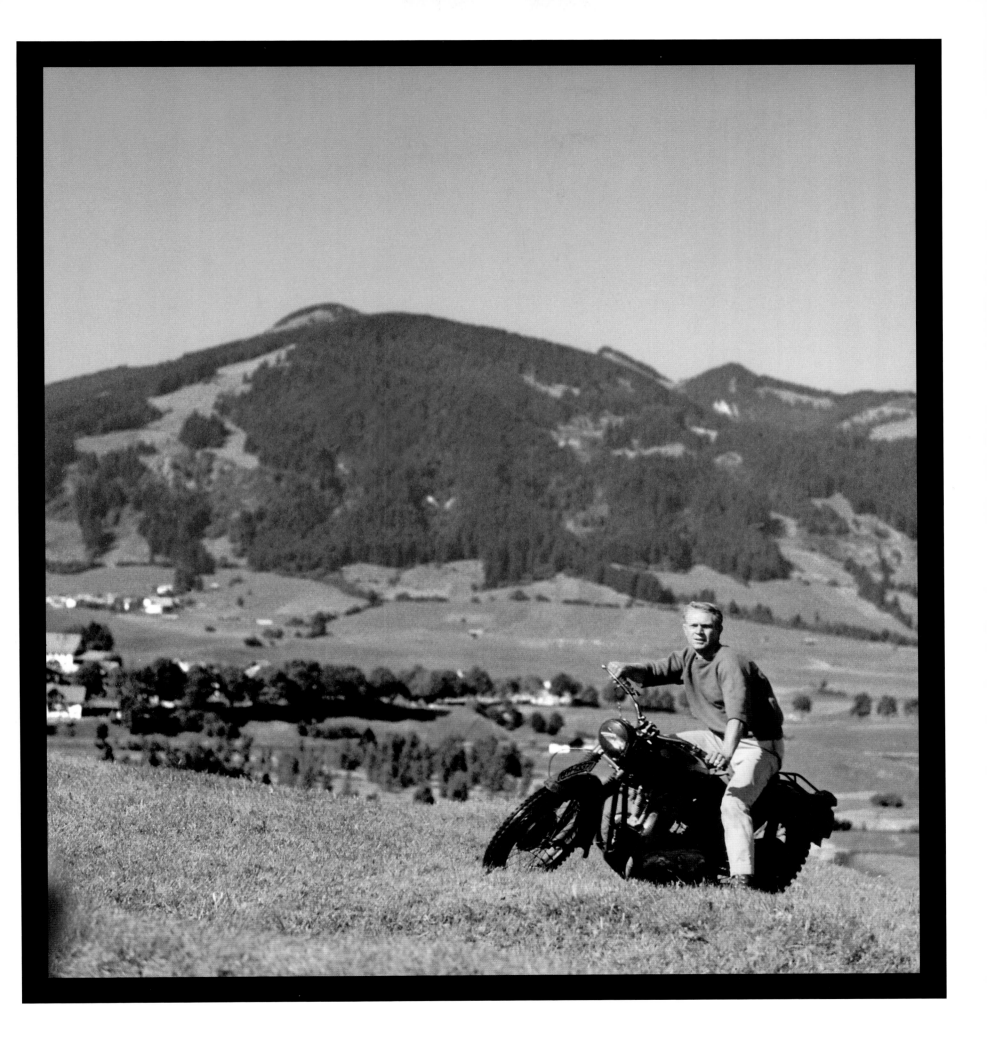

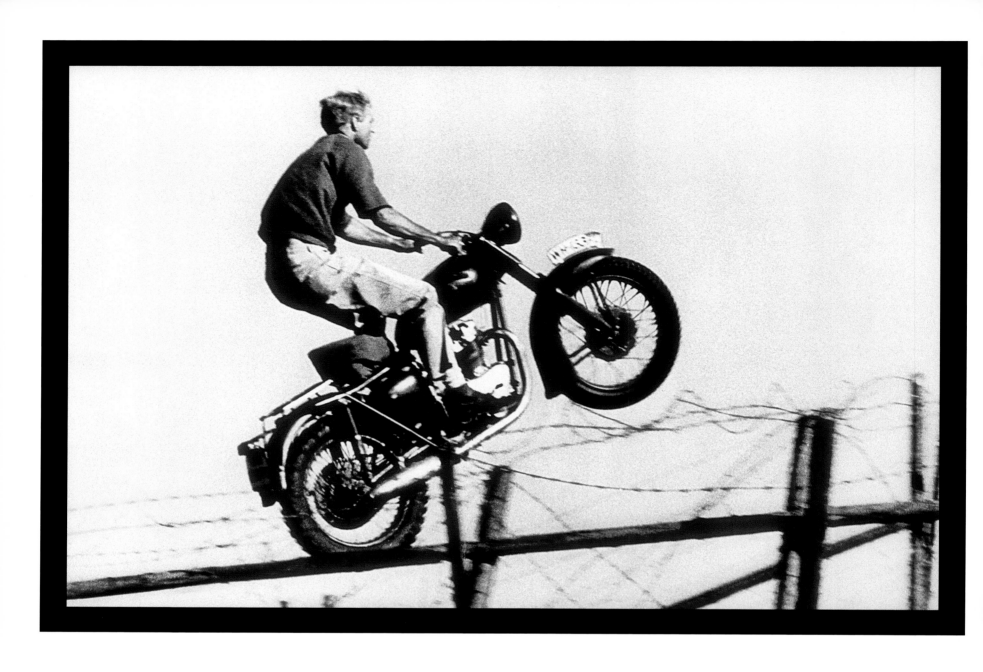

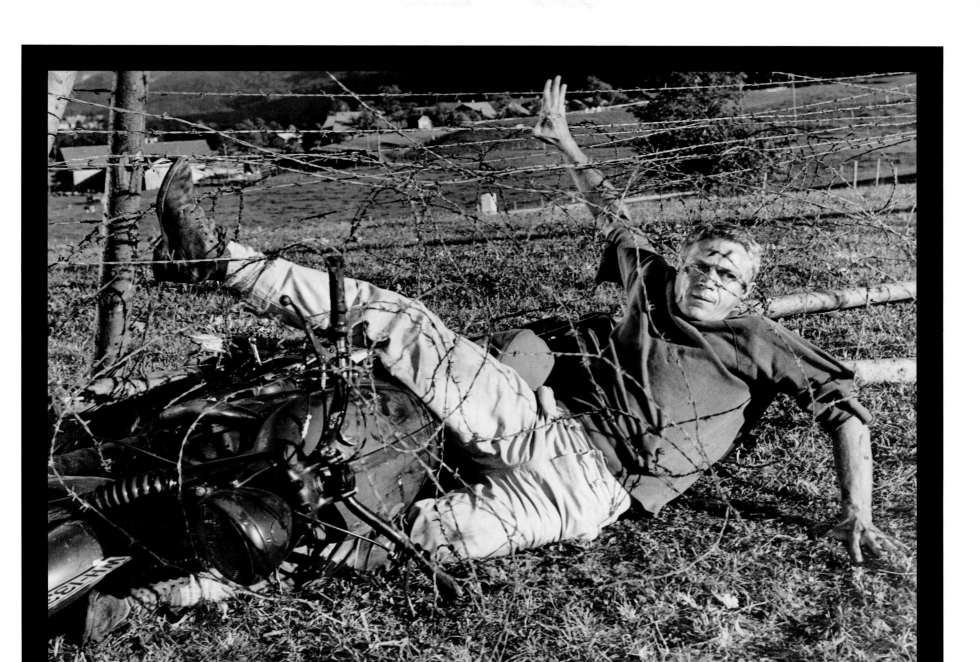

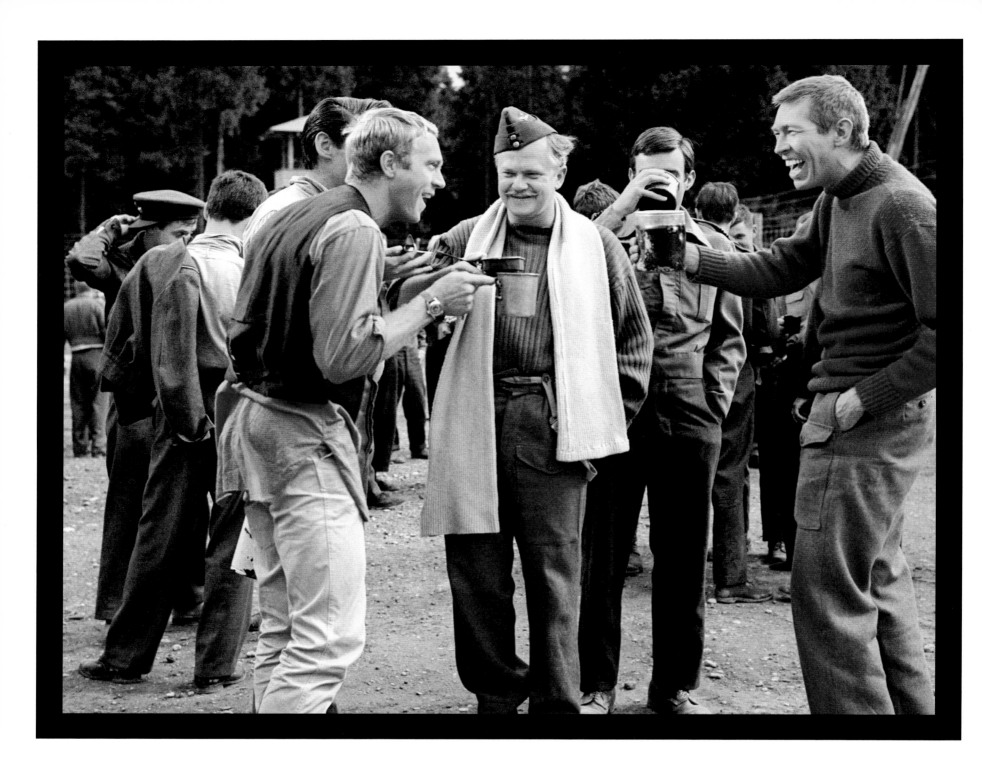

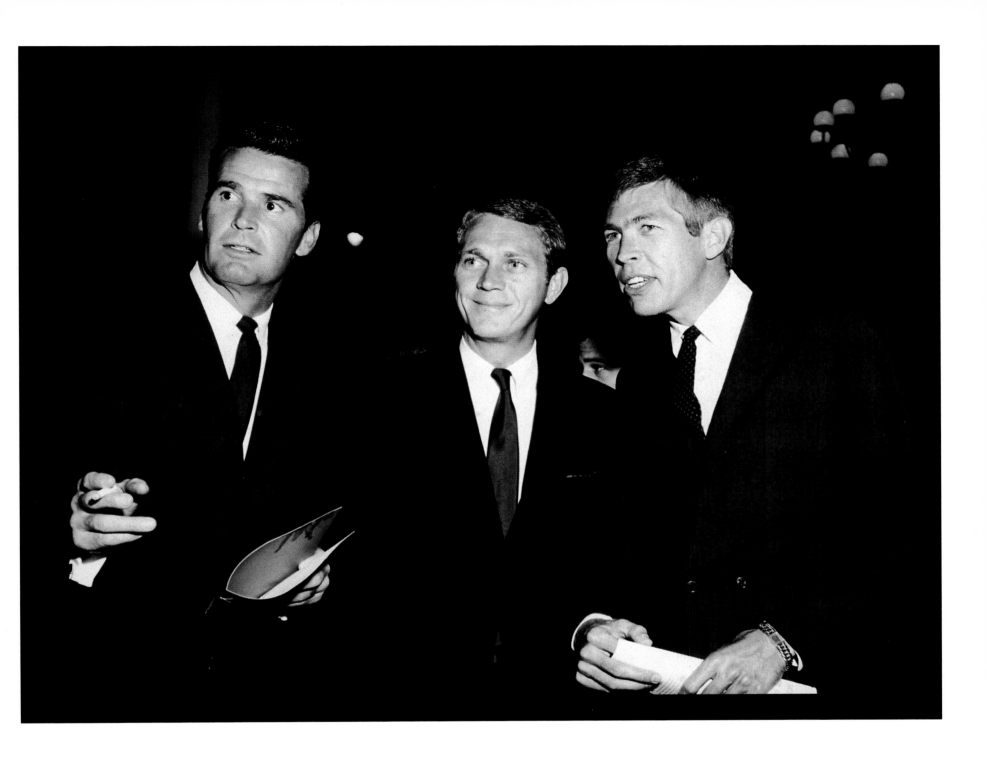

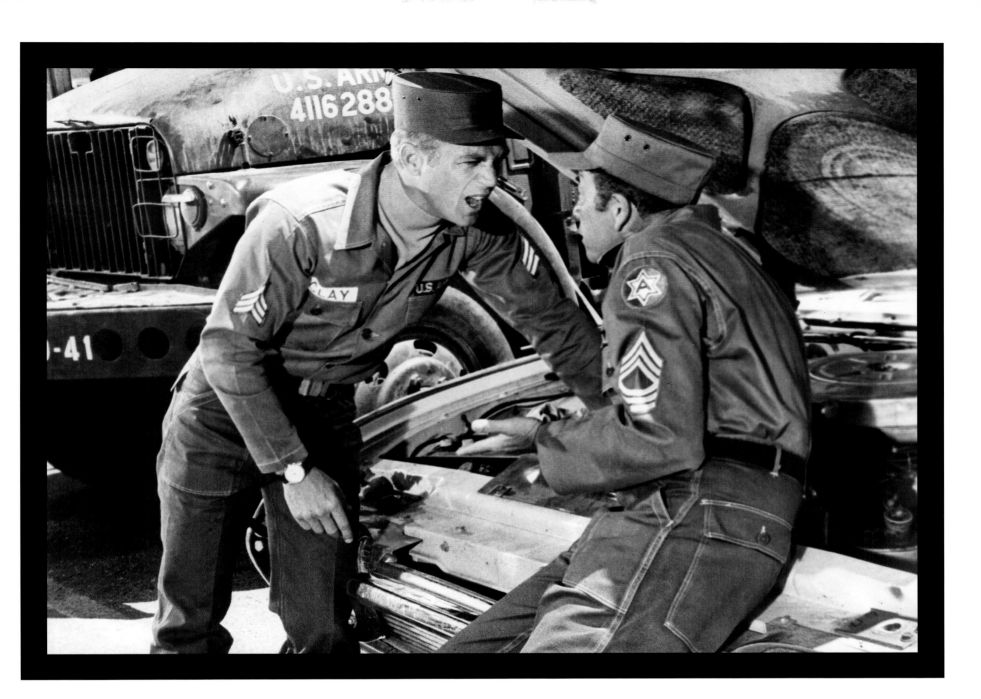

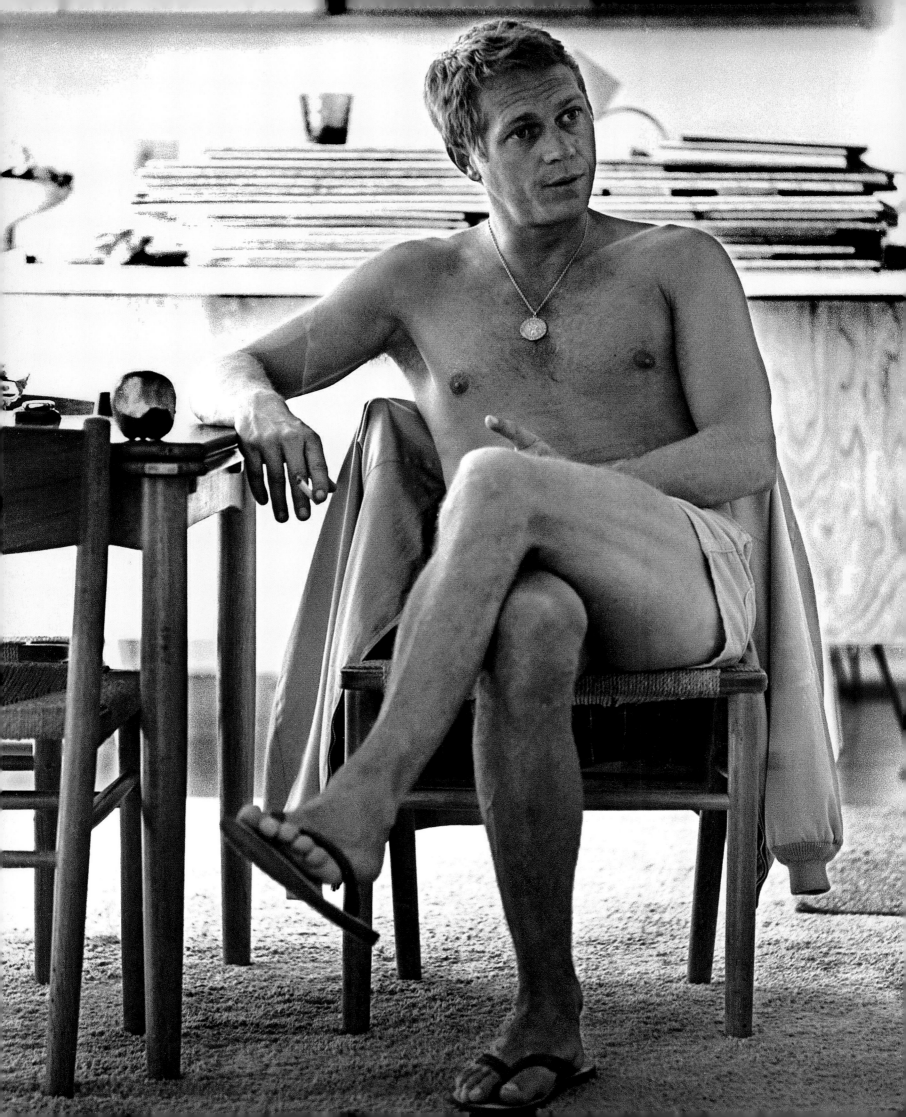

I LIVE FOR MYSELF
AND I ANSWER TO NOBODY.

STEVE MCQUEEN

JE VIS POUR MOI-MEME ET N'OBEIS A PERSONNE.

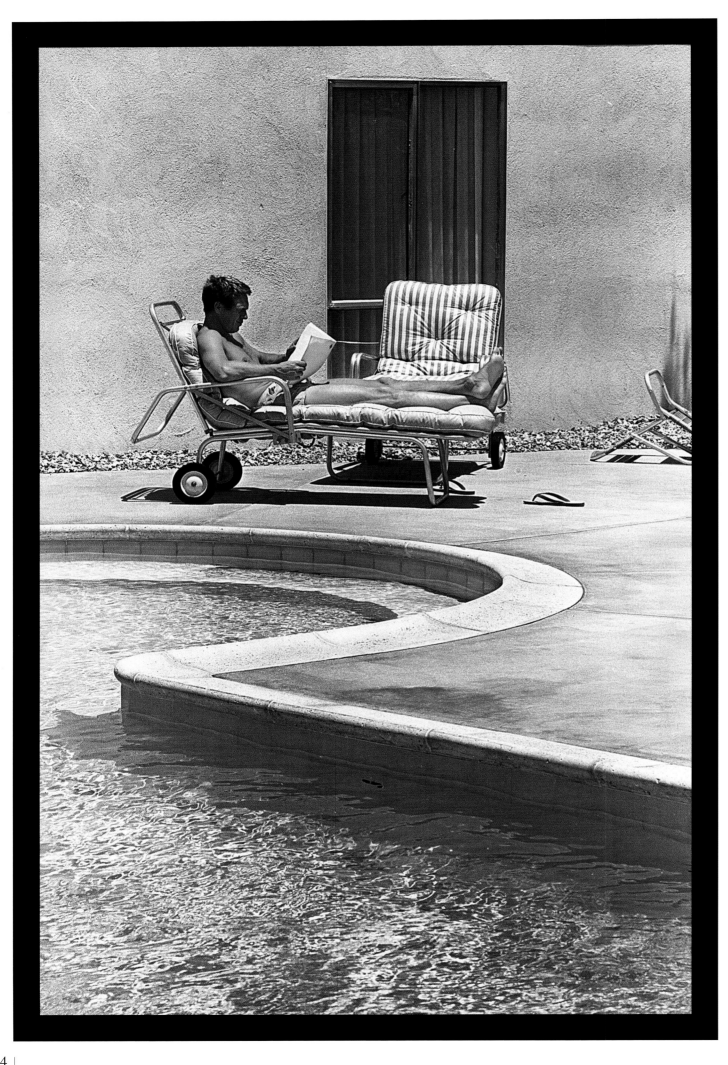

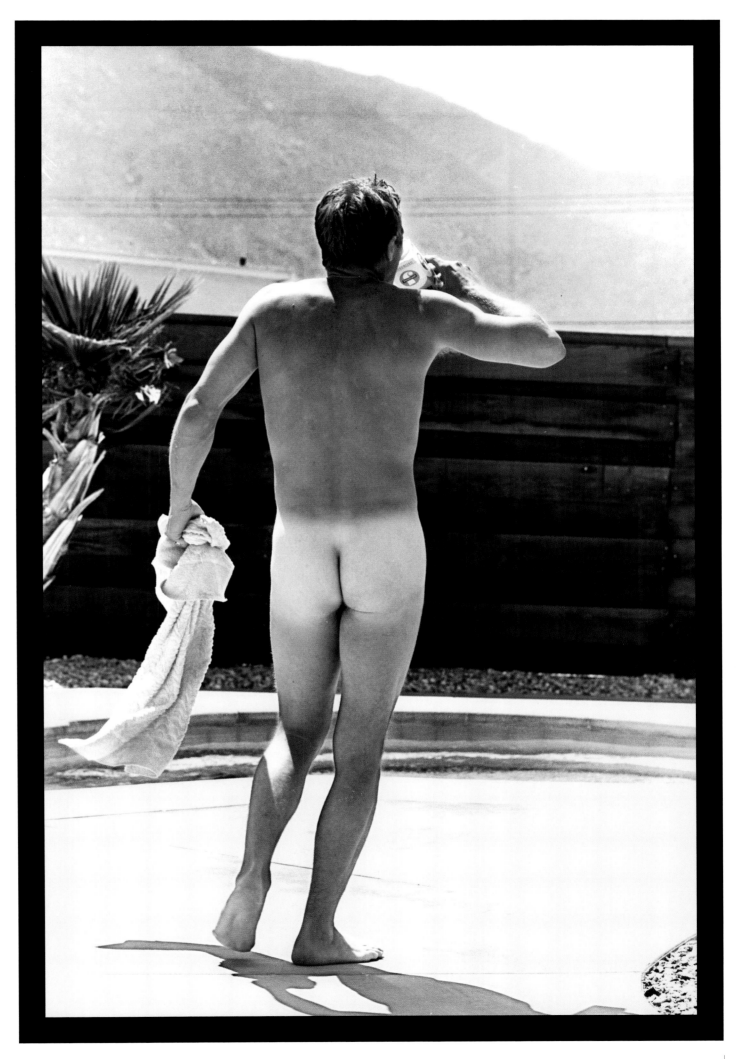

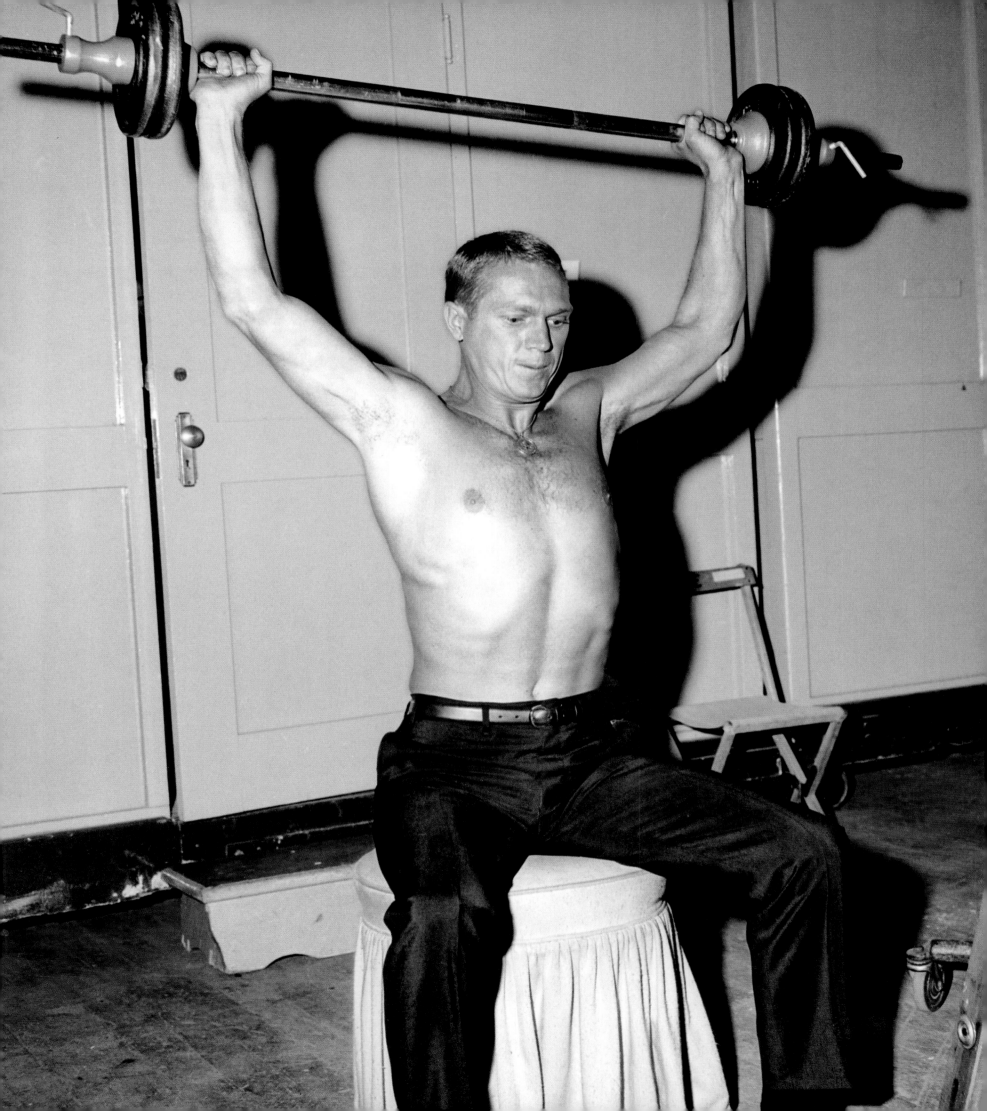

WHEN I BELIEVE IN SOMETHING, I FIGHT LIKE HELL FOR IT

STEVE MCQUEEN

QUAND JE VEUX QUELQUE CHOSE,
JE ME BATS COMME UN CHIEN POUR L'OBTENIR.

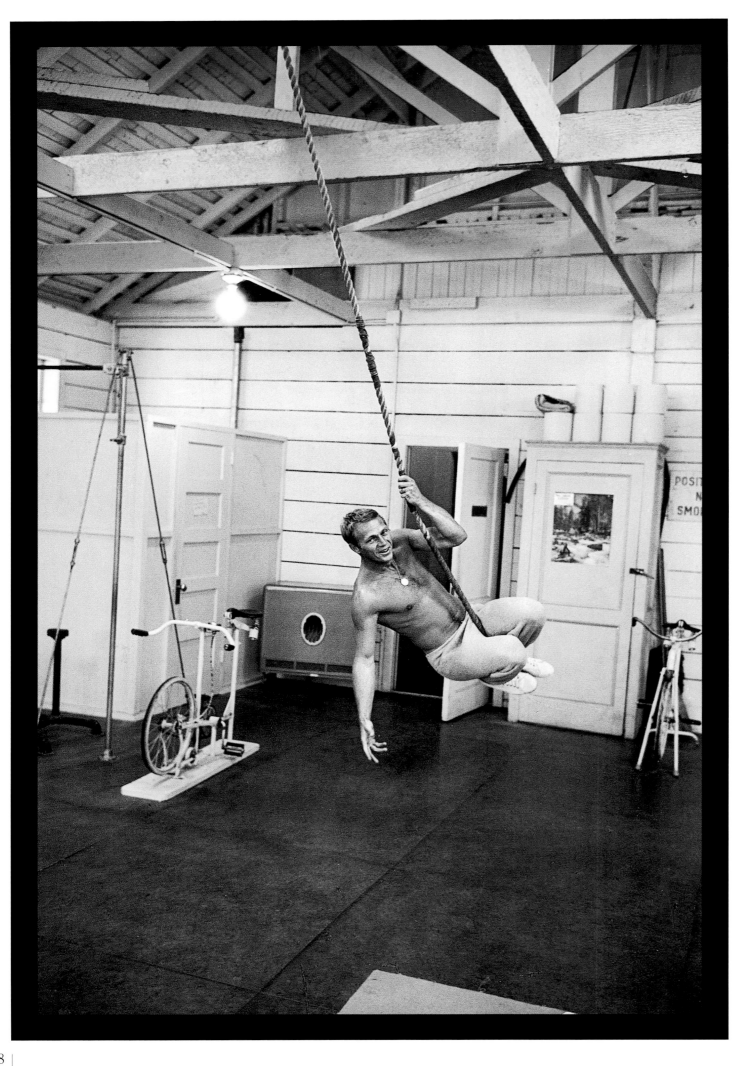

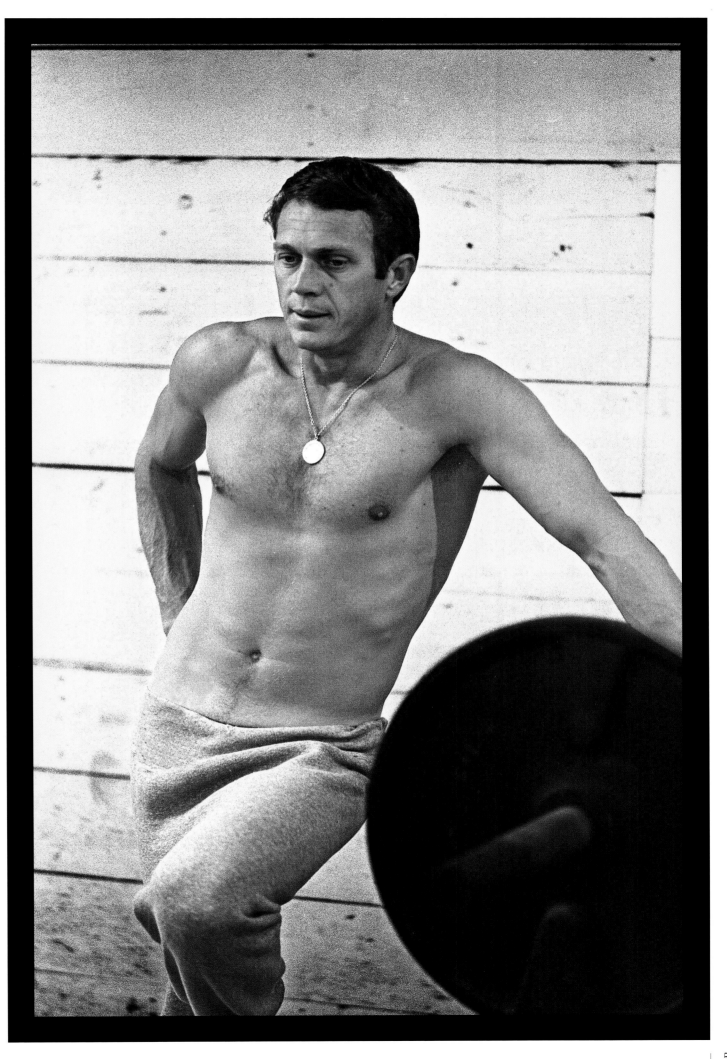

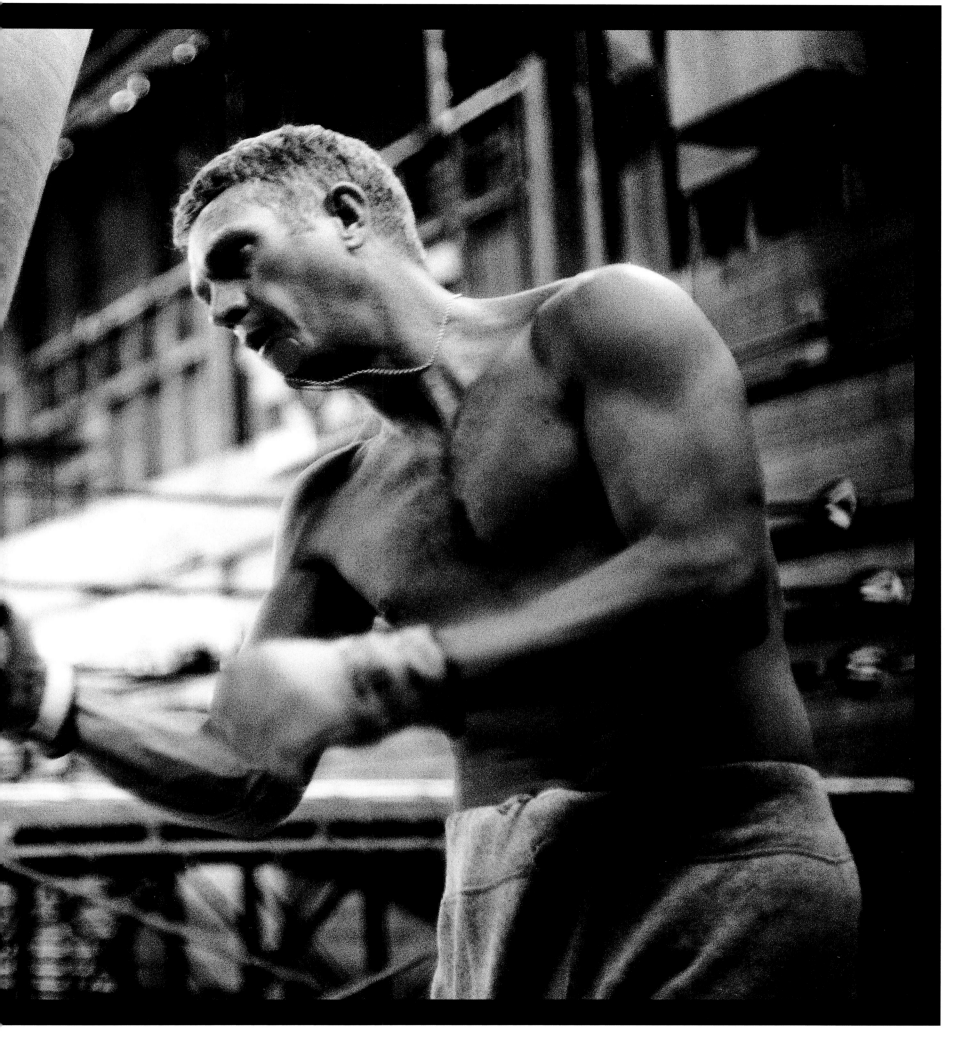

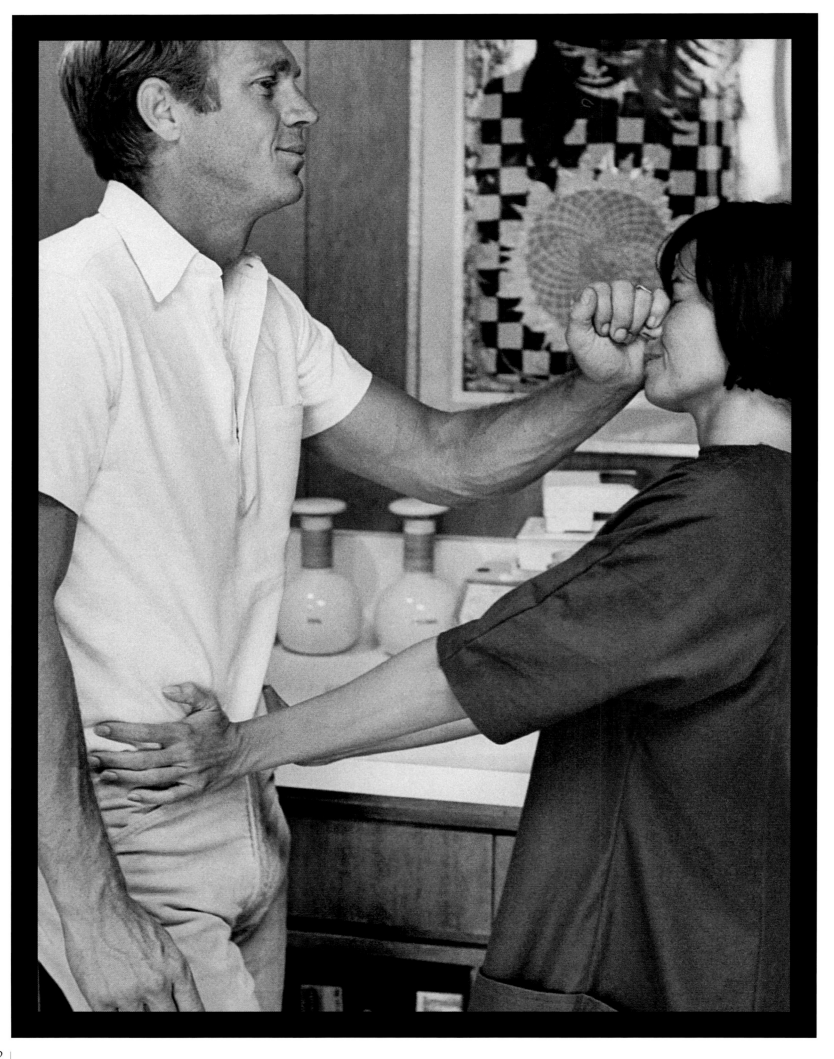

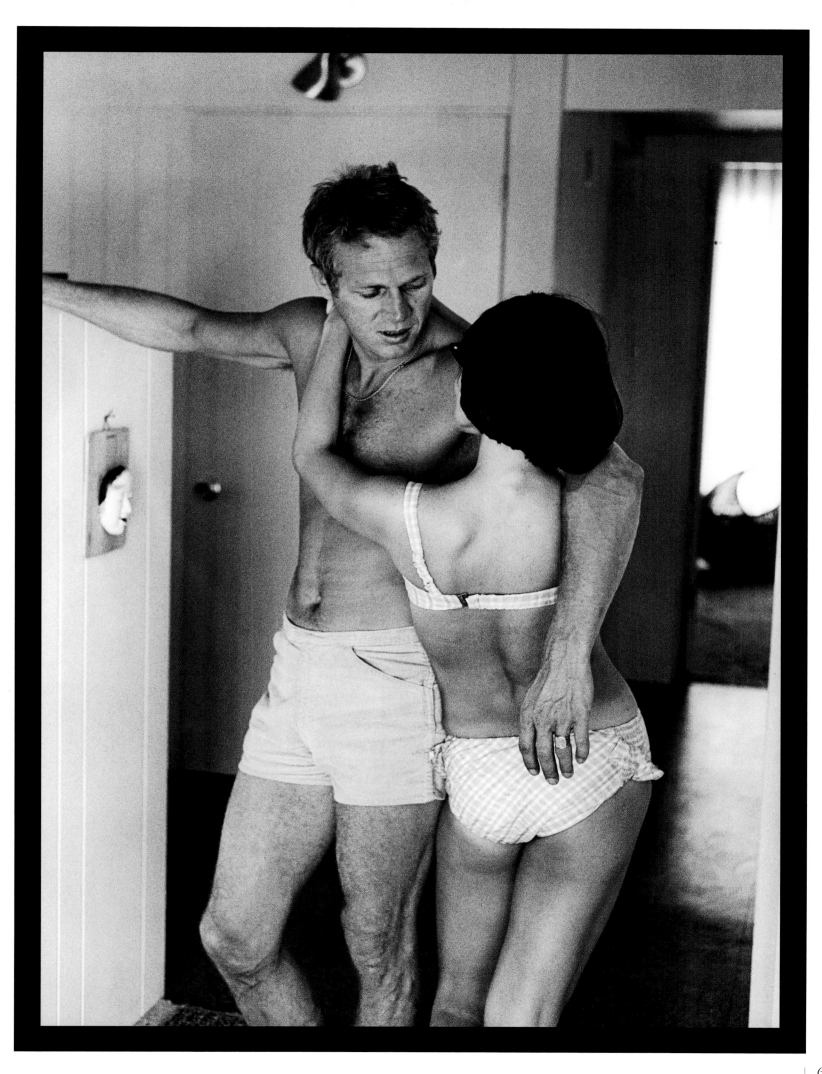

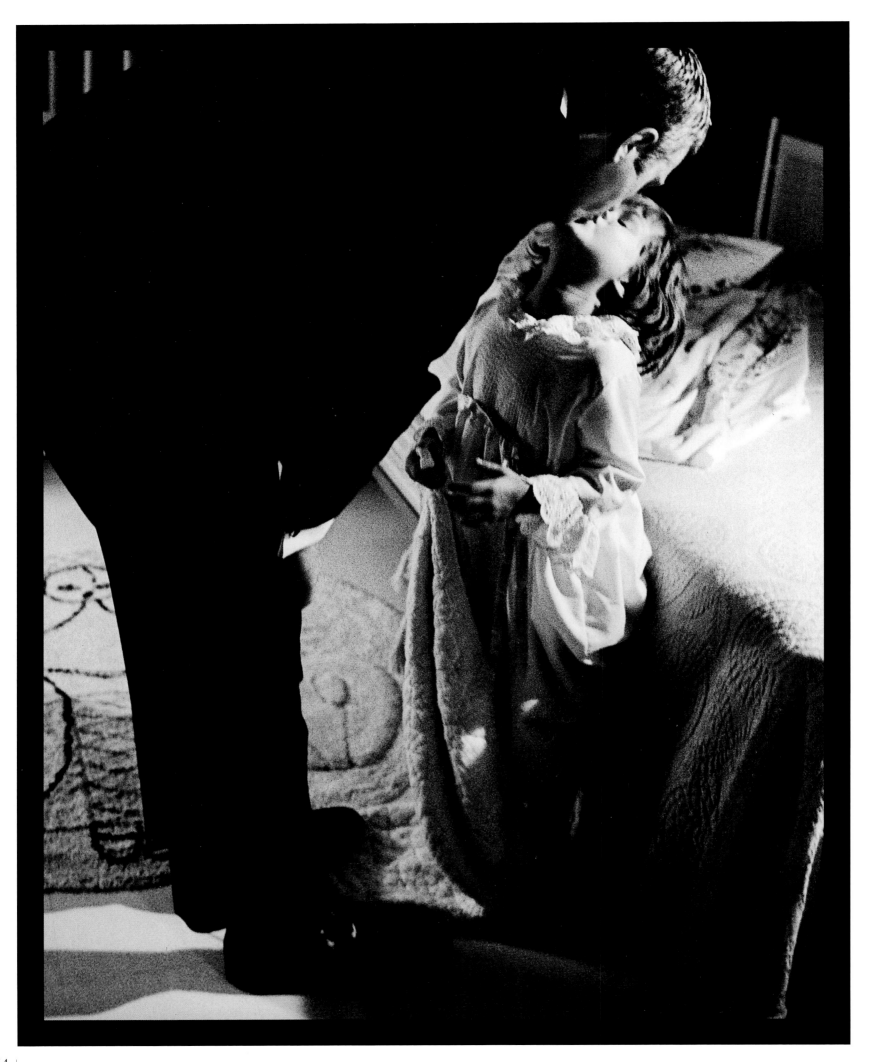

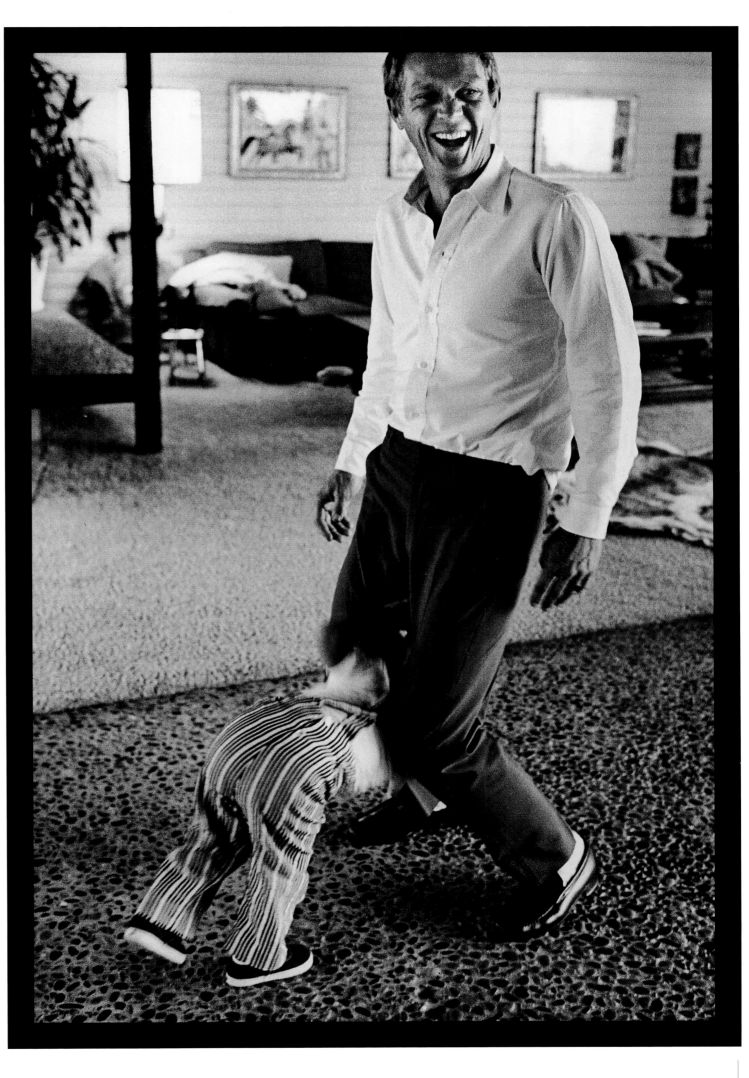

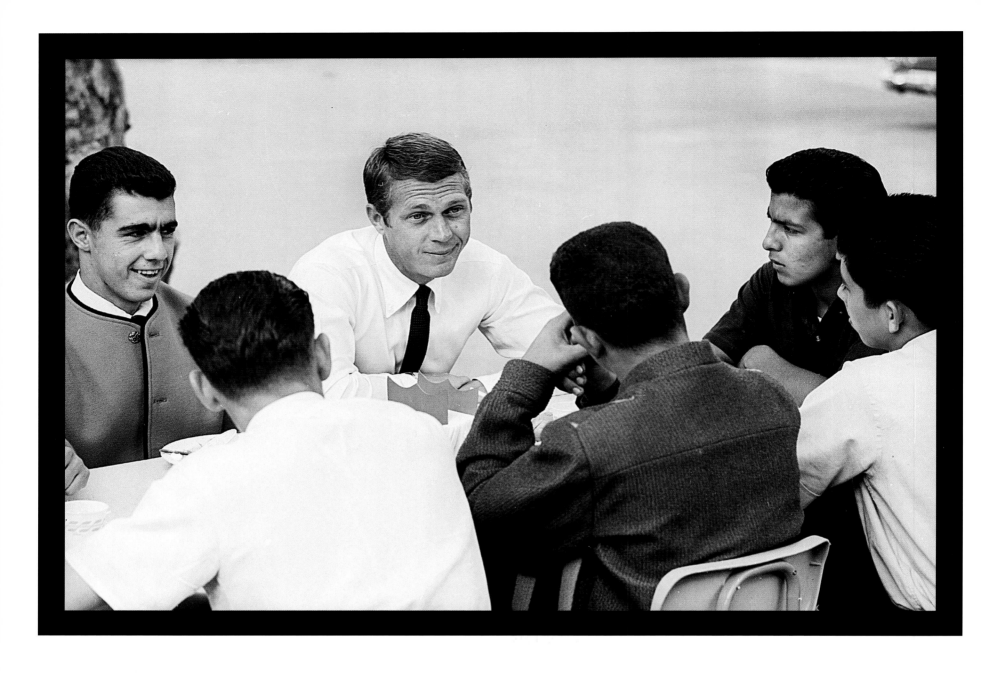

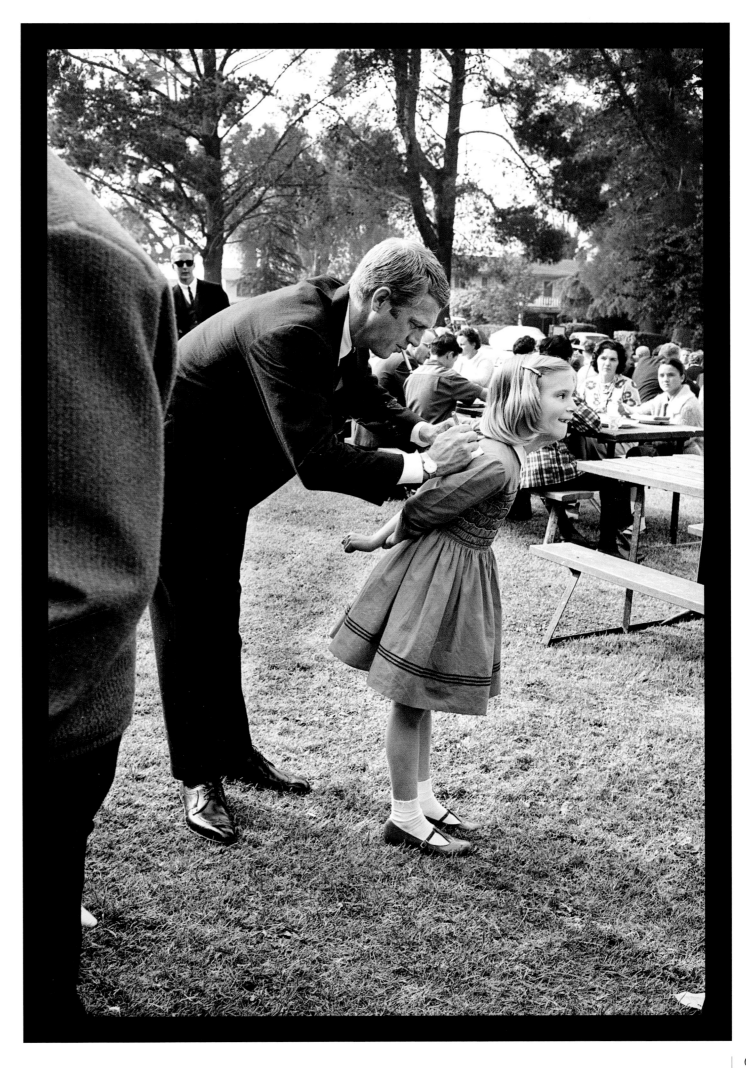

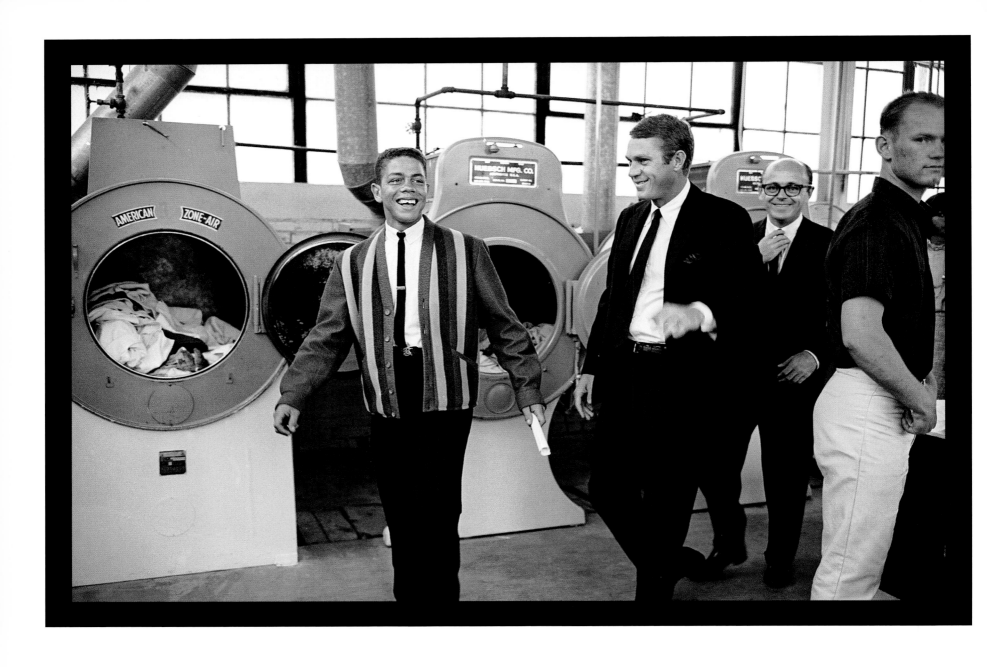

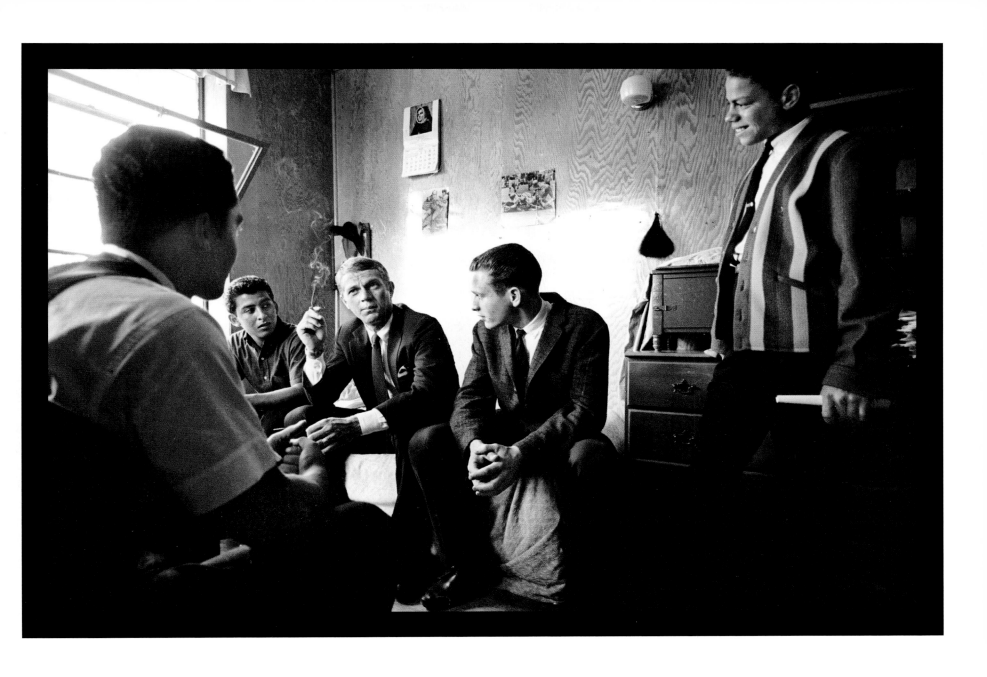

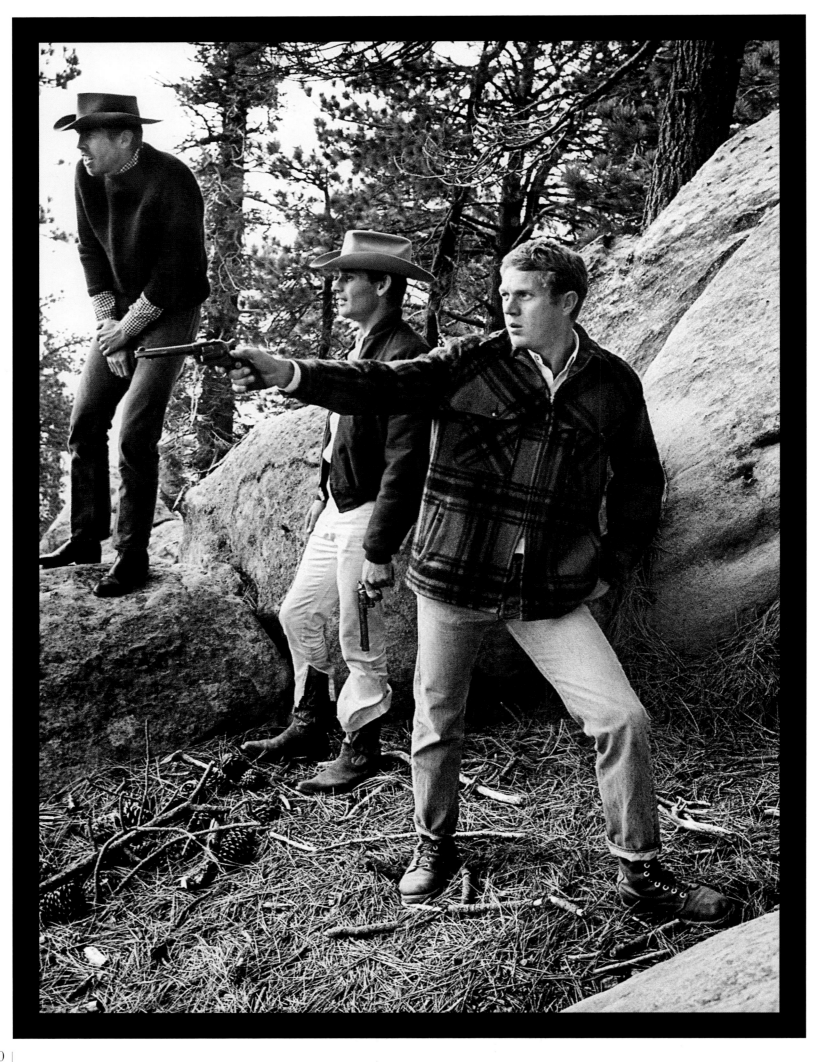

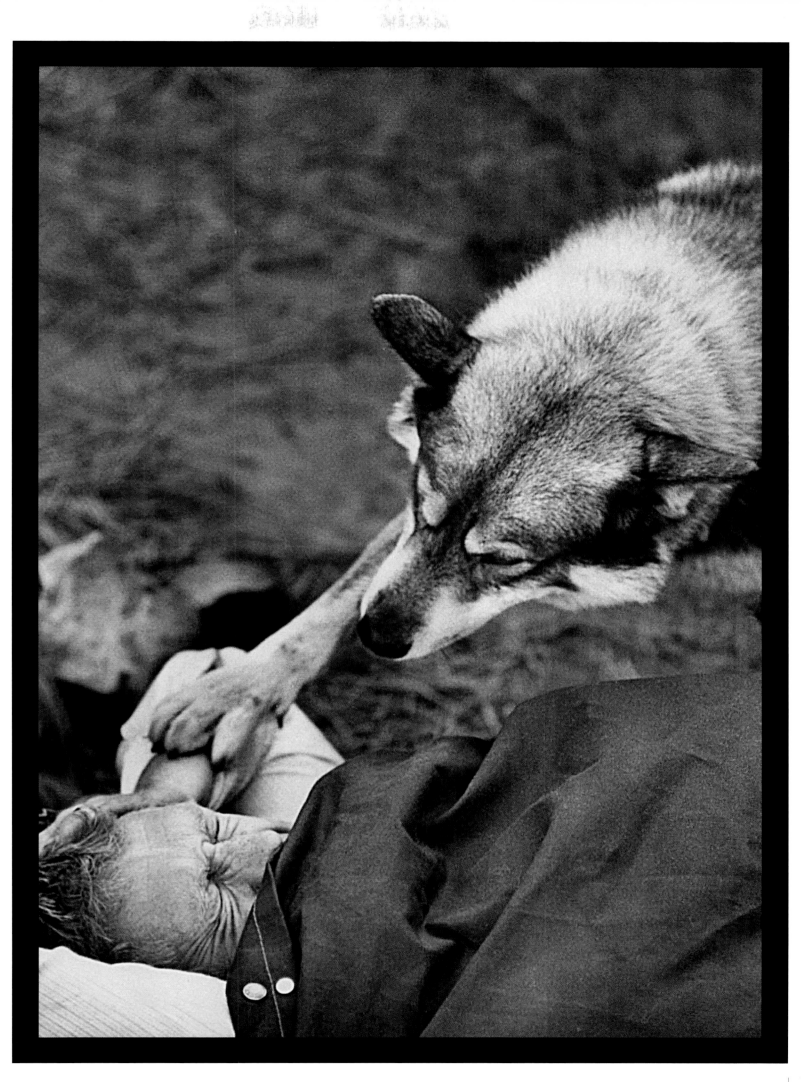

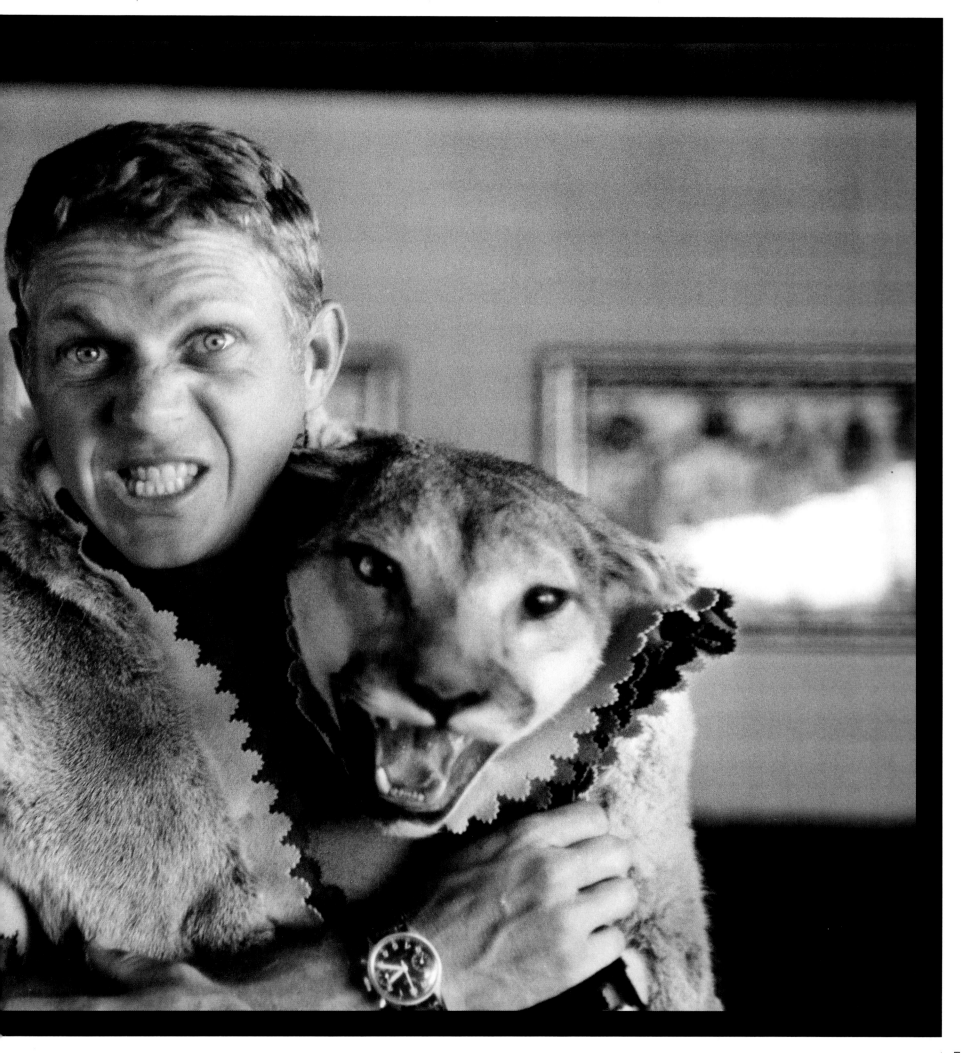

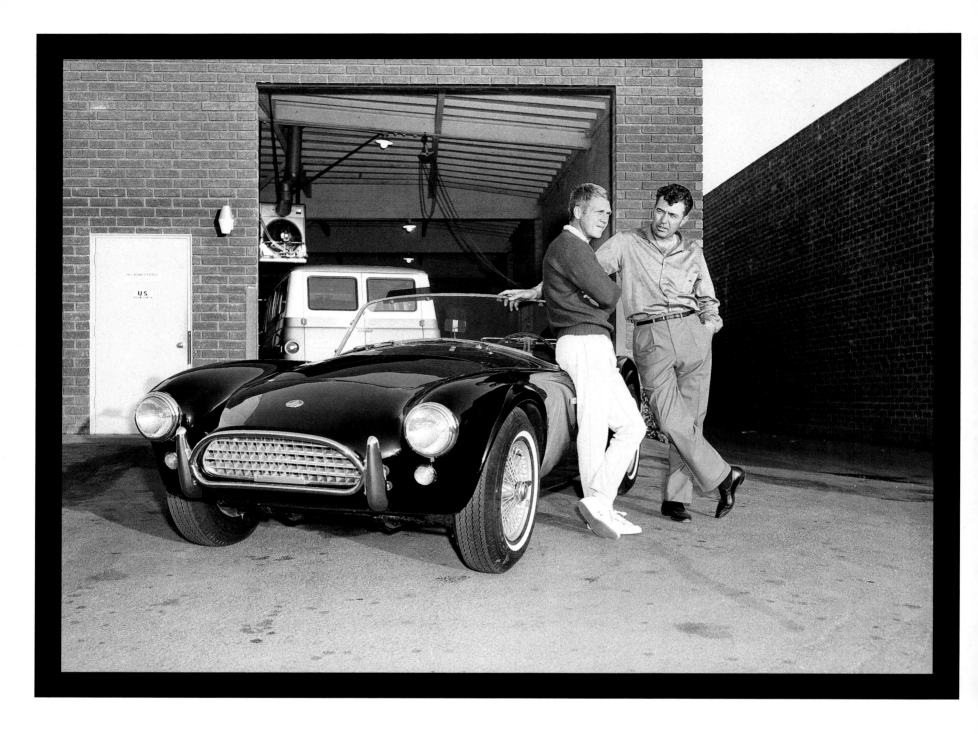

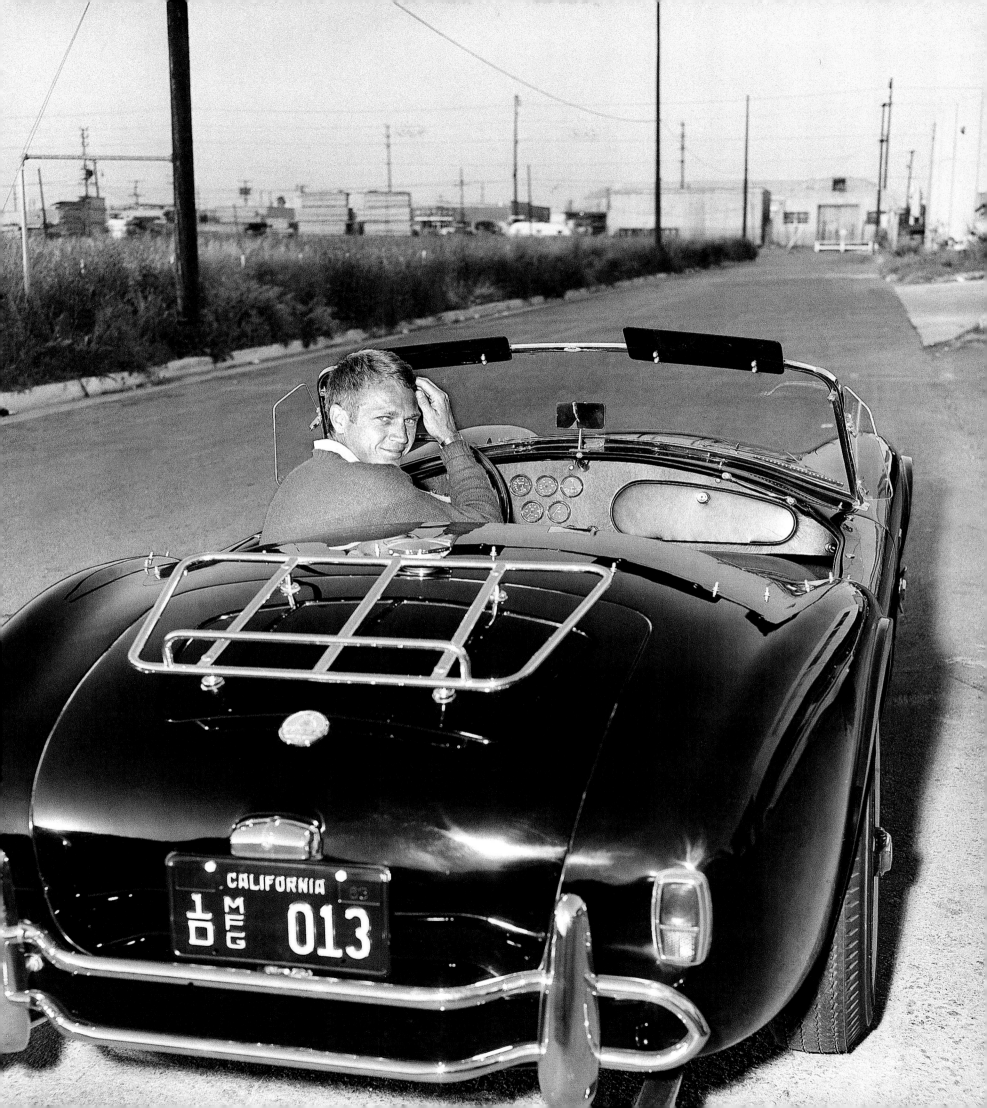

CALIFORNIA
1D MFG 013

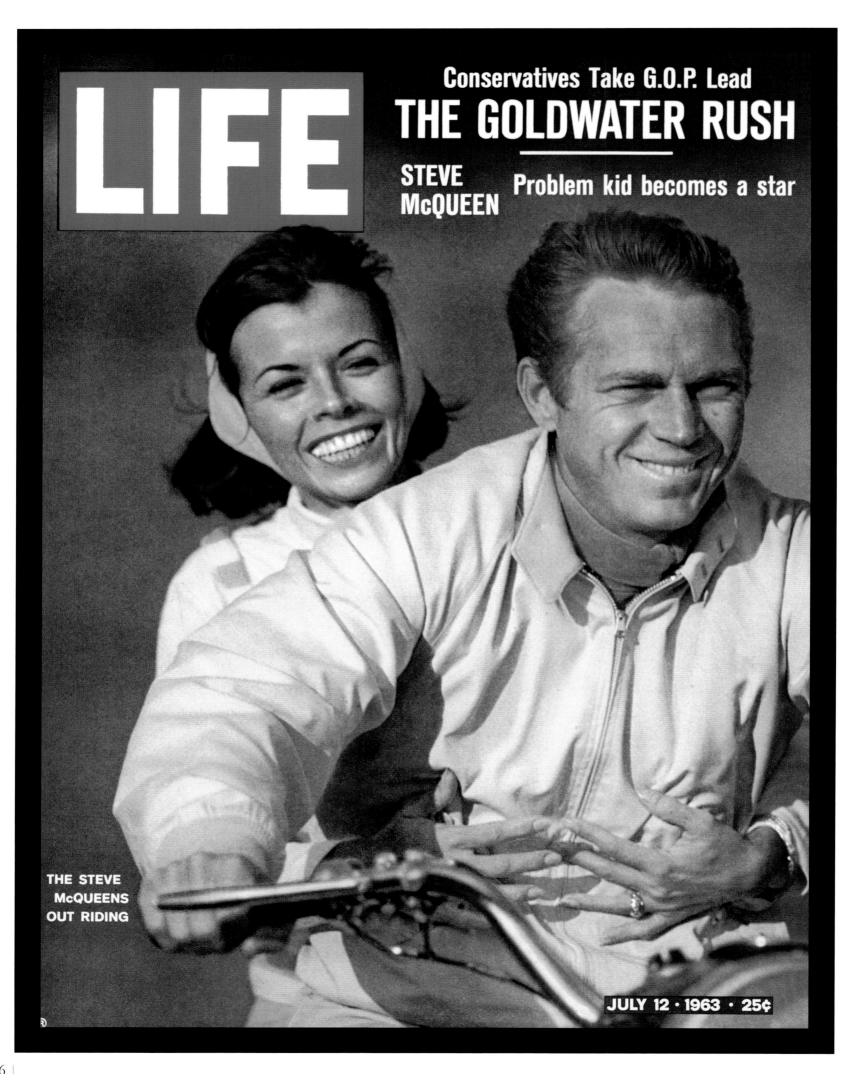

LIFE

Conservatives Take G.O.P. Lead

THE GOLDWATER RUSH

STEVE McQUEEN

Problem kid becomes a star

THE STEVE
McQUEENS
OUT RIDING

JULY 12 · 1963 · 25¢

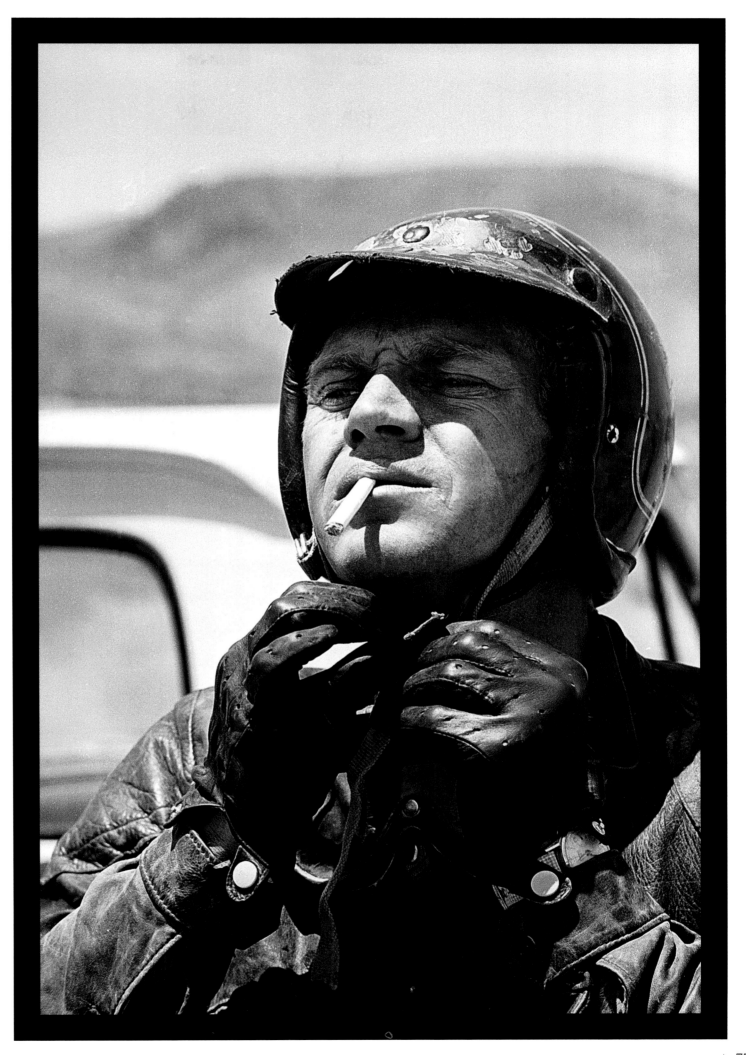

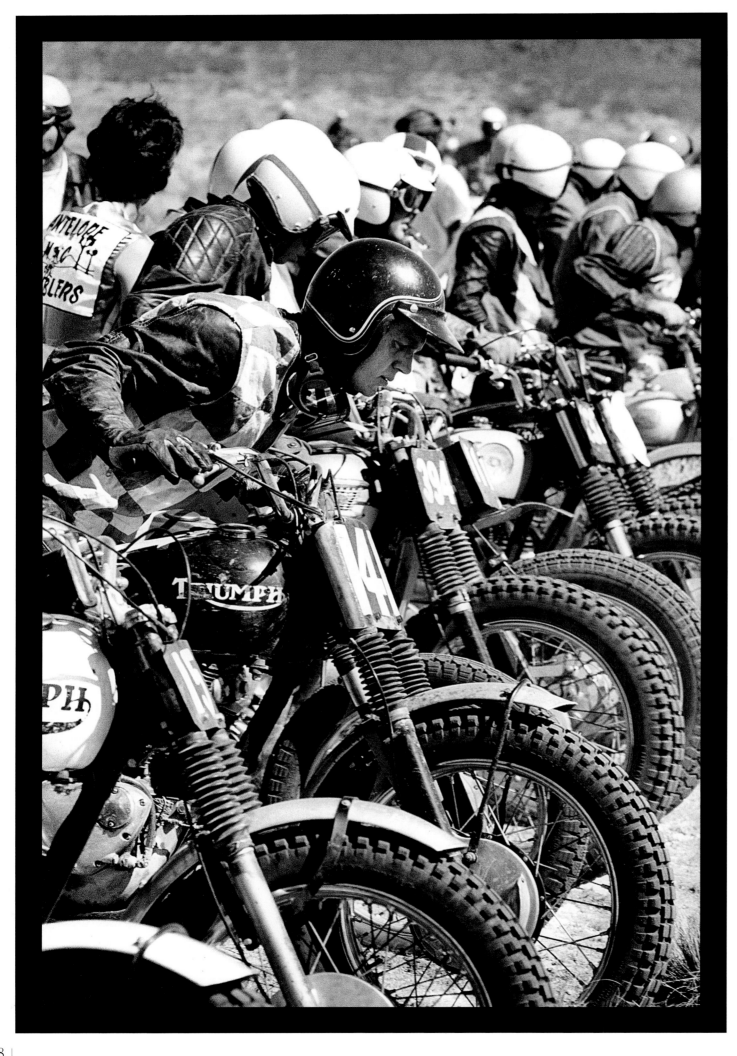

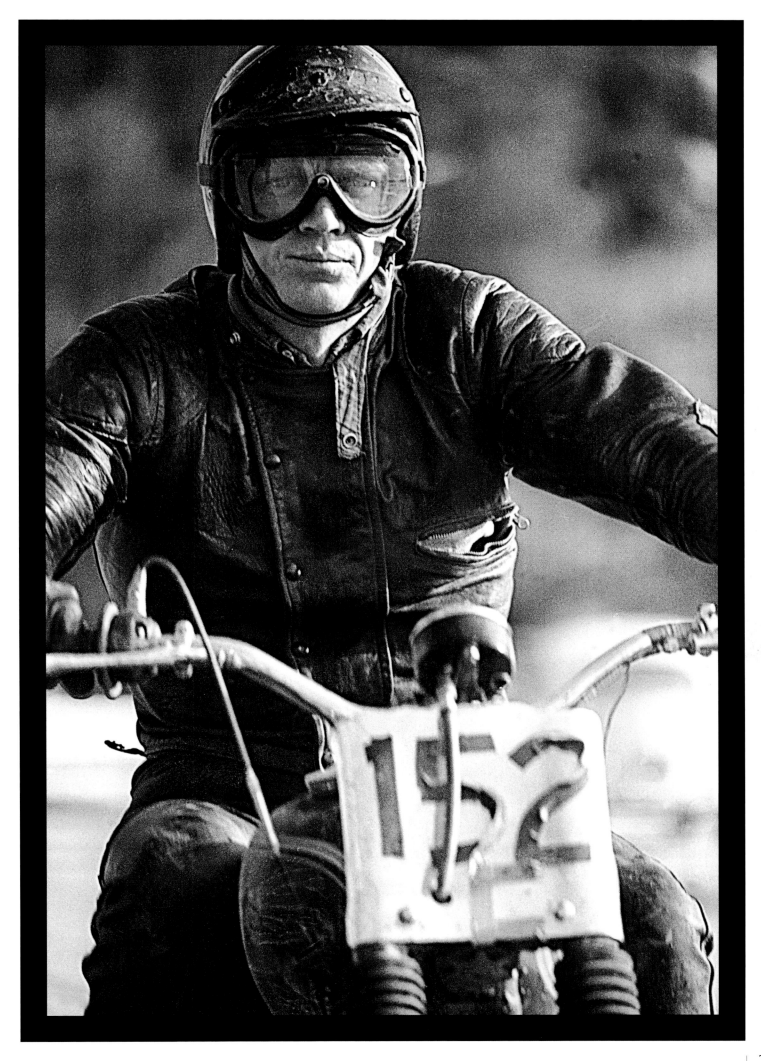

I'M NOT SURE WHETHER I'M AN ACTOR WHO RACES OR A RACER WHO ACTS.

STEVE MCQUEEN

JE ME DEMANDE SI JE SUIS
UN ACTEUR QUI FAIT DE LA COURSE AUTOMOBILE,
OU UN COUREUR QUI FAIT DU CINEMA.

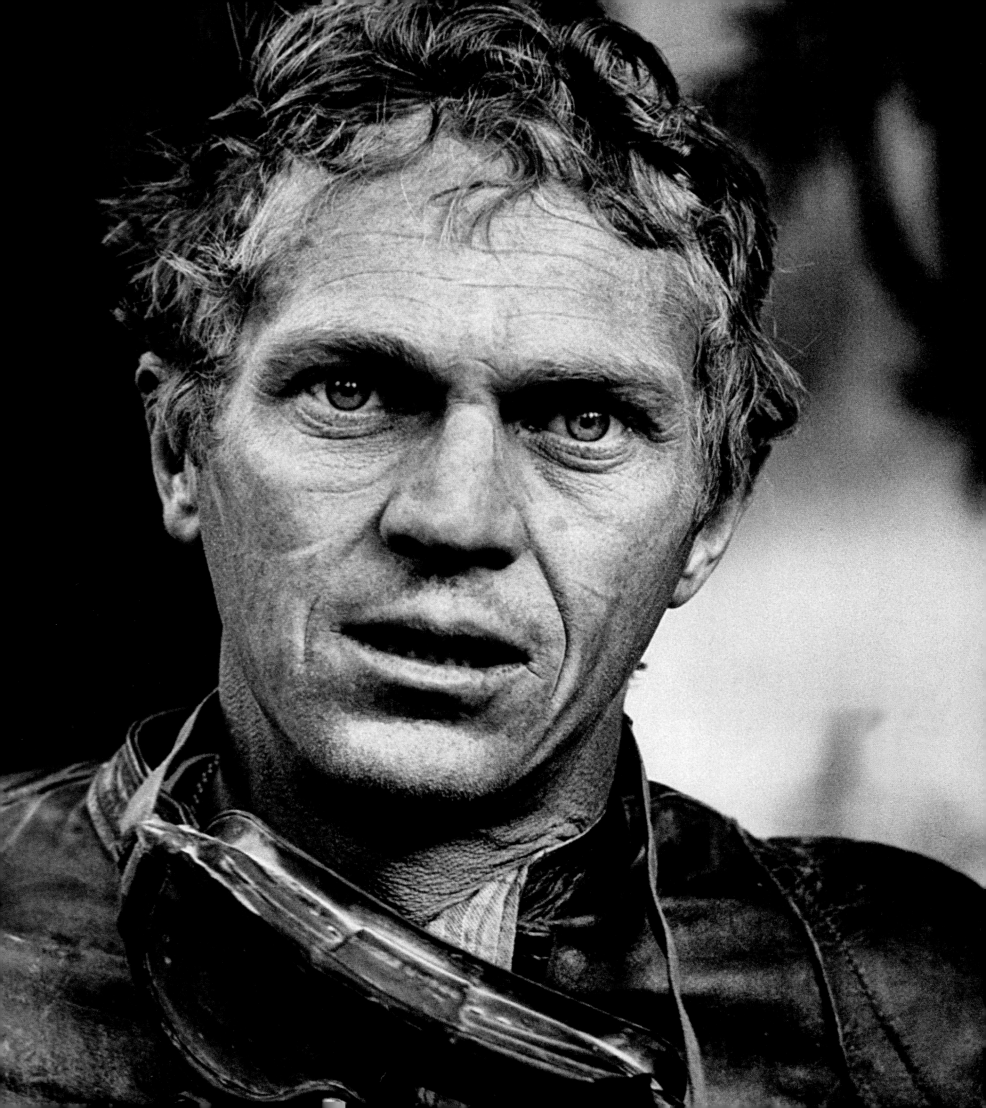

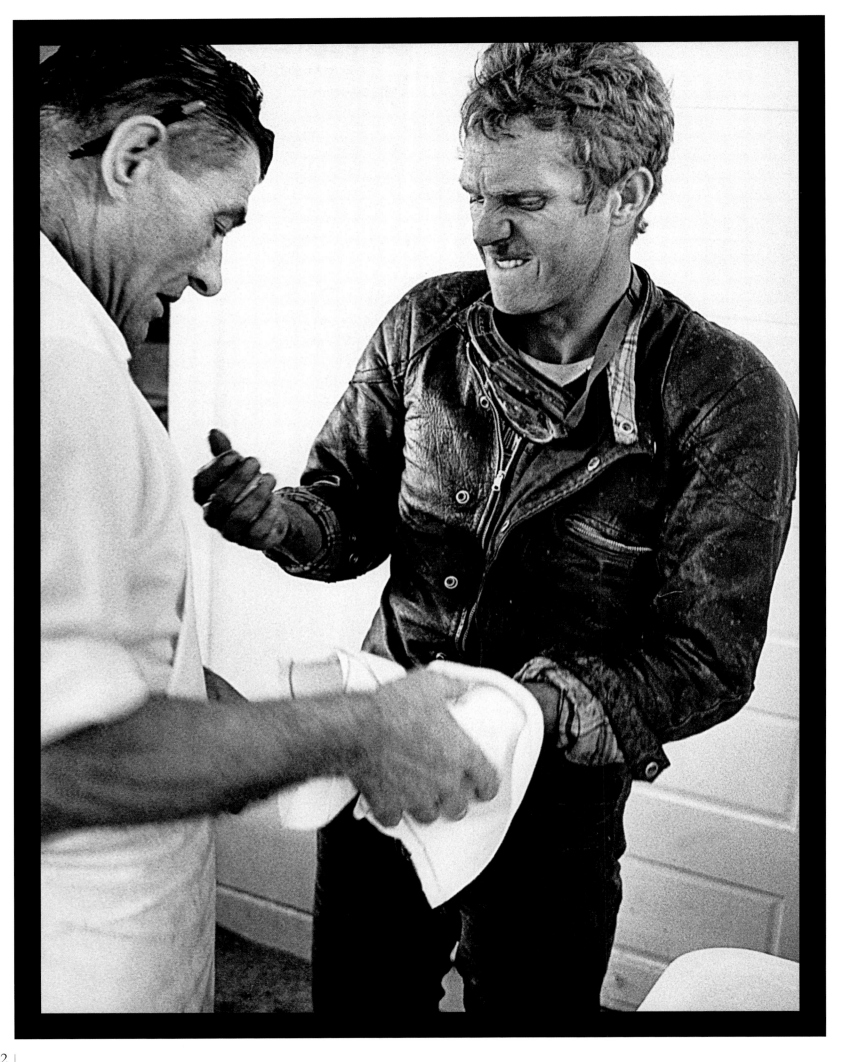

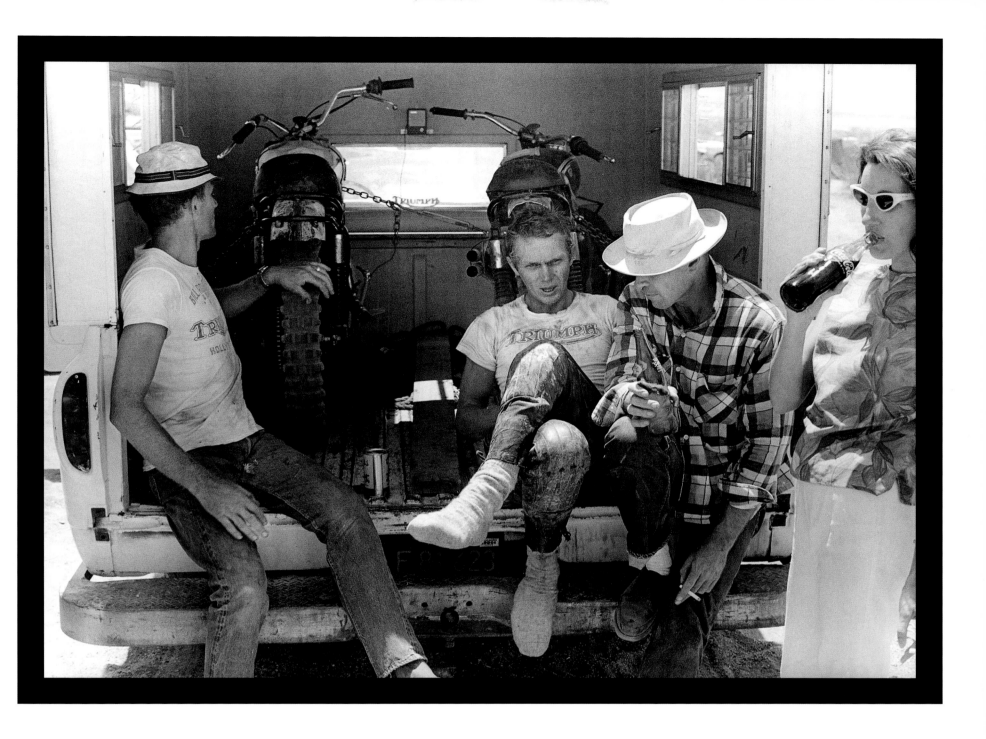

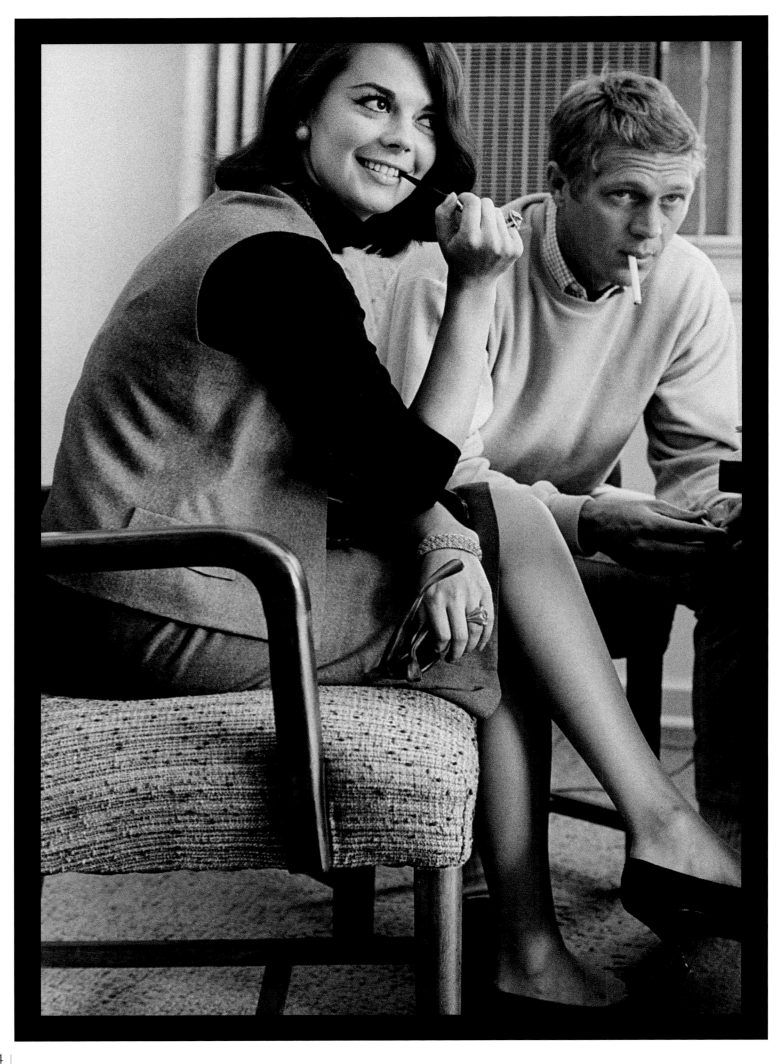

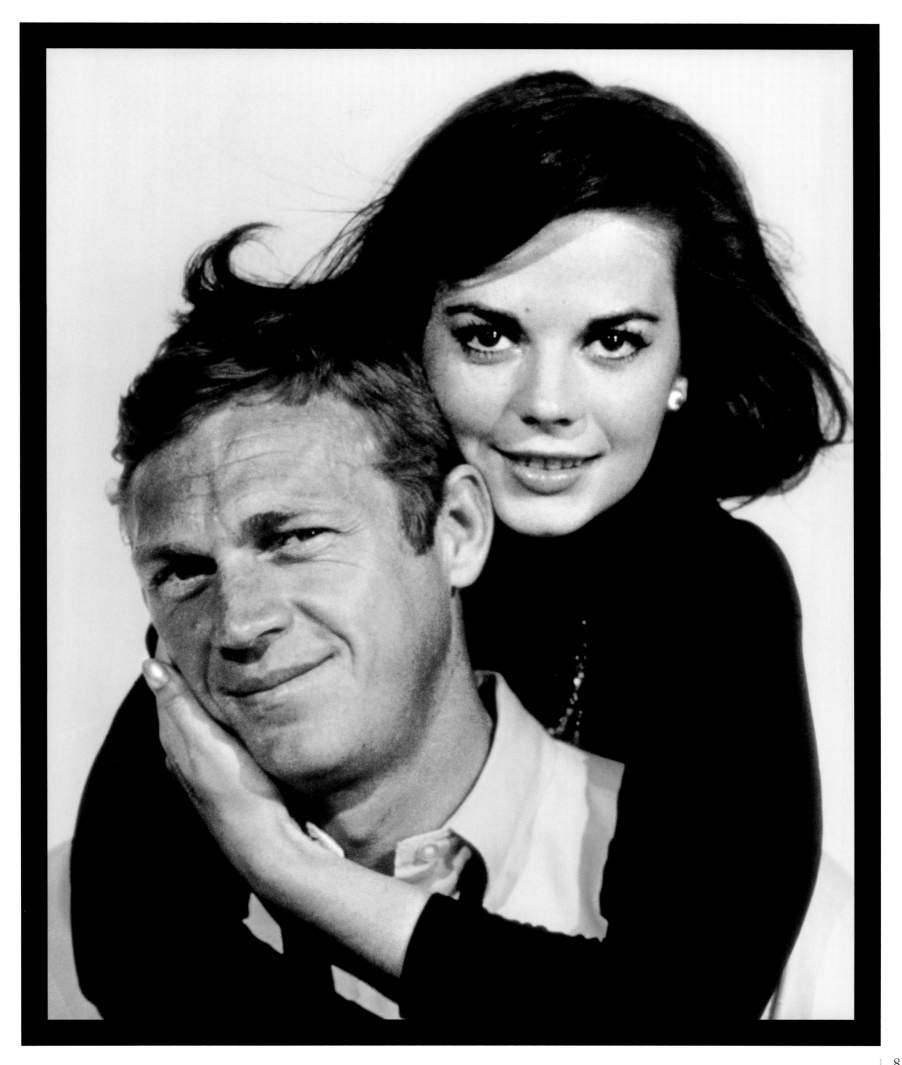

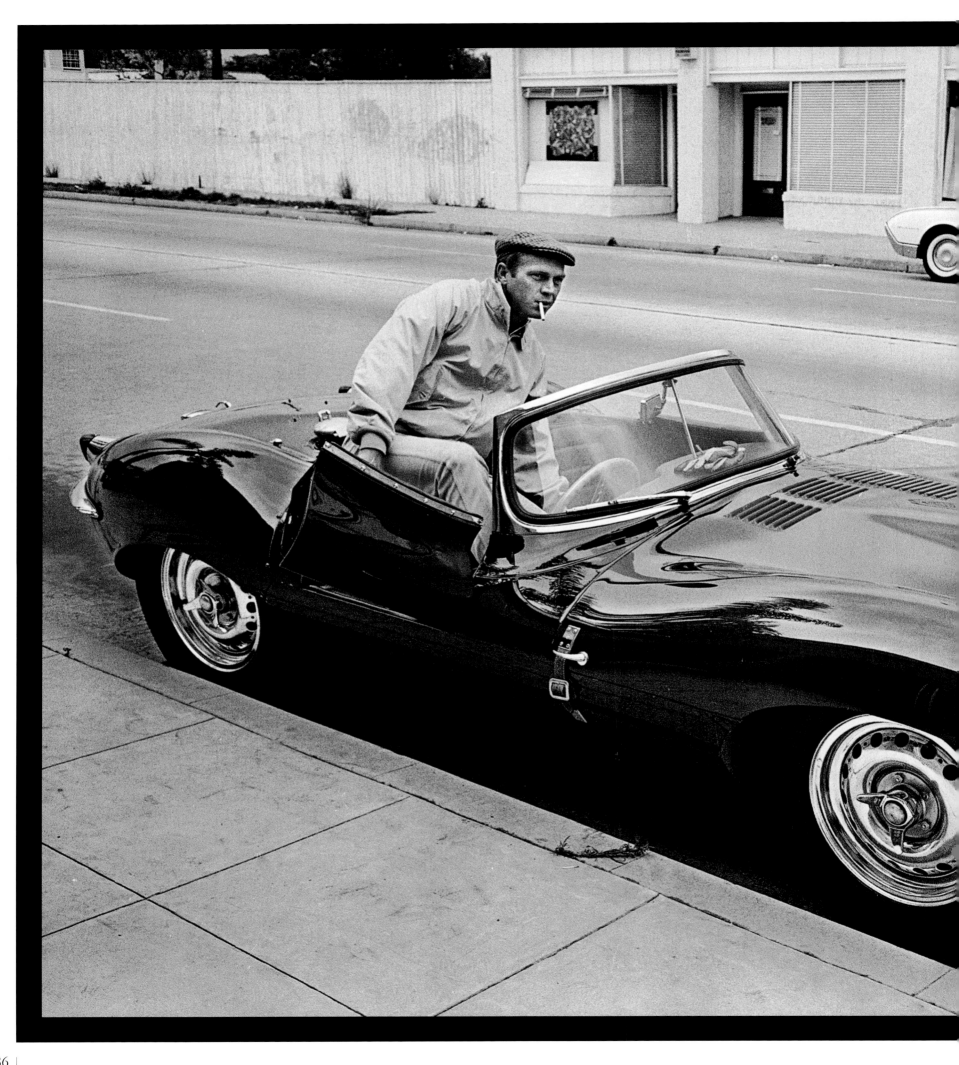

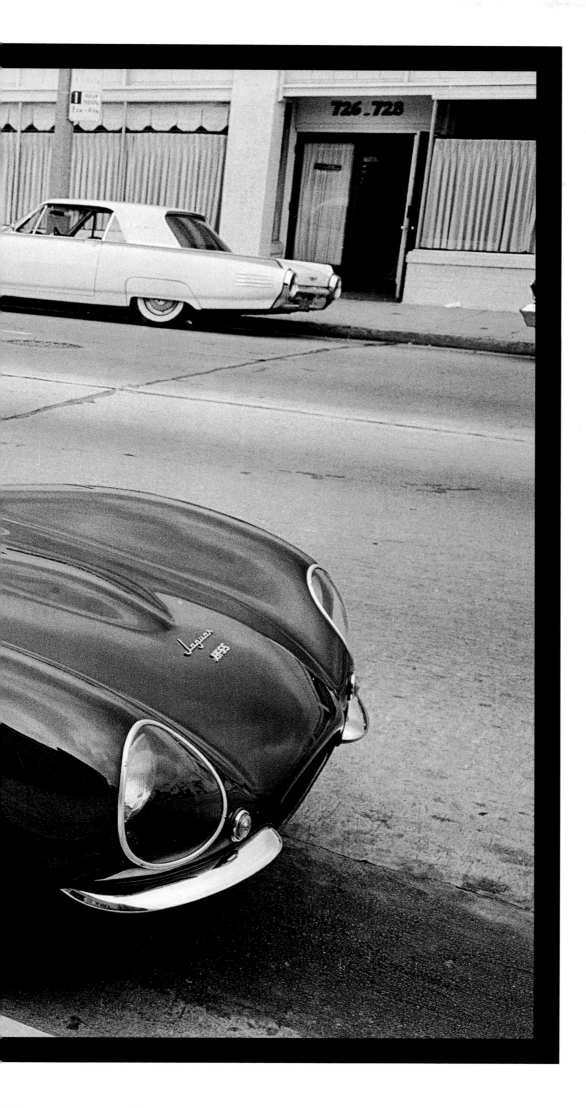

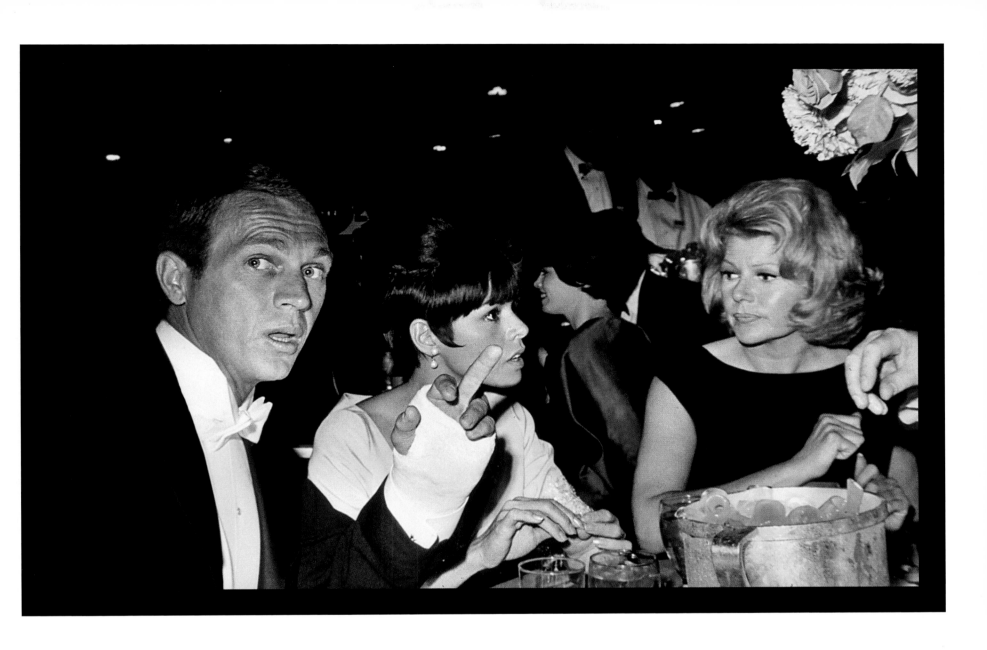

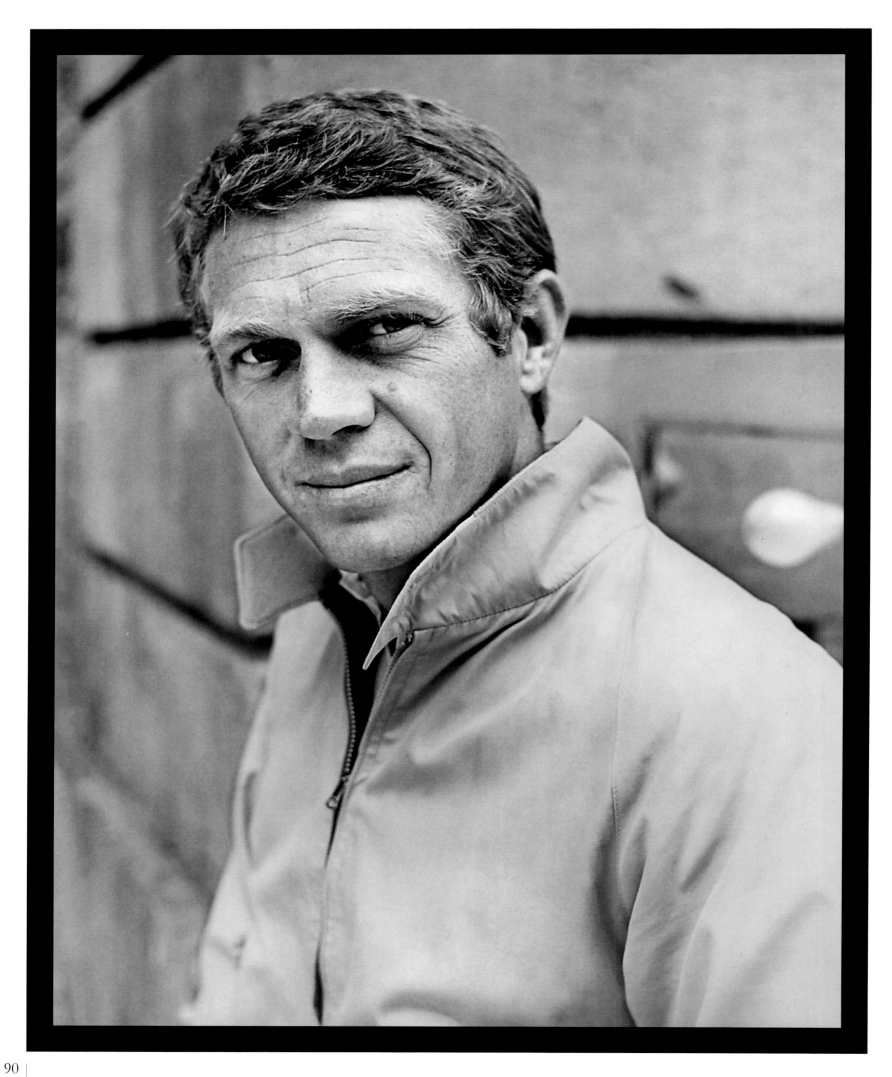

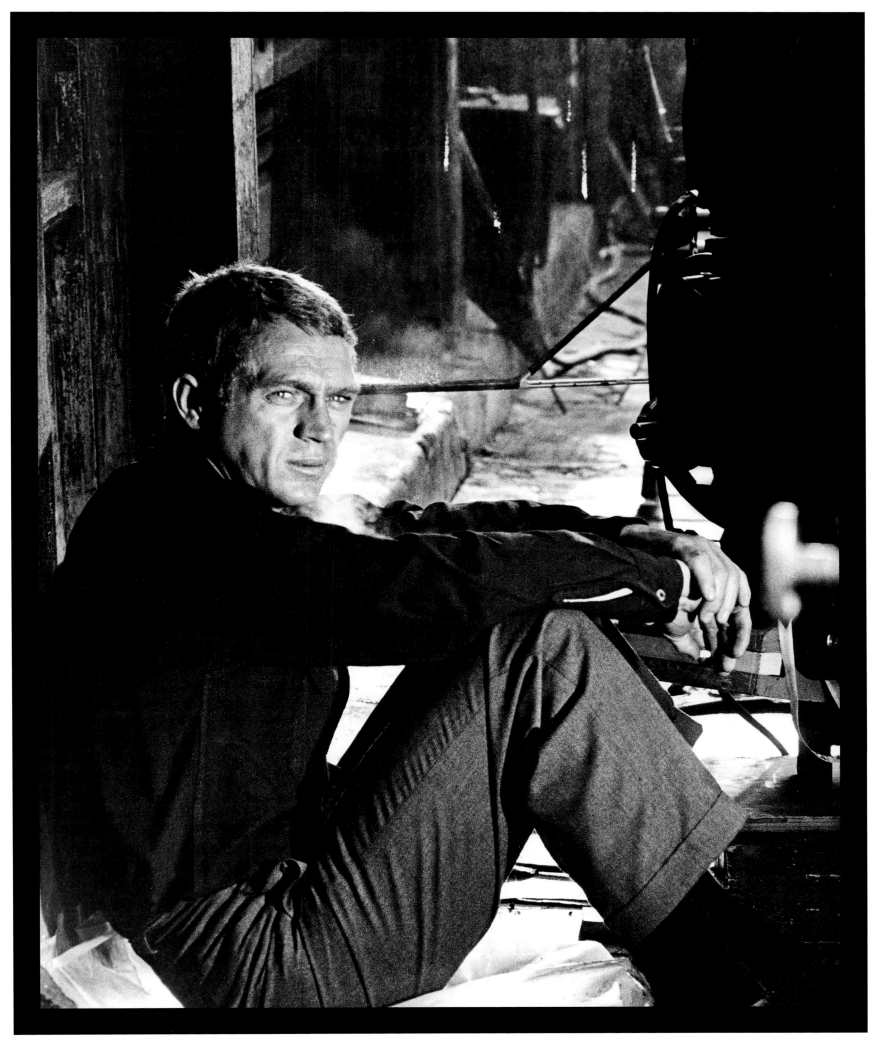

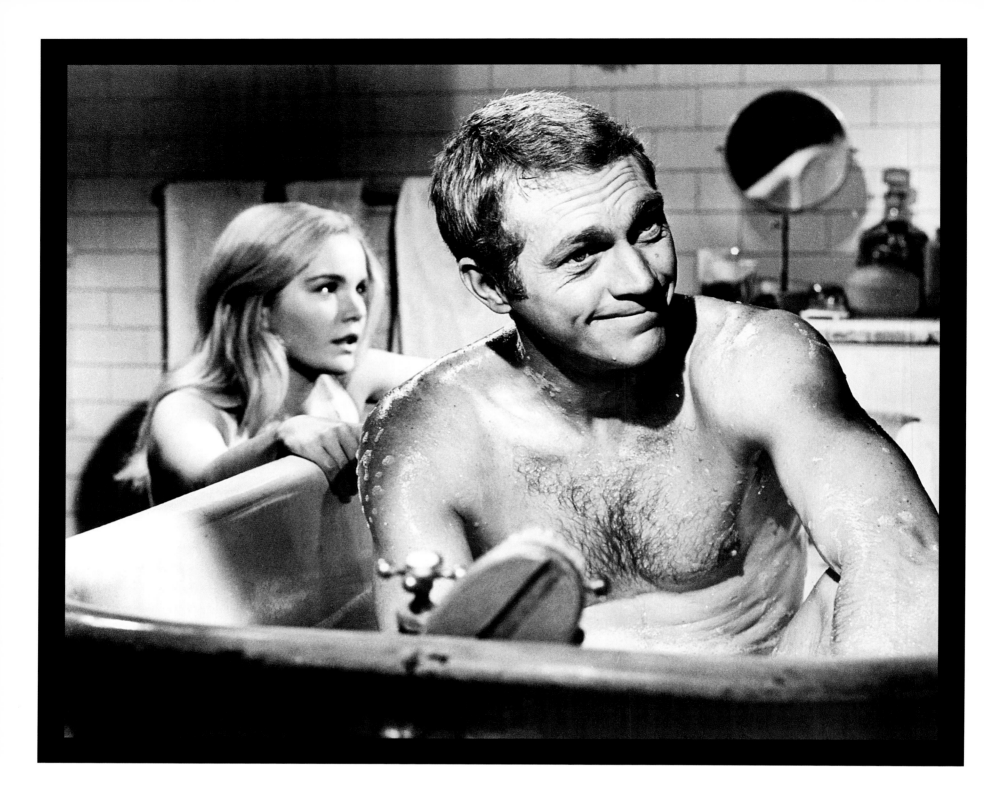

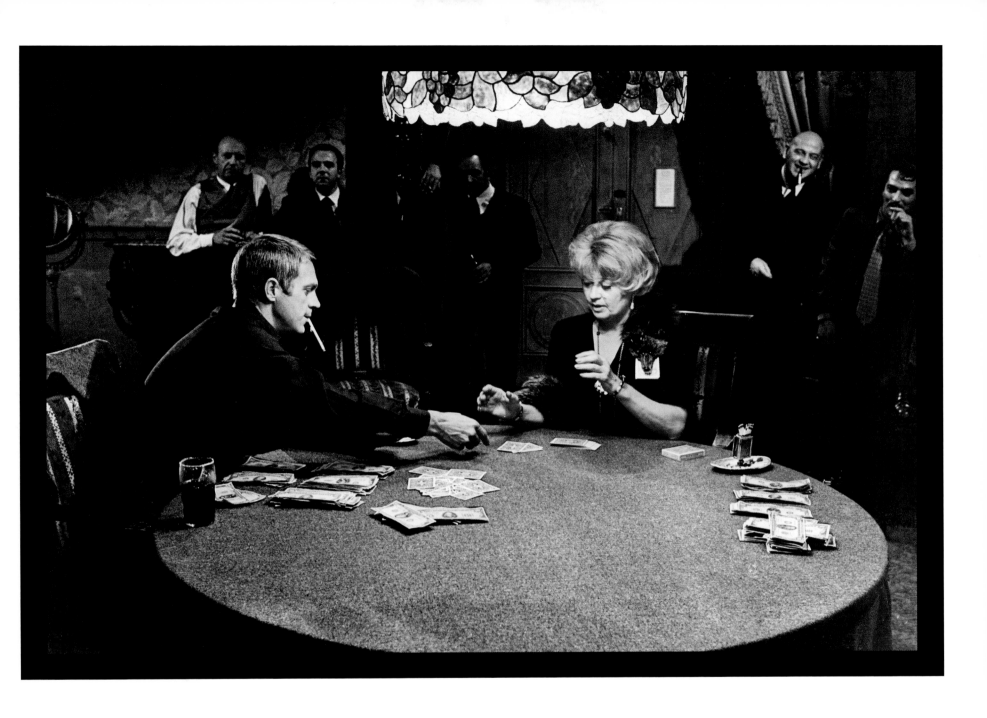

WHEN A HORSE LEARNS TO BUY MARTINIS, 'LL LEARN TO LIKE HORSES.

'EVE MCQUEEN

AND LES CHEVAUX SAURONT COMMANDER DES MARTINIS,
'ORS JE ME METTRAI A LES AIMER.

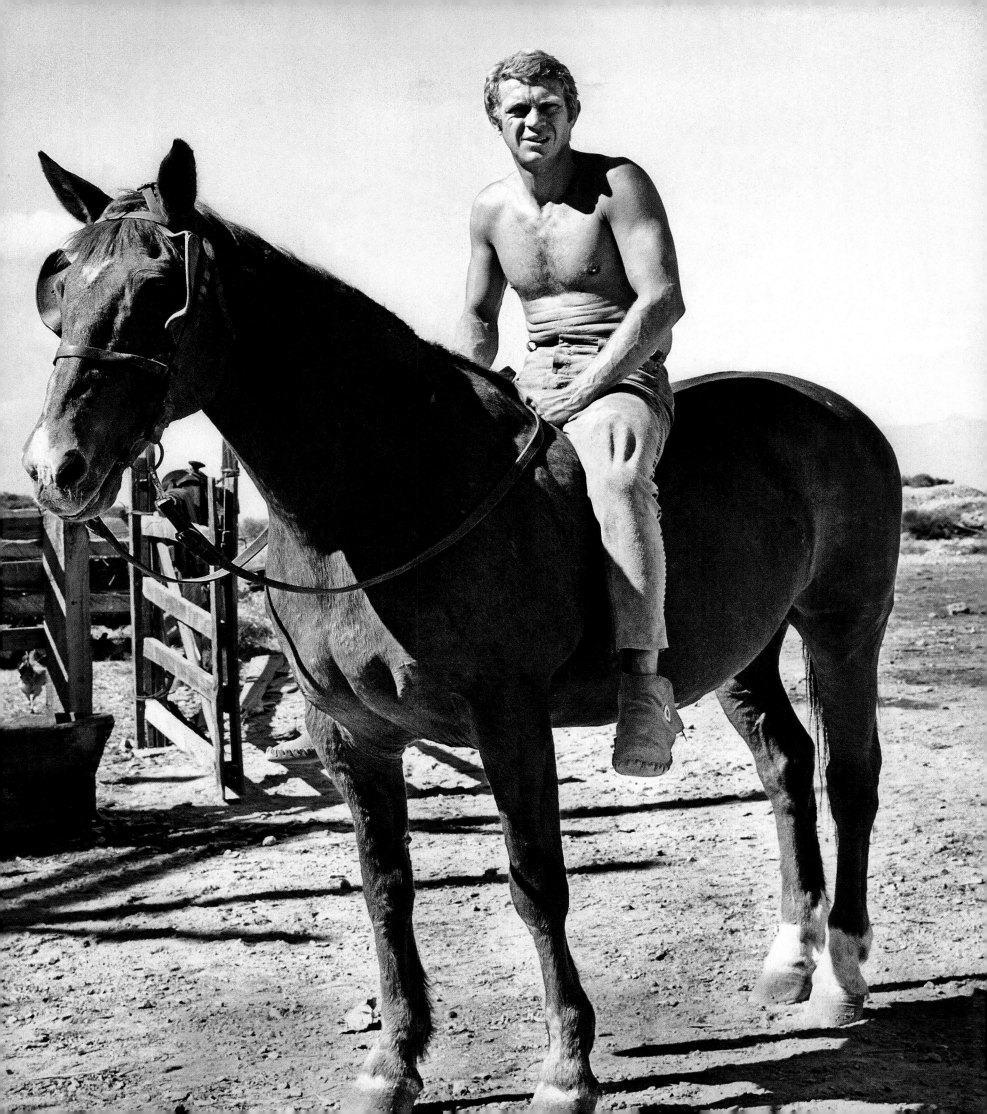

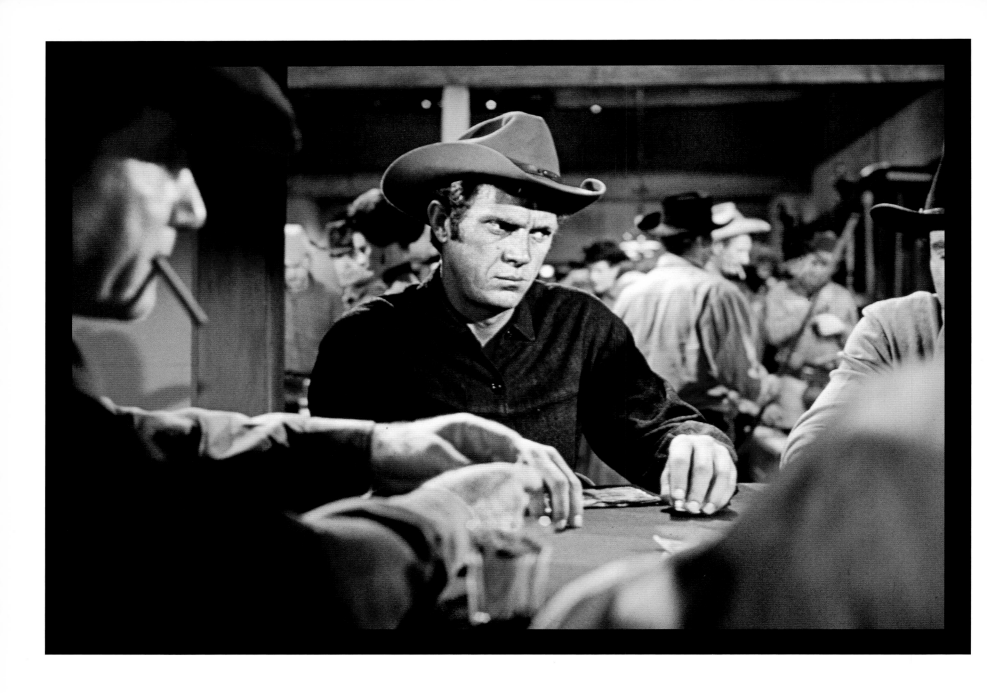

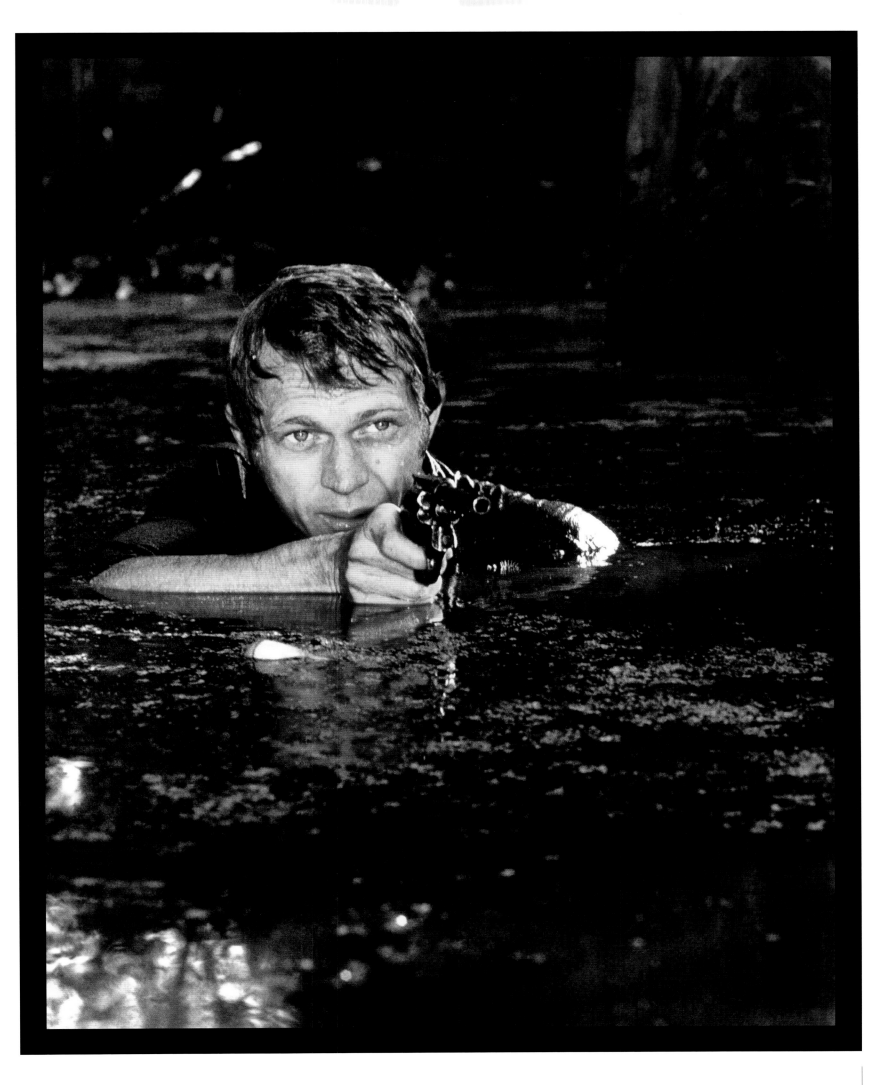

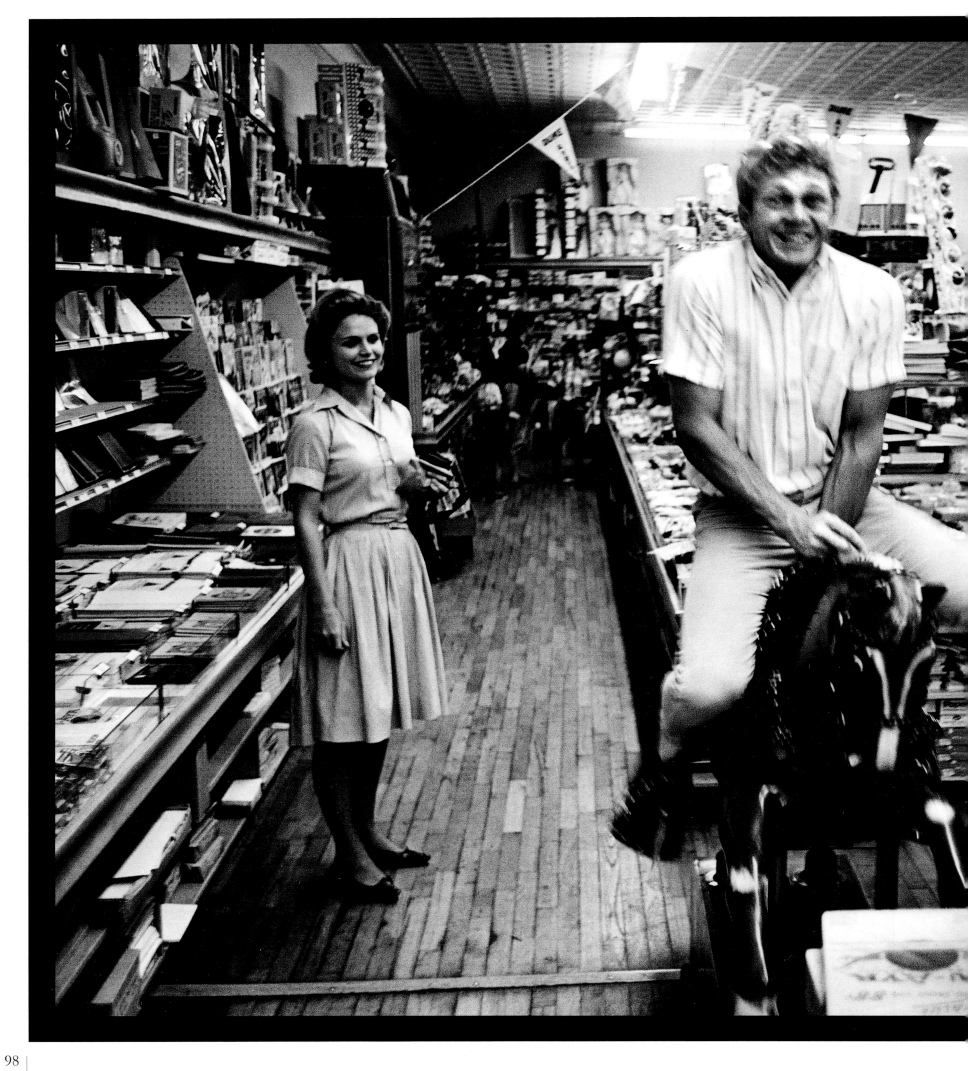

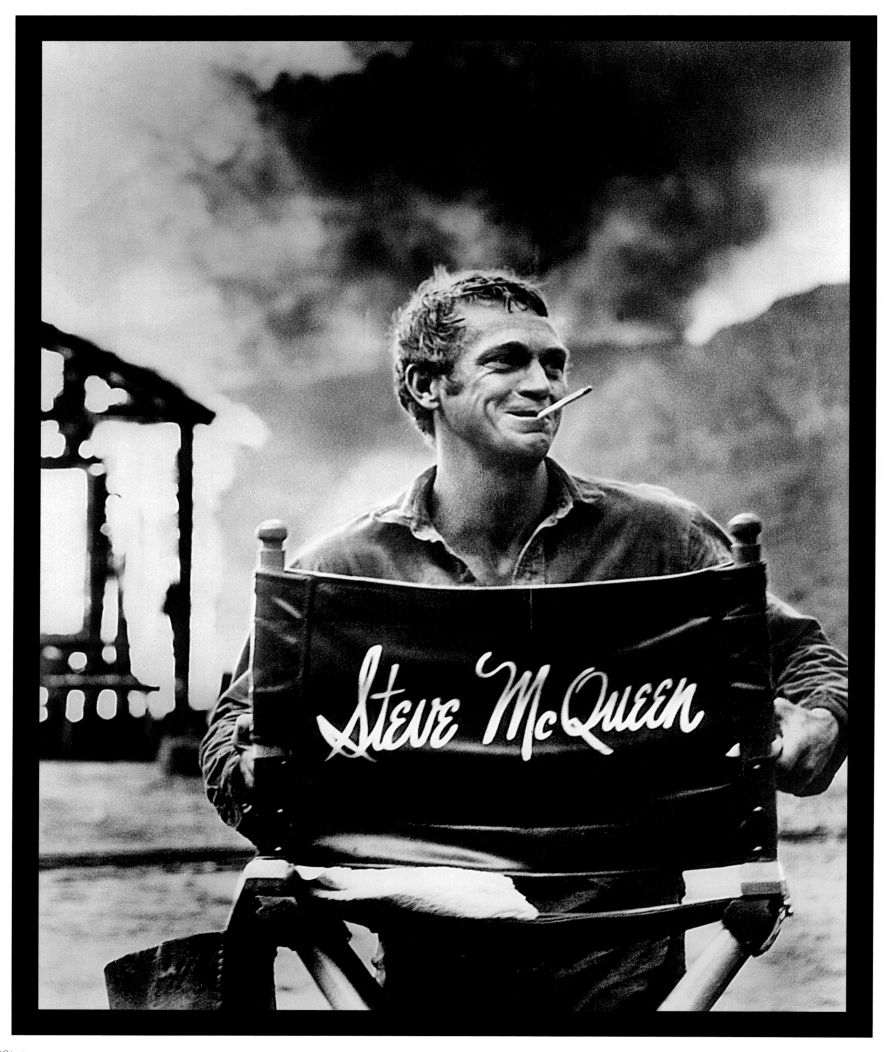

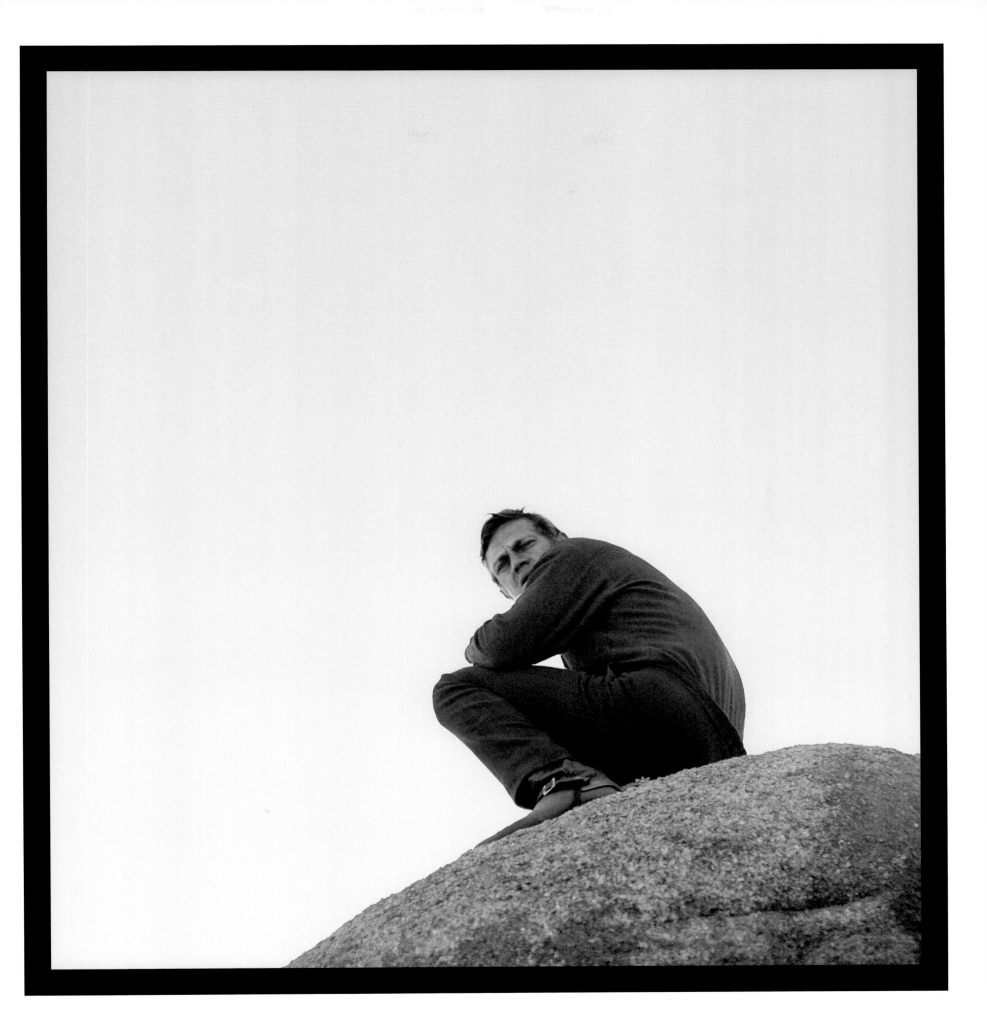

IT WAS ALL VERY PLEASANT JUST LYING IN THE SUN AND WATCHING THE GIRLS GO BY, BUT ONE DAY I SUDDENLY FELT BORED WITH HANGING AROUND AND WENT AND JOINED THE MARINES.

STEVE MCQUEEN

C'ÉTAIT SYMPA DE LANGUIR AU SOLEIL EN REGARDANT PASSER LES FILLES, ET PUIS UN JOUR J'EN AI EU ASSEZ ET JE ME SUIS ENGAGÉ DANS LES MARINES.

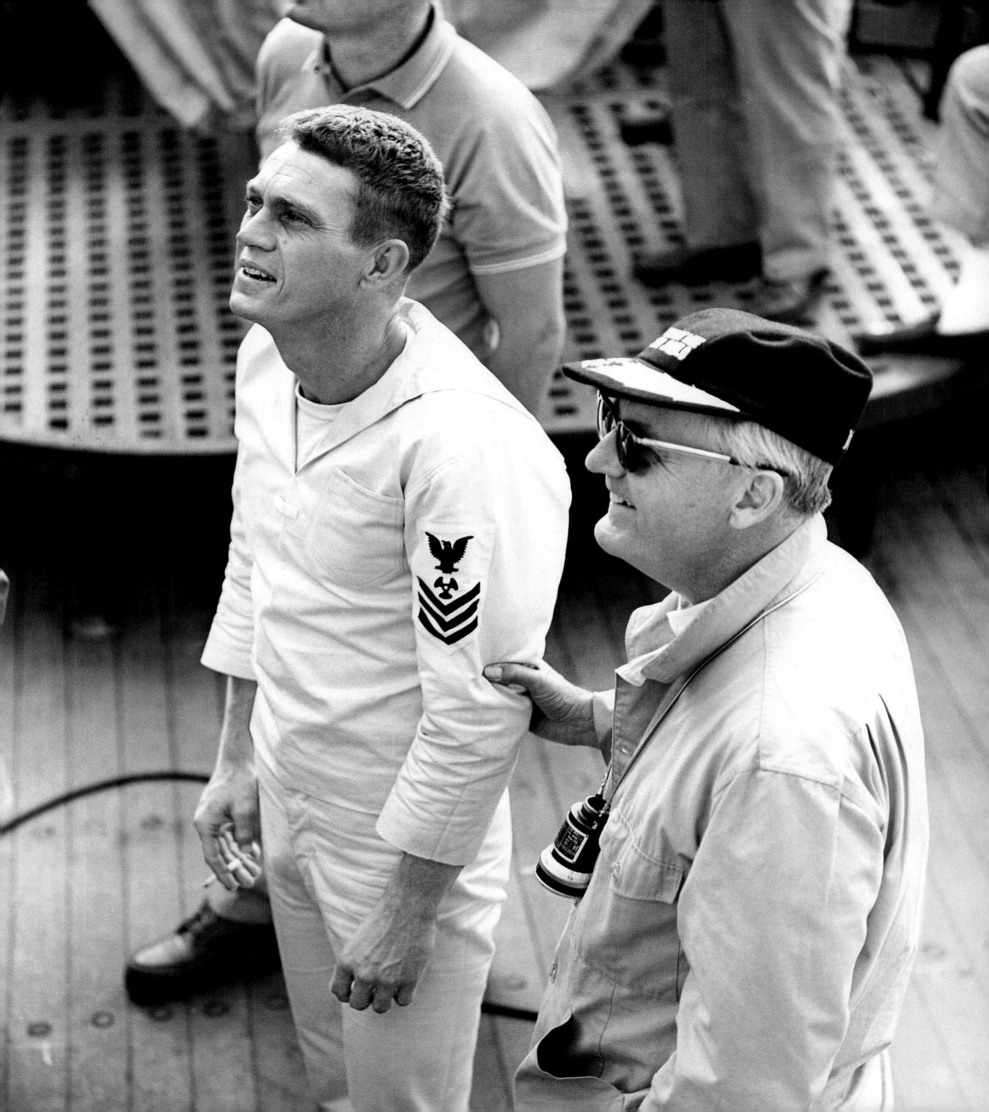

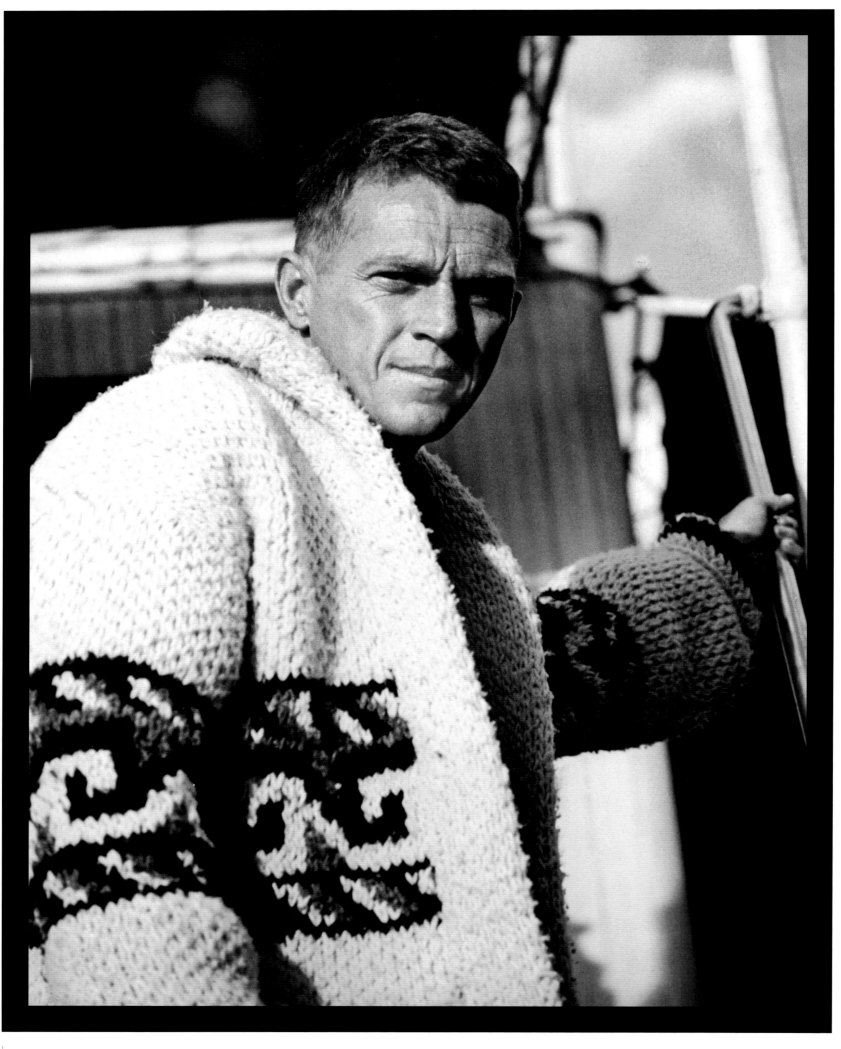

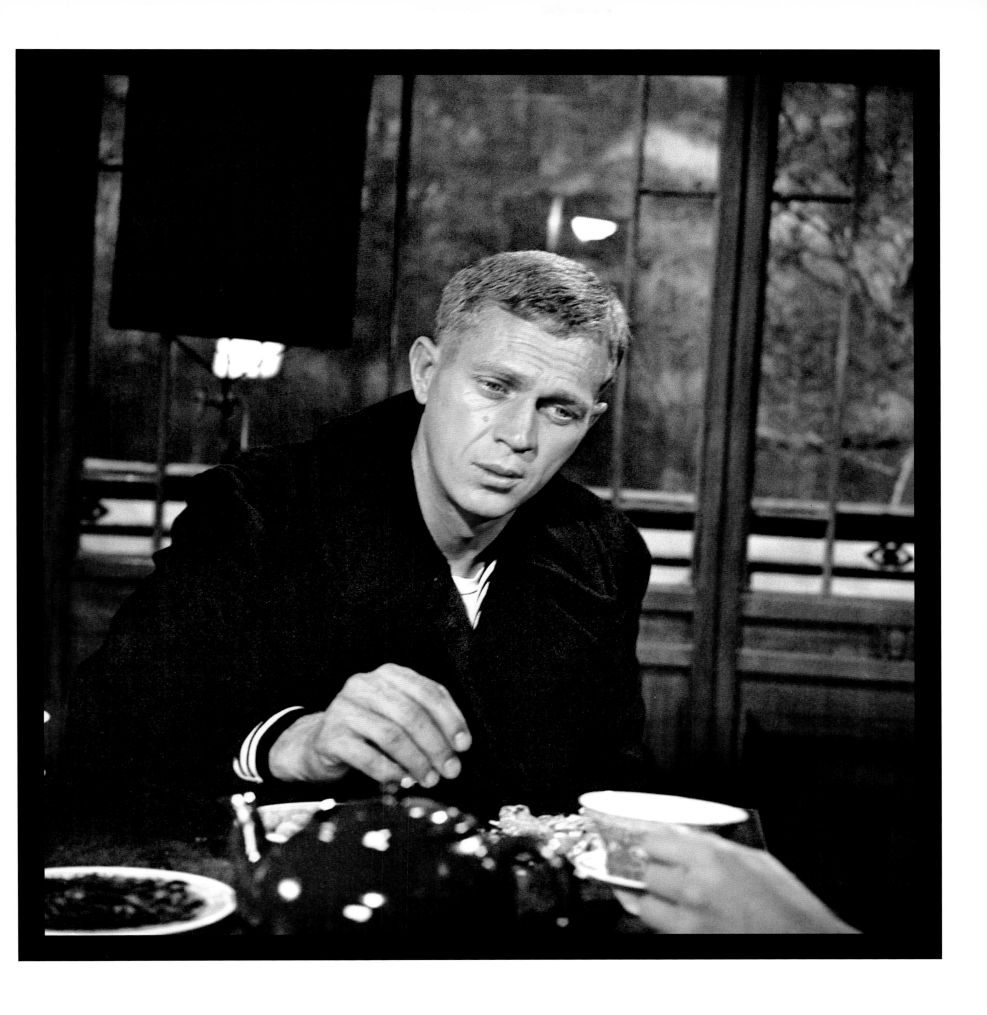

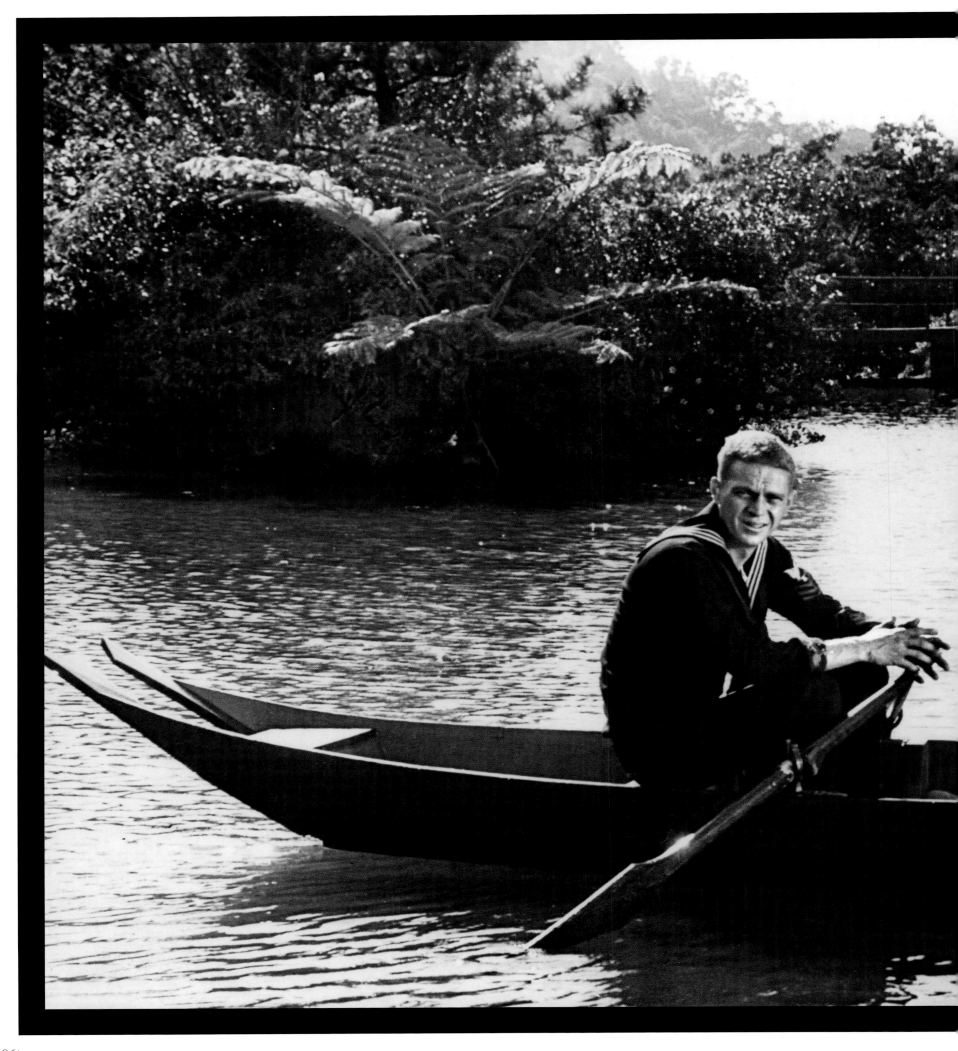

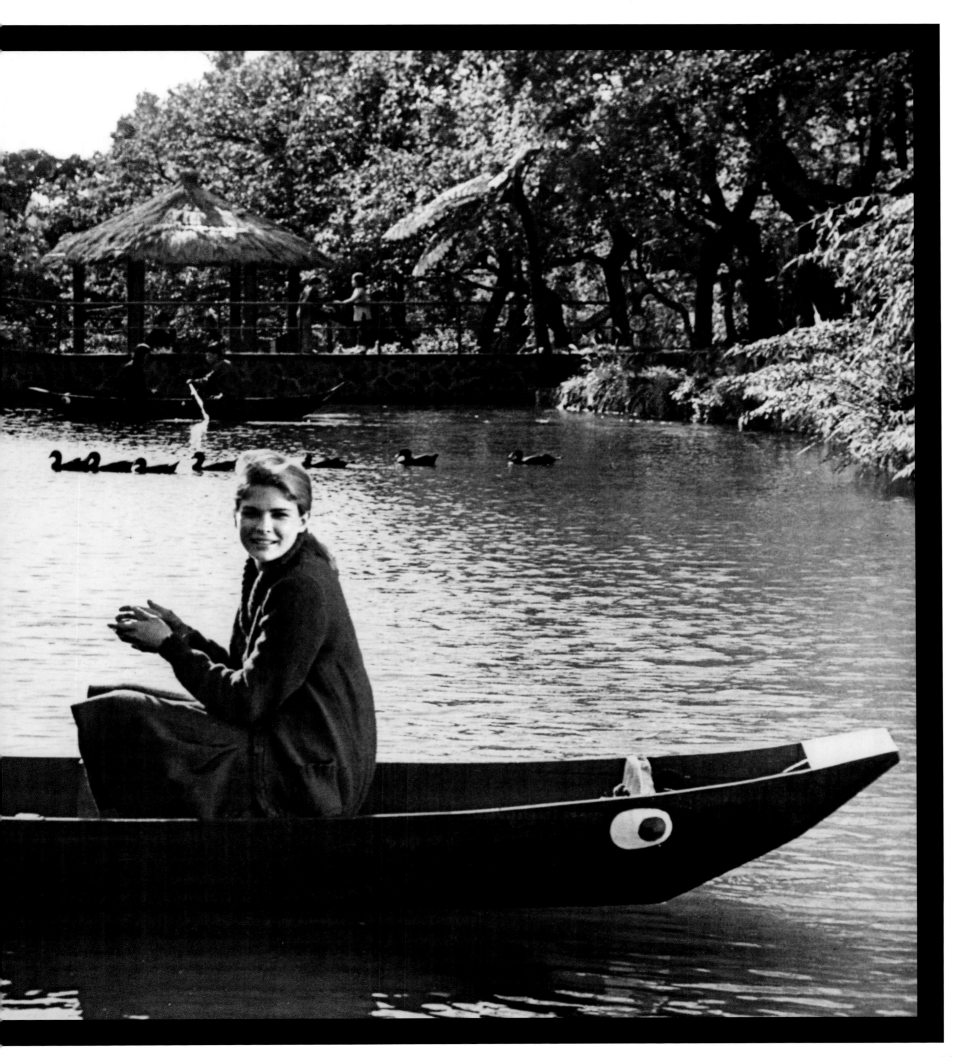

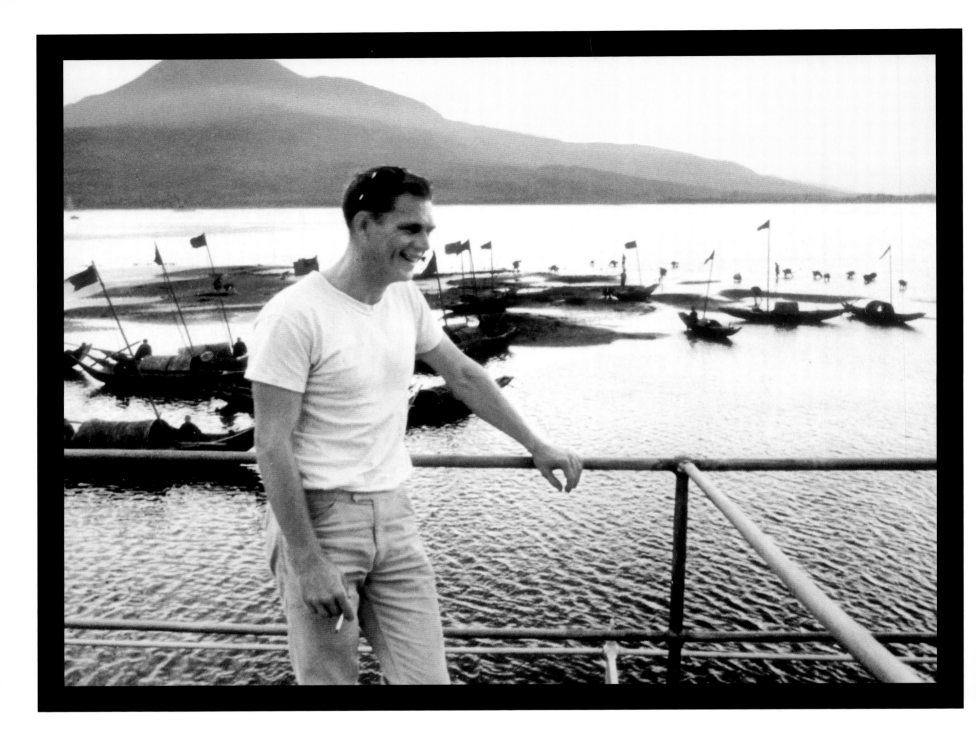

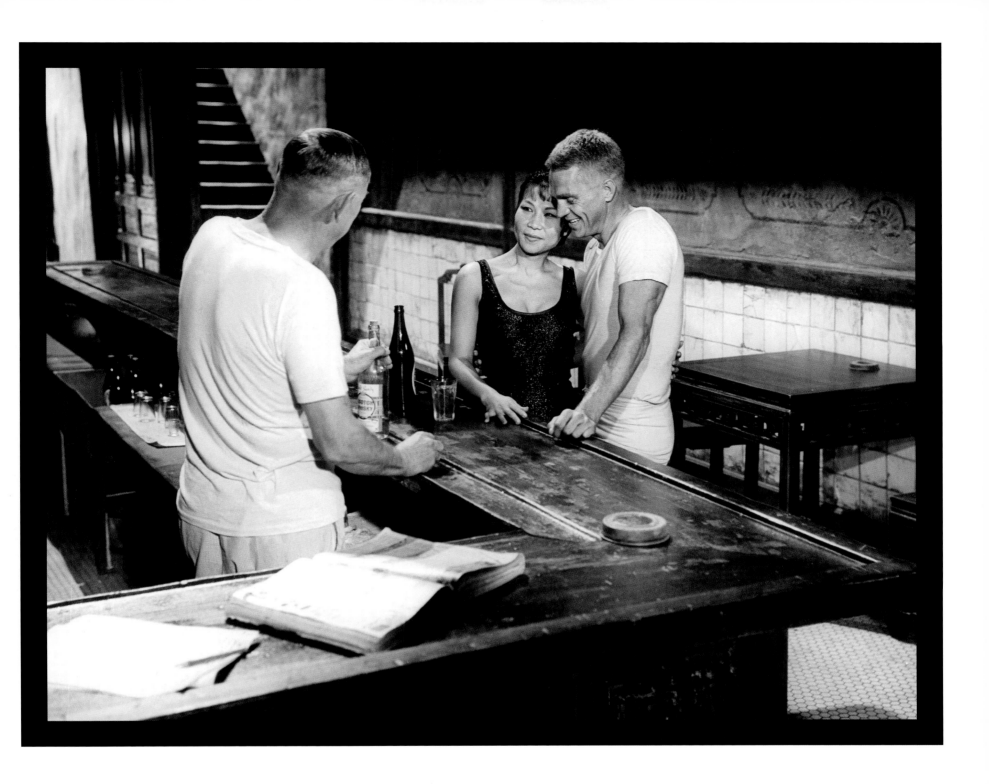

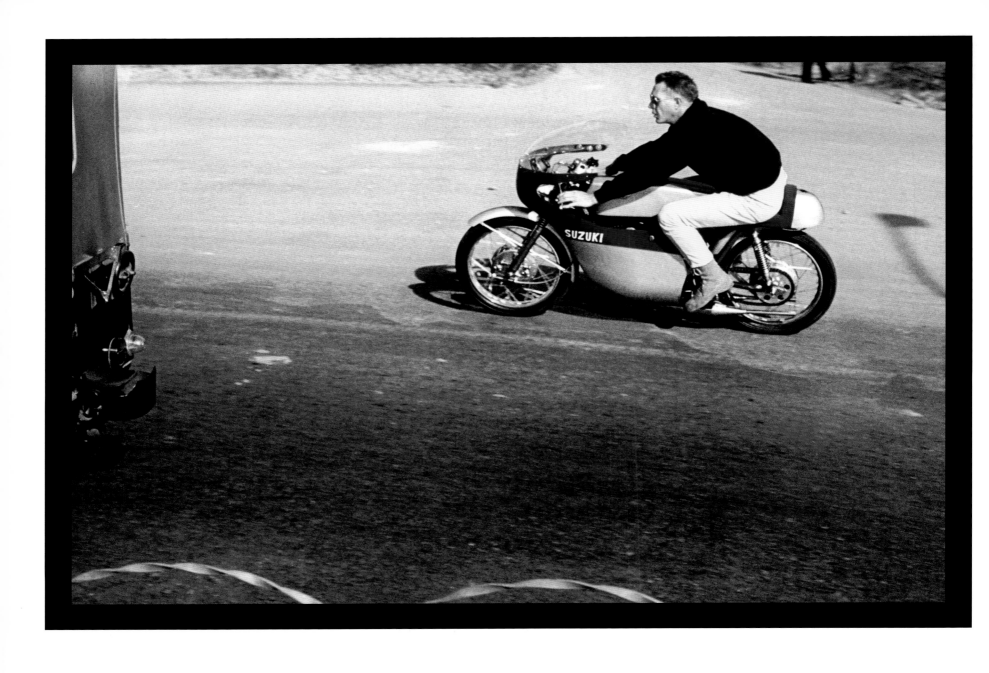

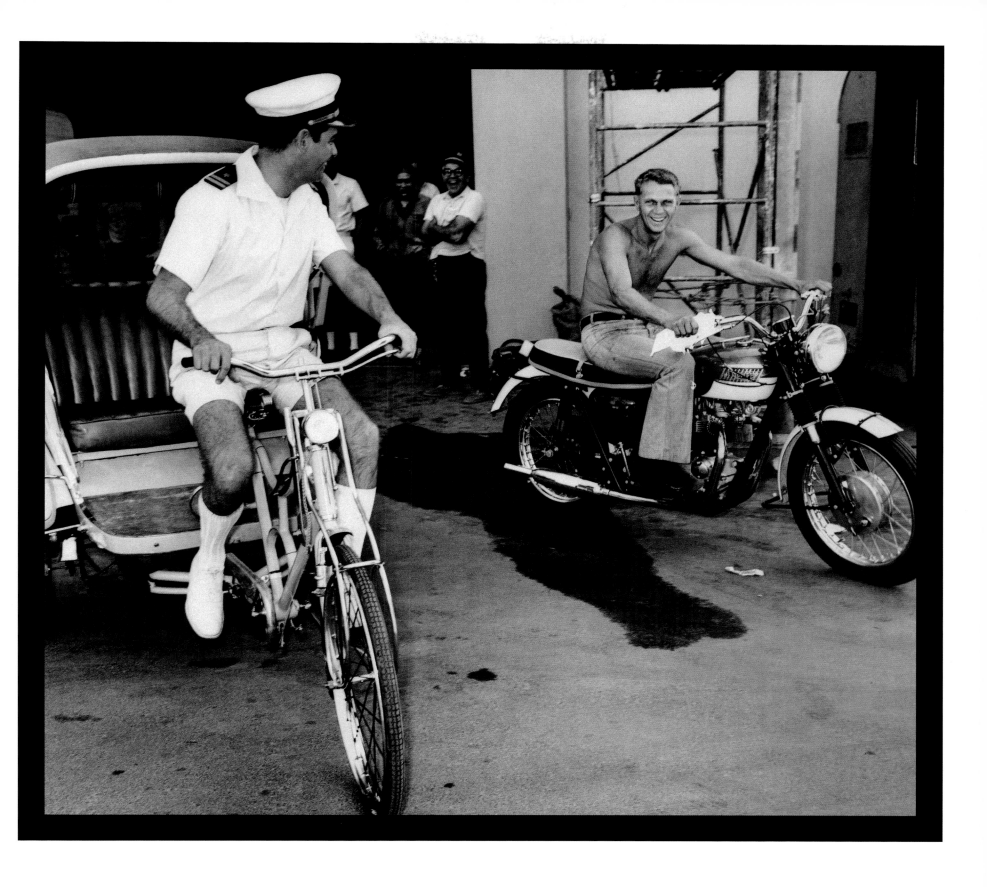

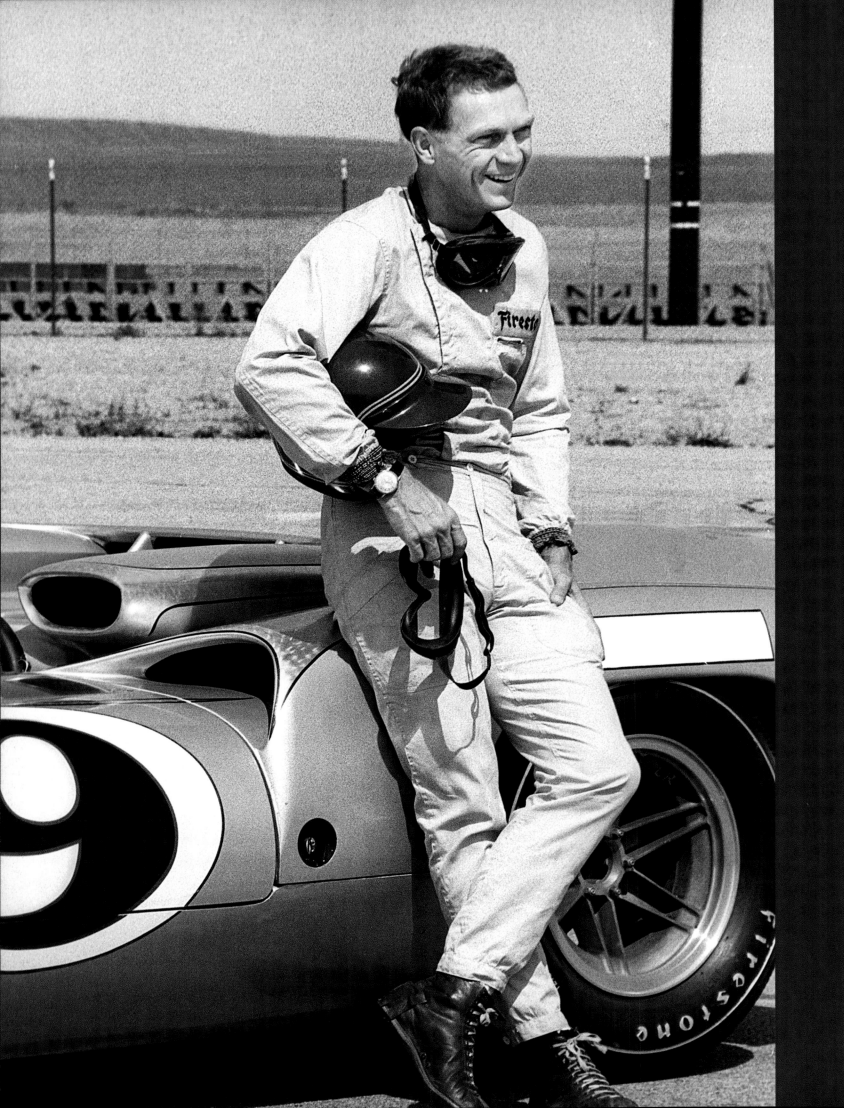

IT'S ONLY WHEN I'M GOING FAST, IN A RACING CAR OR BIKE, THAT I REALLY RELAX.

STEVE MCQUEEN

EN VOITURE OU A MOTO,
CE N'EST QUE LORSQUE JE FONCE
QUE JE ME DETENDS VRAIMENT.

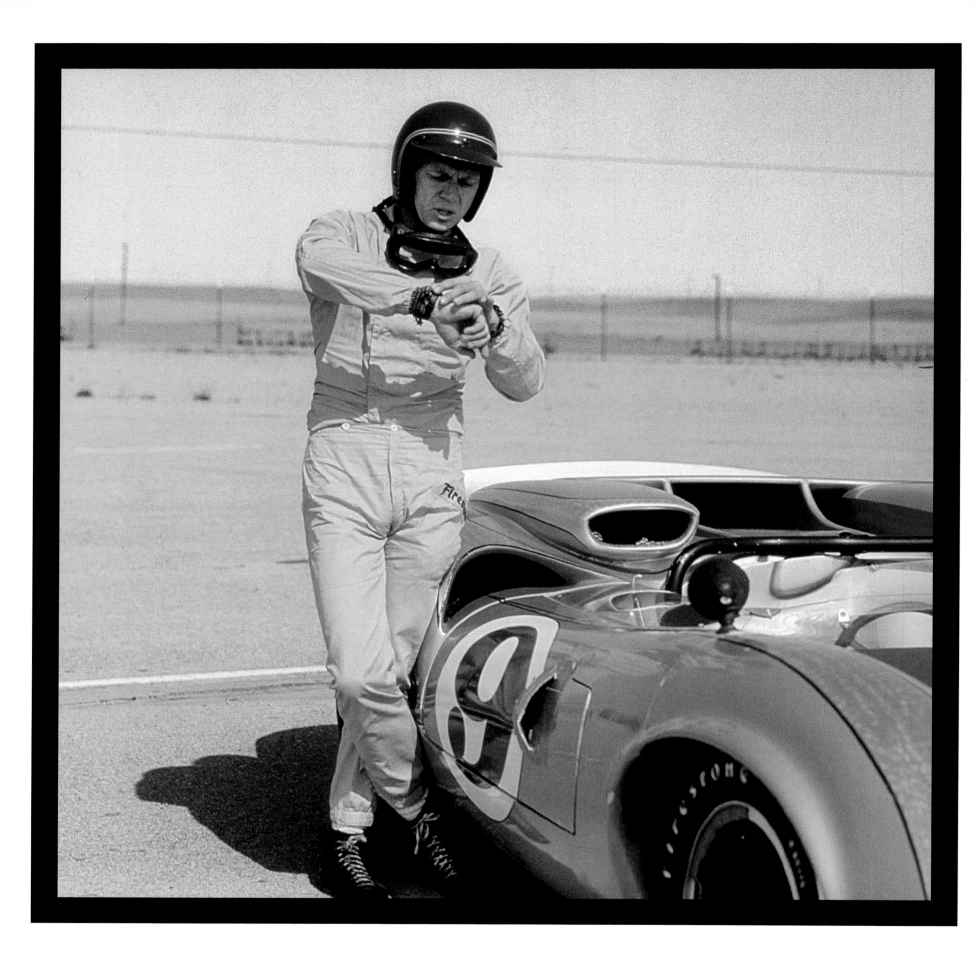

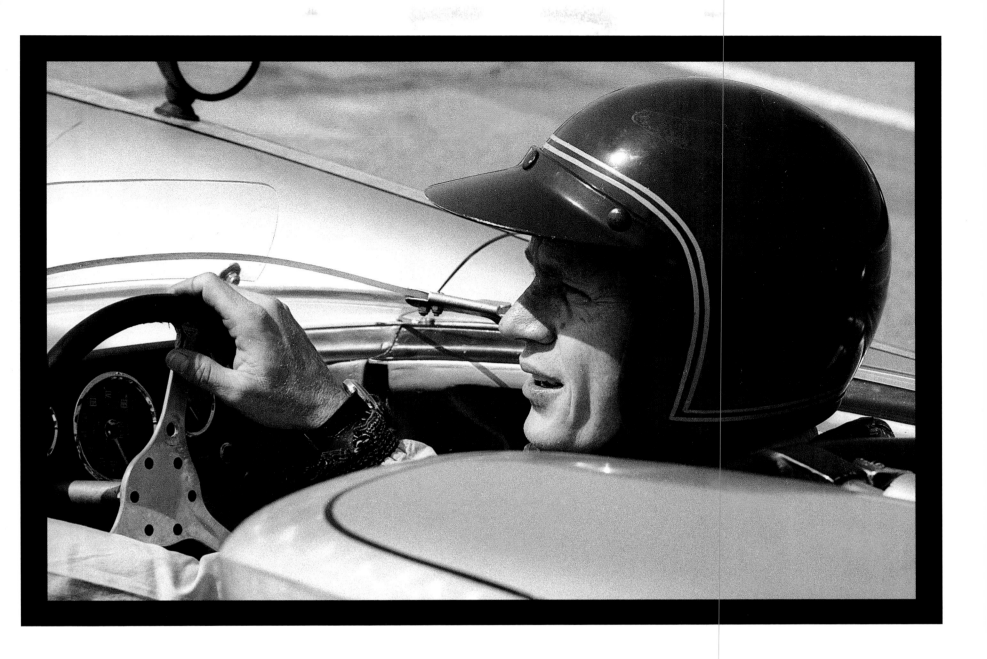

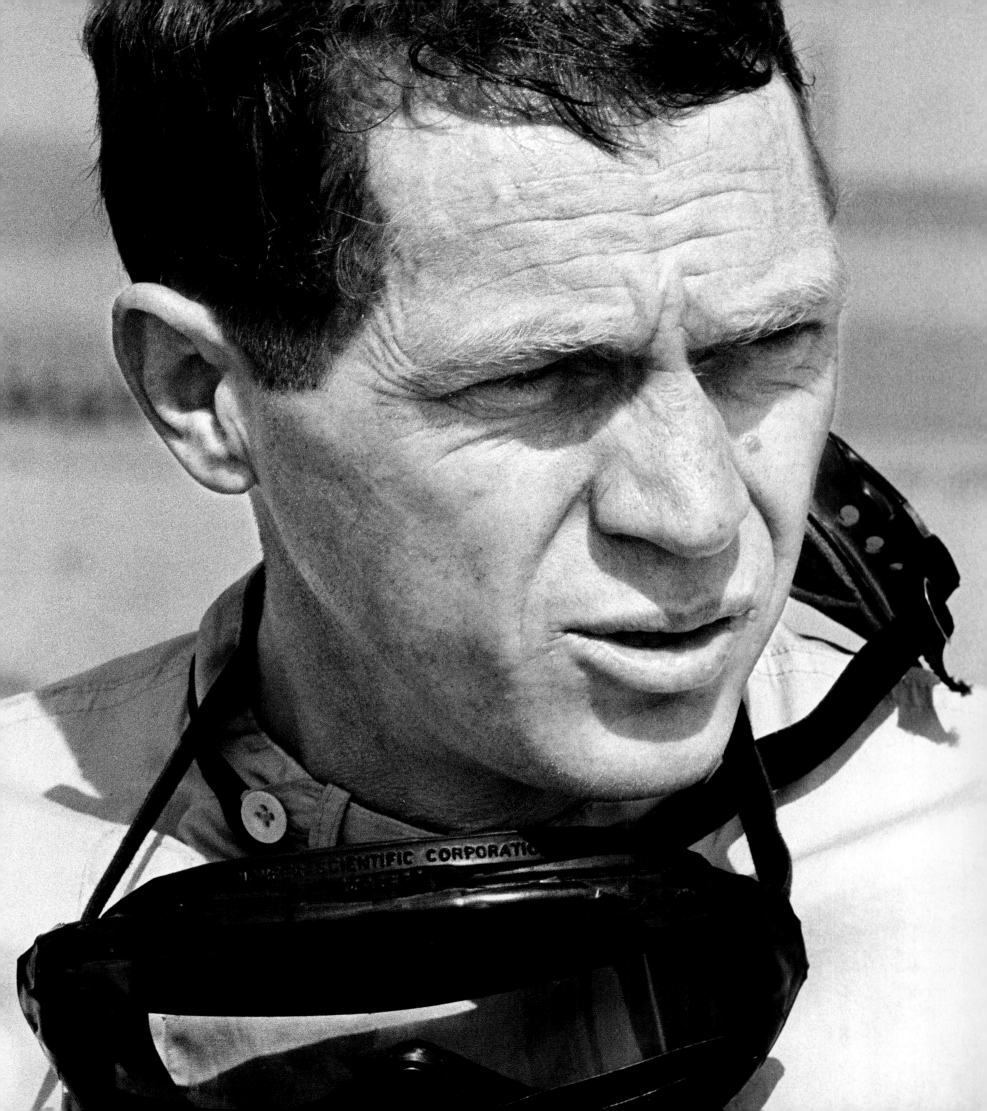

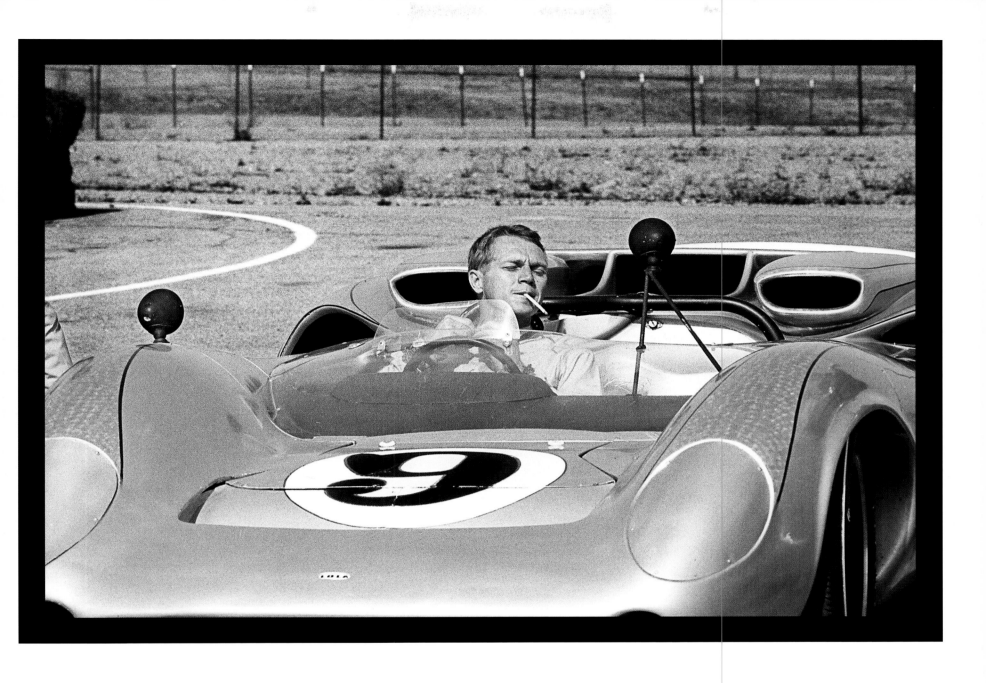

STARDOM EQUALS FREEDOM.
IT'S THE ONLY EQUATION THAT MATTERS.

STEVE MCQUEEN

CELEBRITE = LIBERTE.
C'EST LA SEULE EQUATION QUI VAILLE.

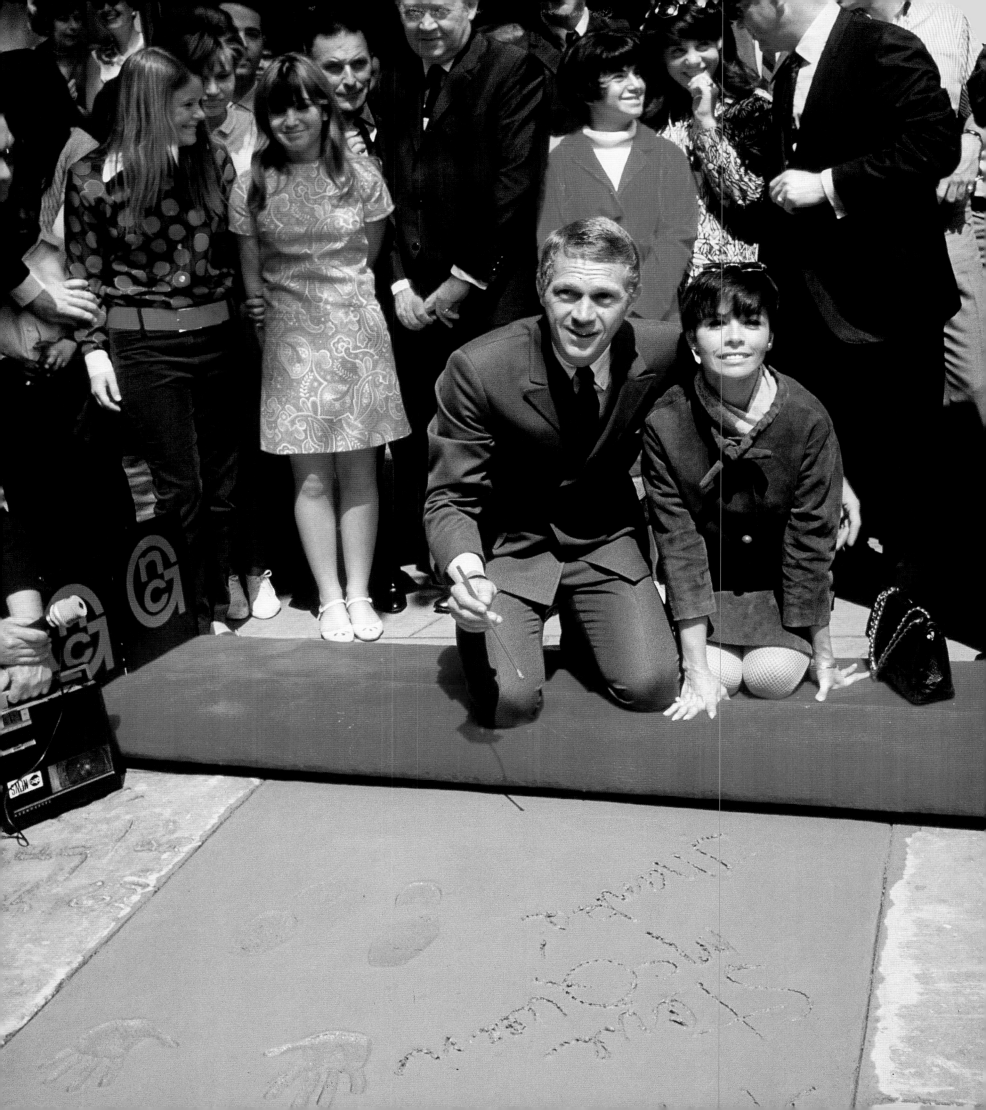

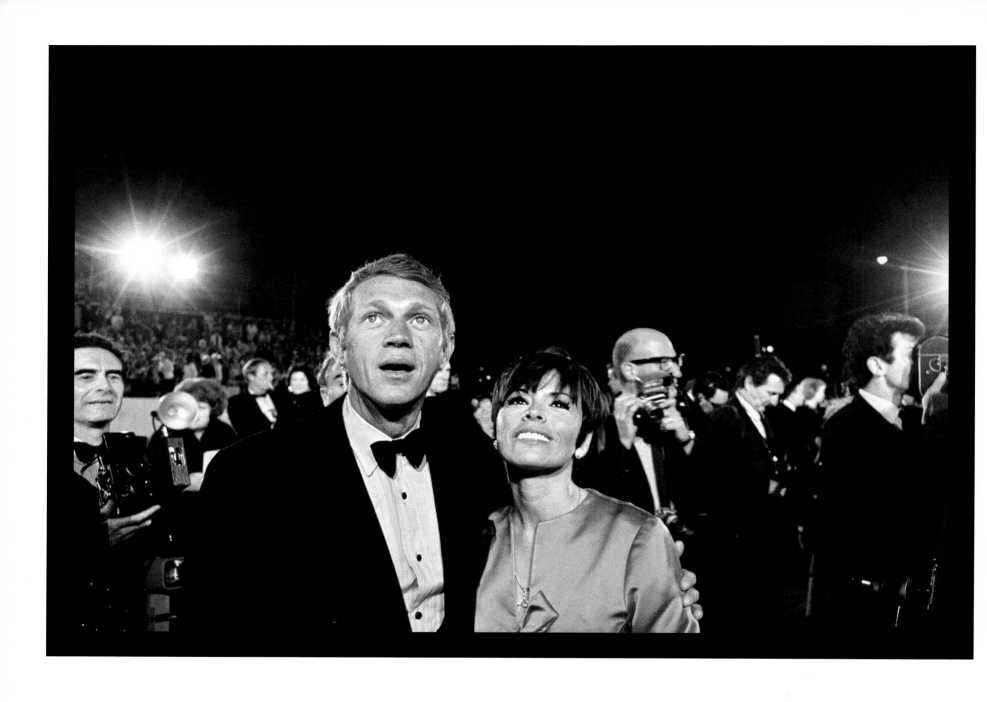

ACTING'S A GOOD RACKET. AND LETS FACE IT, YOU CAN'T BEAT IT FOR THE BREAD.

STEVE MCQUEEN

ACTEUR, C'EST UN BOULOT SYMPA. ET, SOYONS HONNETES,
IL N'Y A RIEN QUI PAIE PLUS.

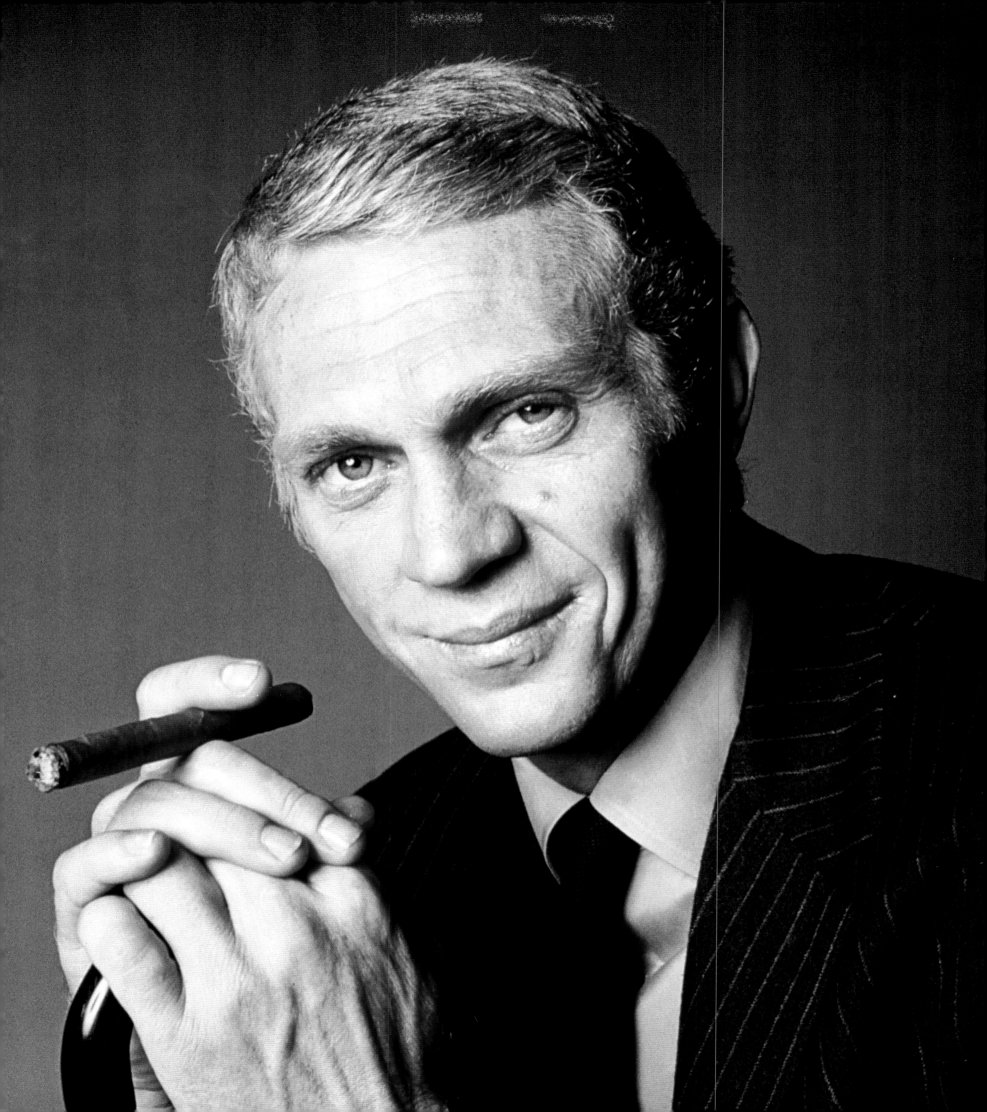

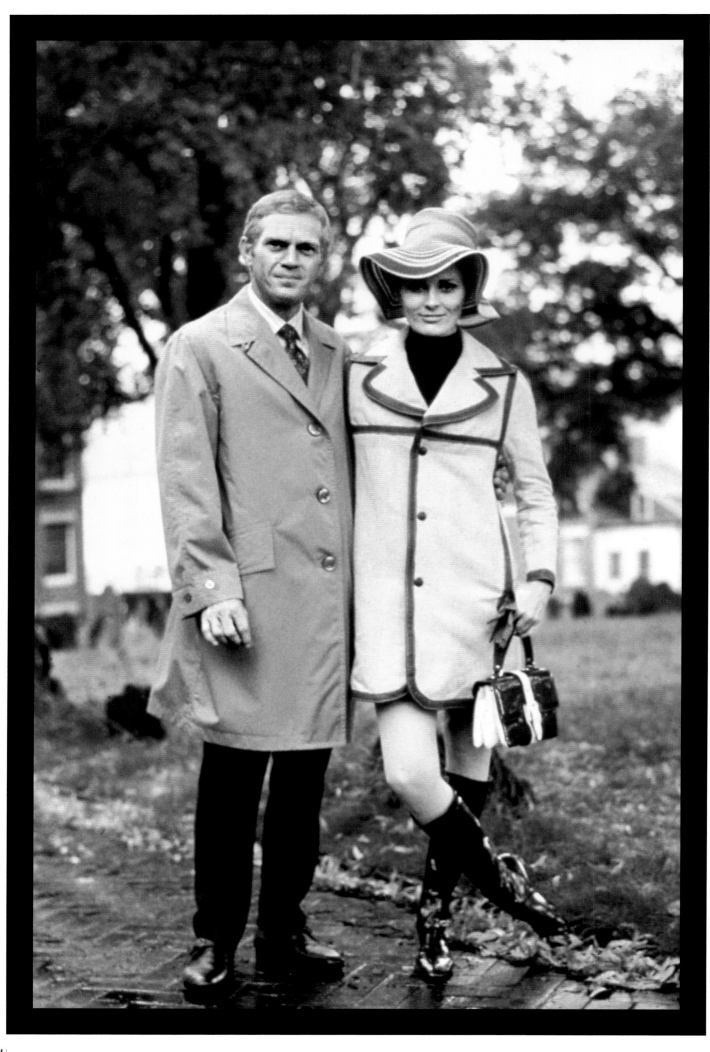

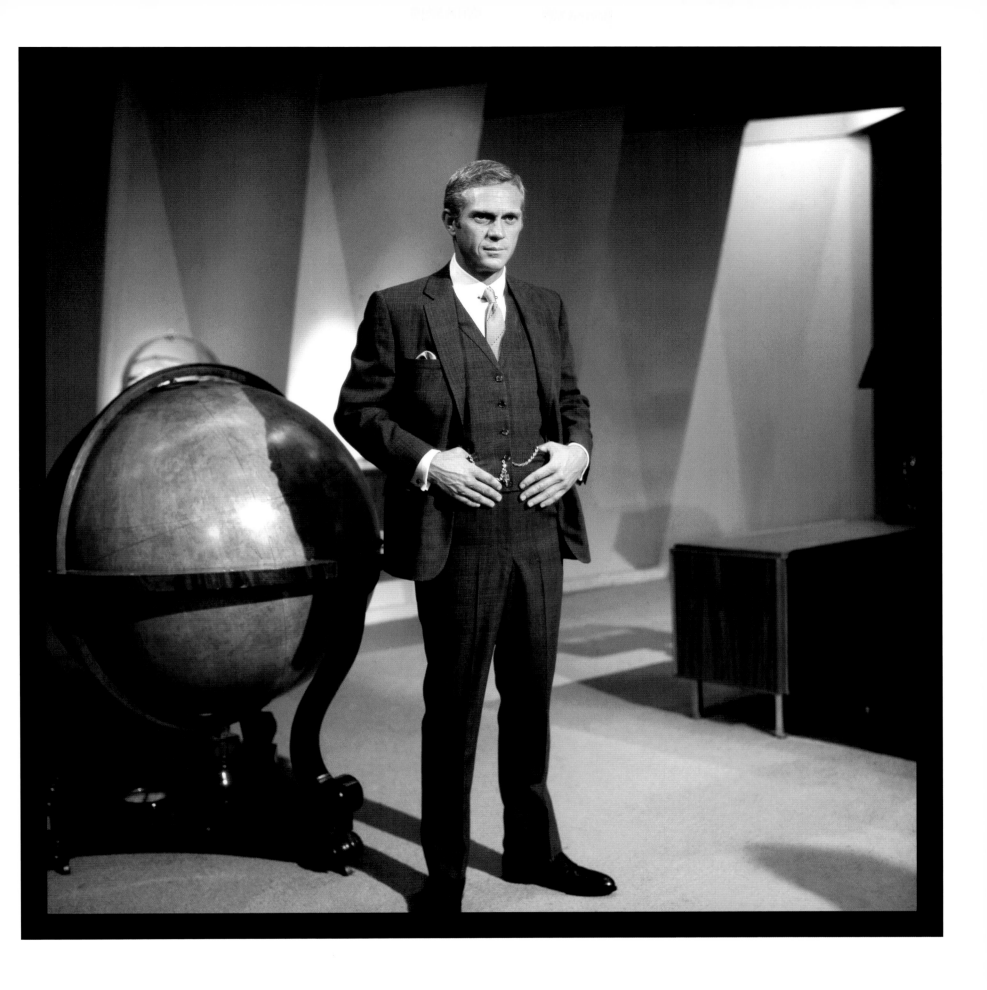

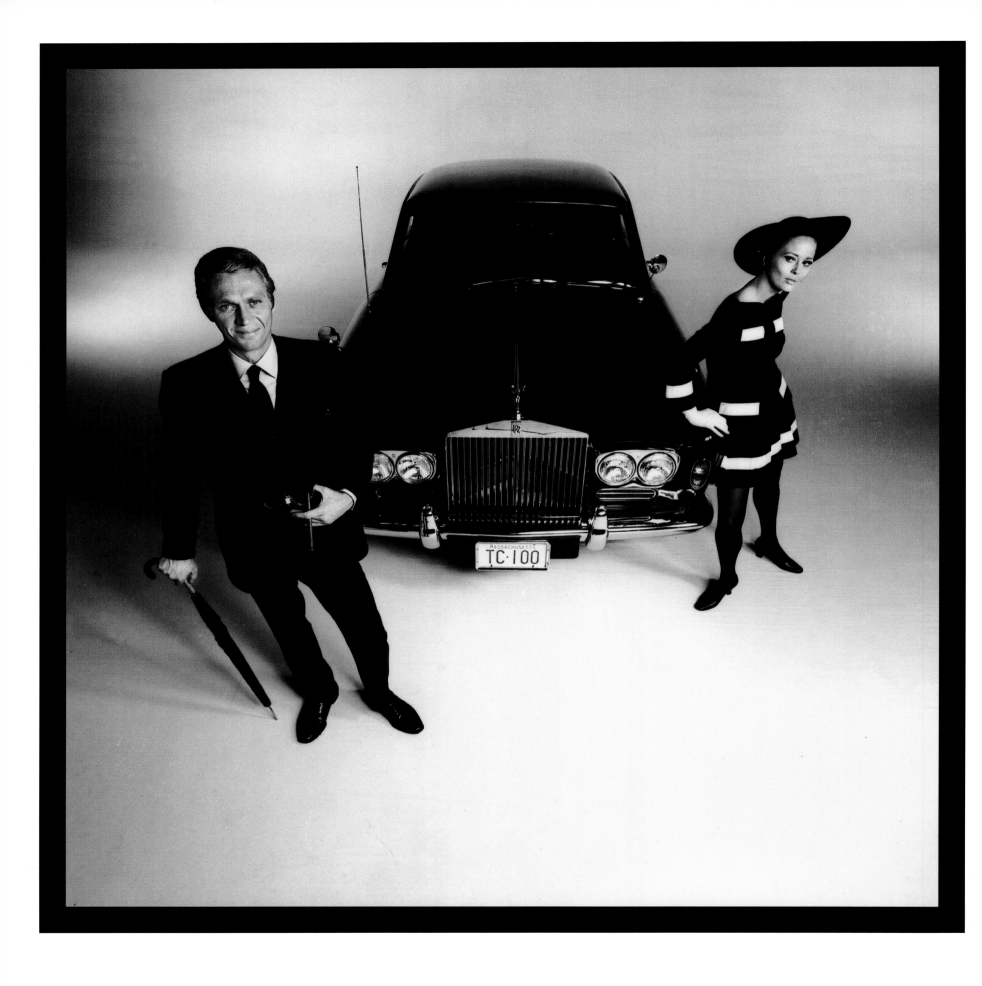

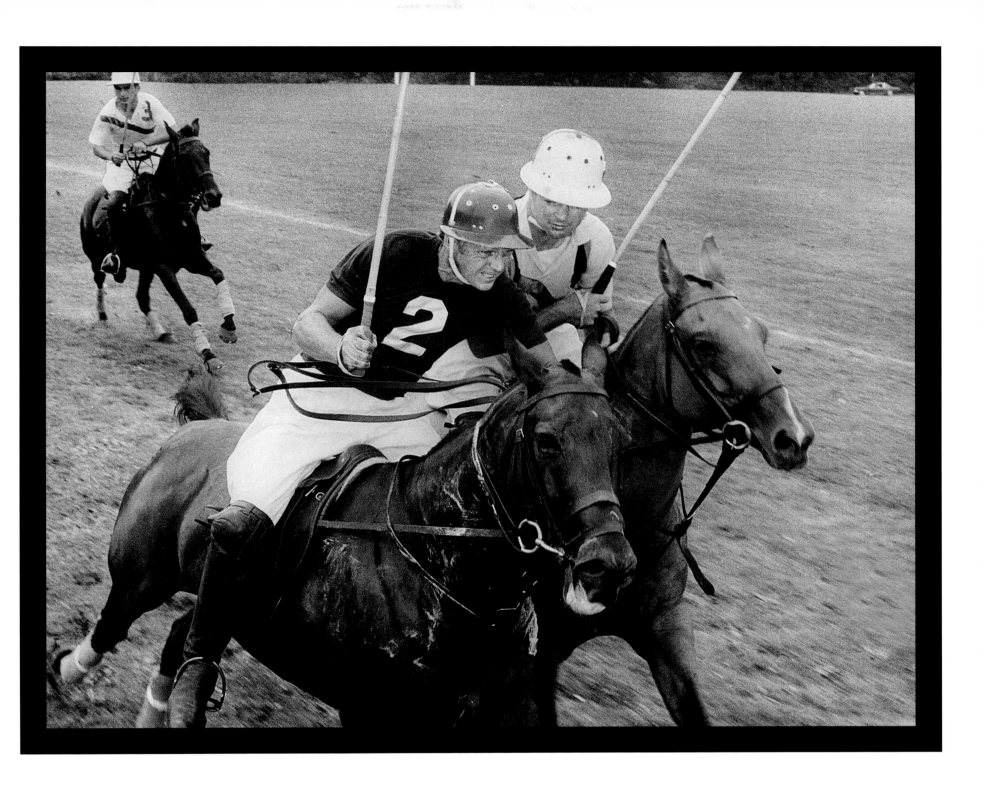

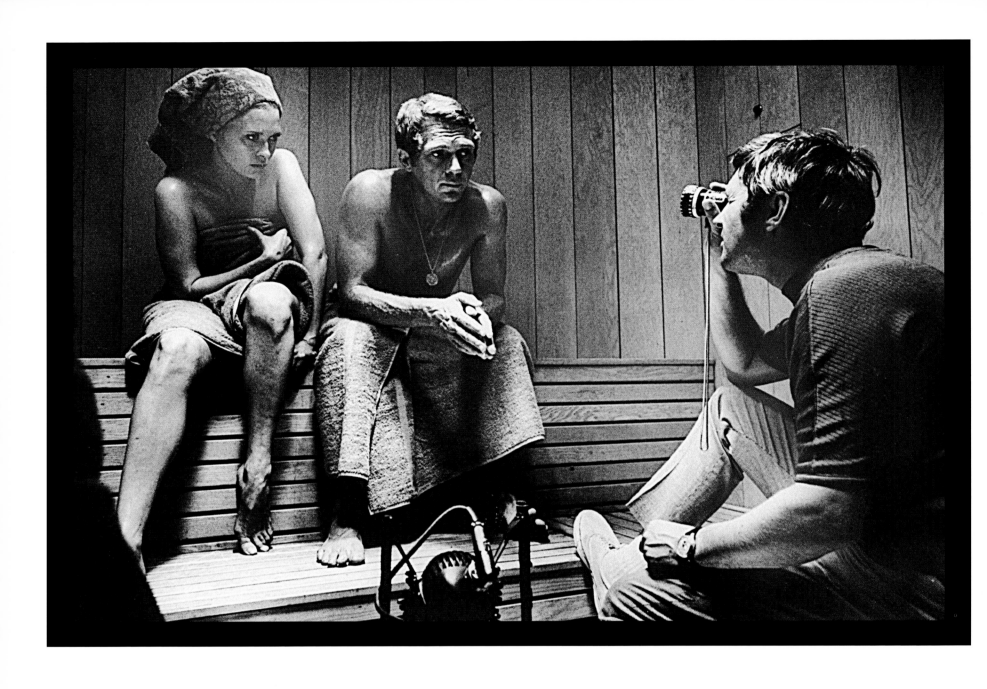

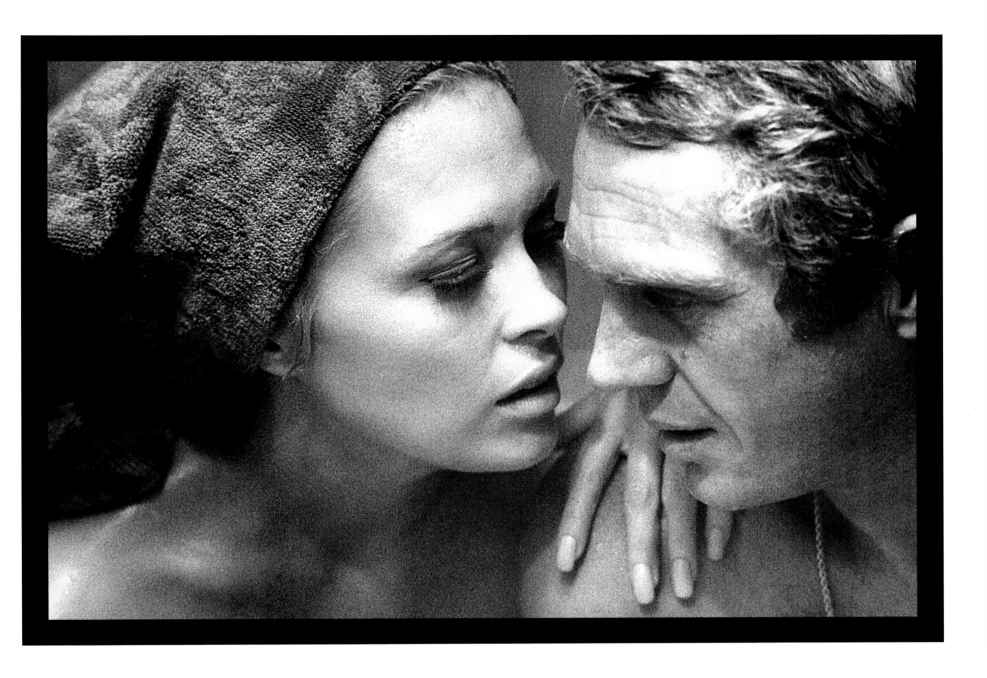

I REALLY DON'T LIKE TO ACT. AT THE BEGINNING, BACK IN '51, I HAD TO FORCE MYSELF TO STICK WITH IT. I WAS REAL UNCOMFORTABLE, REAL UNCOMFORTABLE.

STEVE MCQUEEN

JE N'AIME VRAIMENT PAS JOUER LA COMEDIE.
AU DEBUT, EN 1951, JE DEVAIS ME FORCER POUR Y ARRIVER.
C'ETAIT VRAIMENT, VRAIMENT DESAGREABLE.

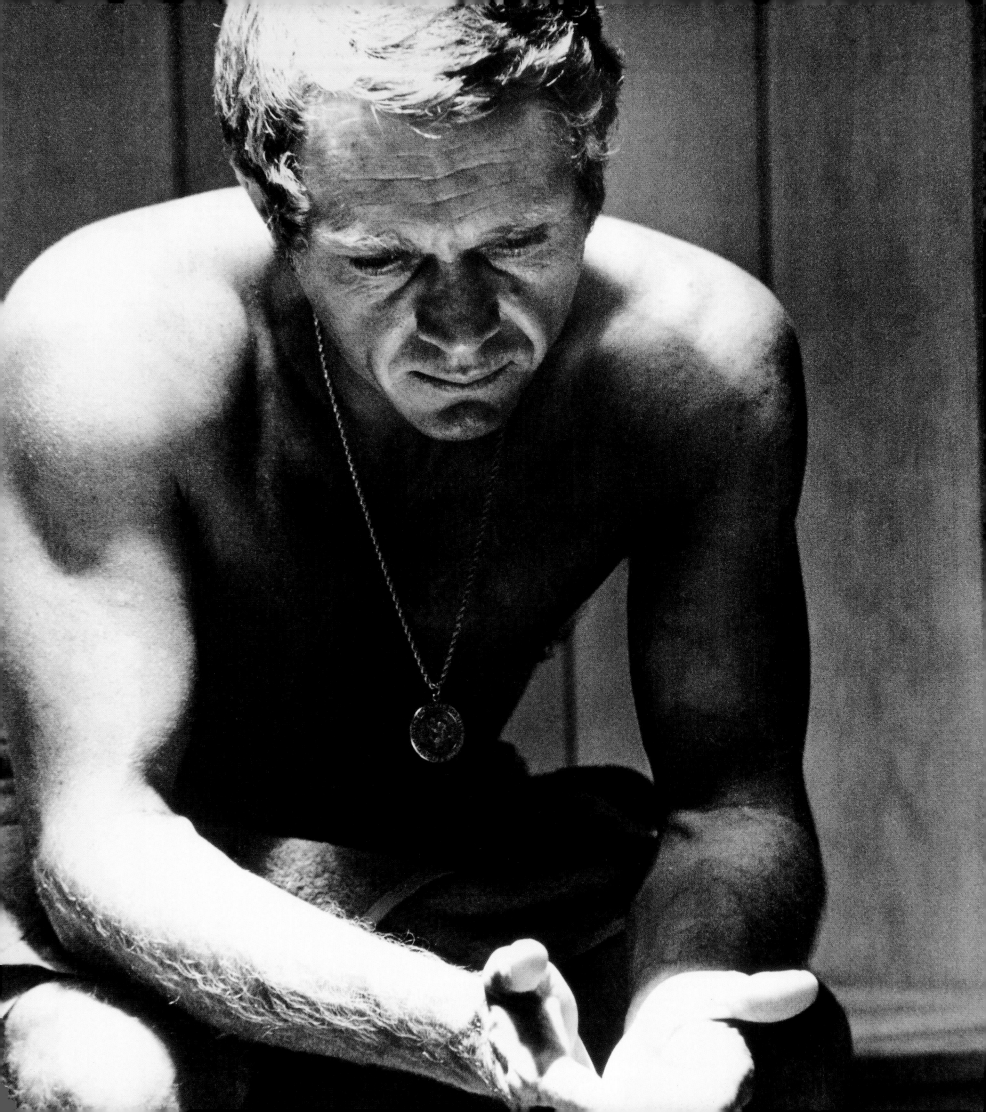

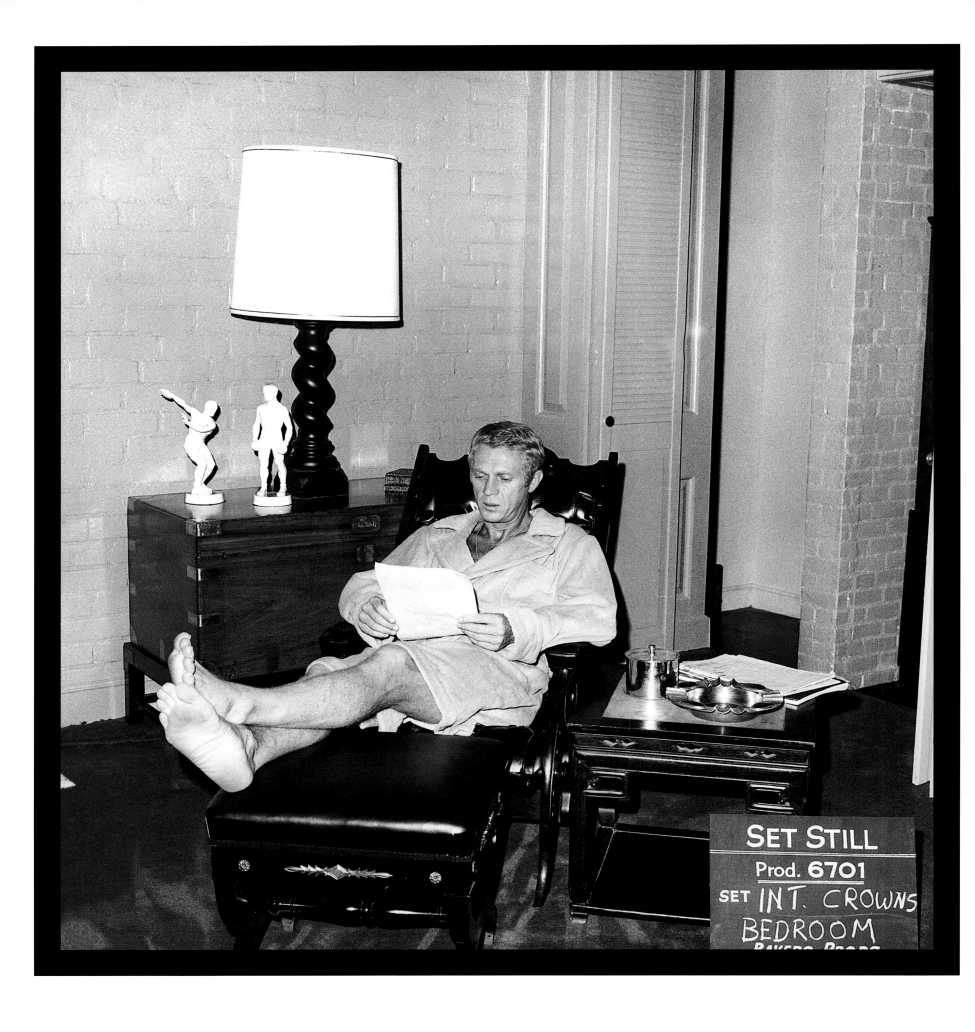

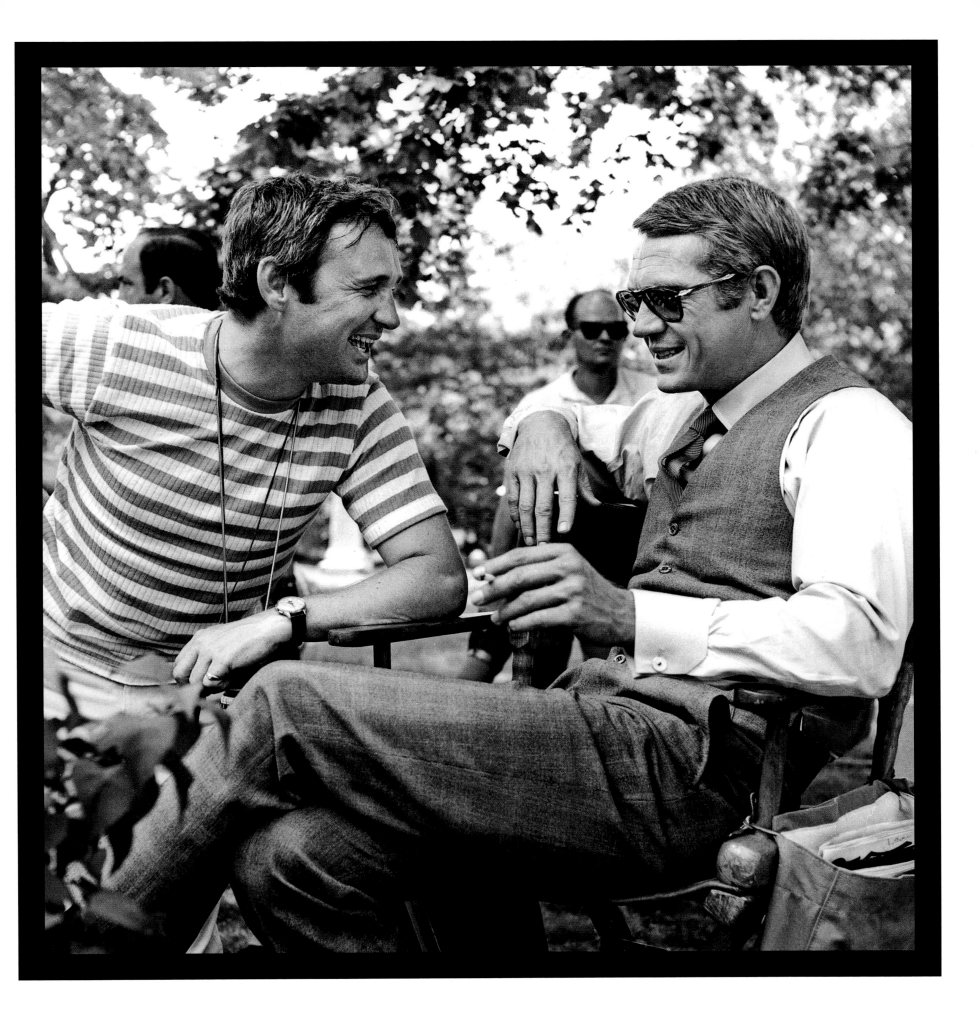

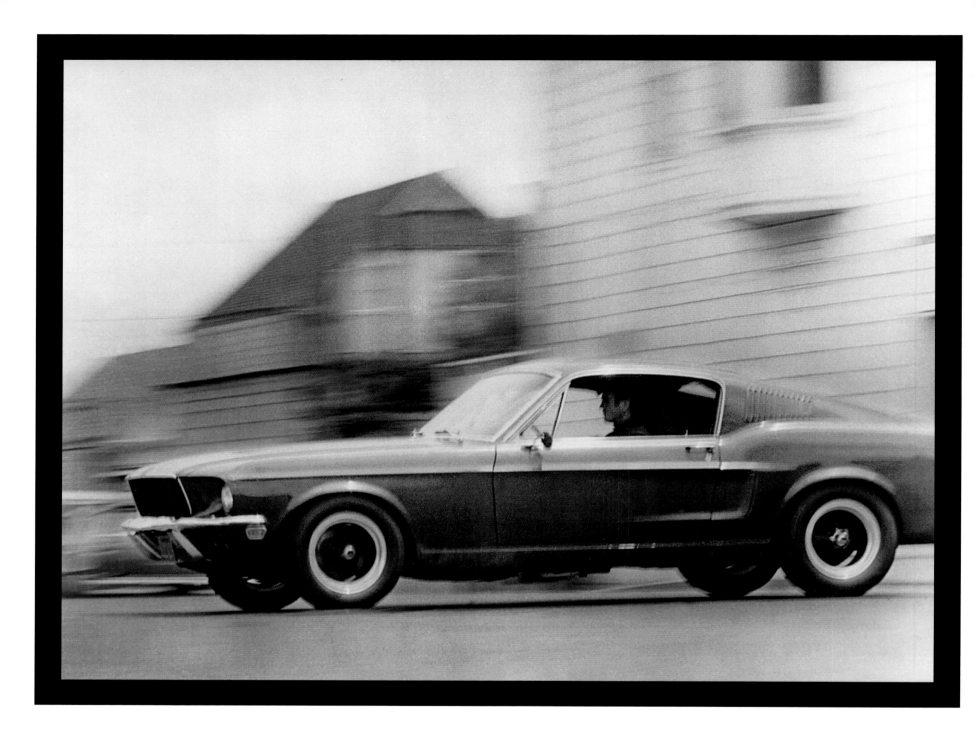

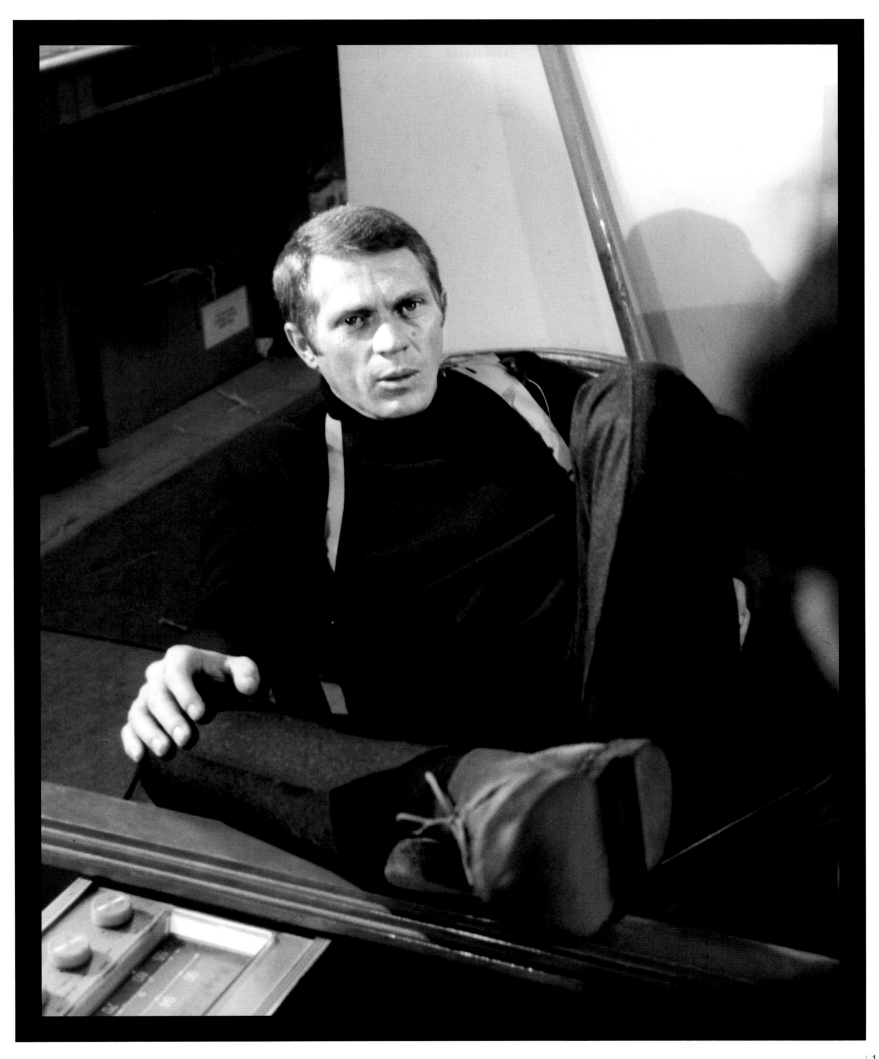

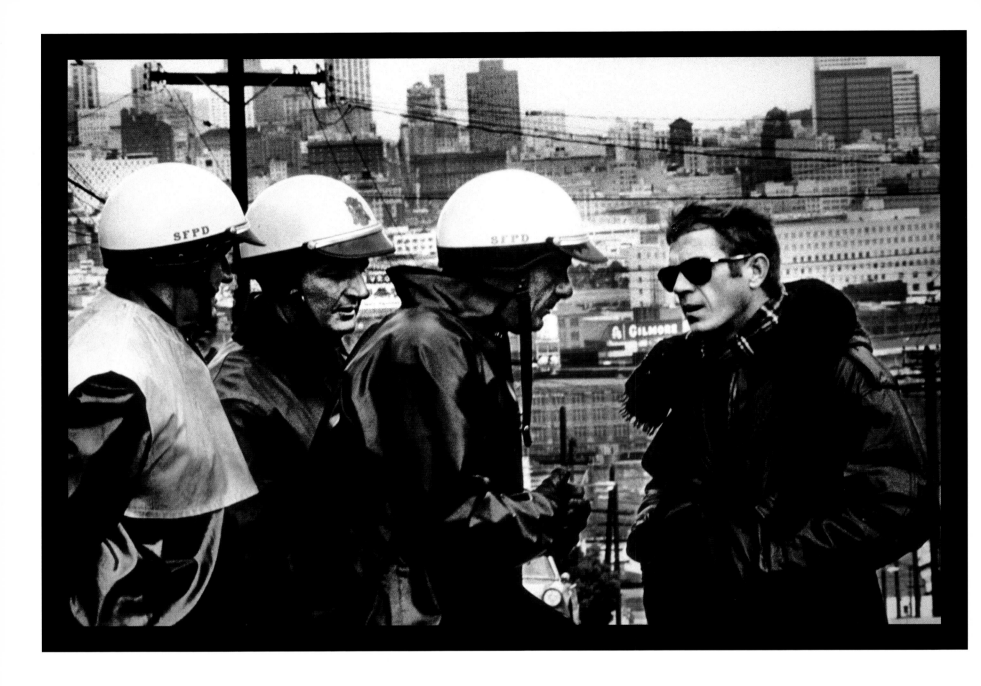

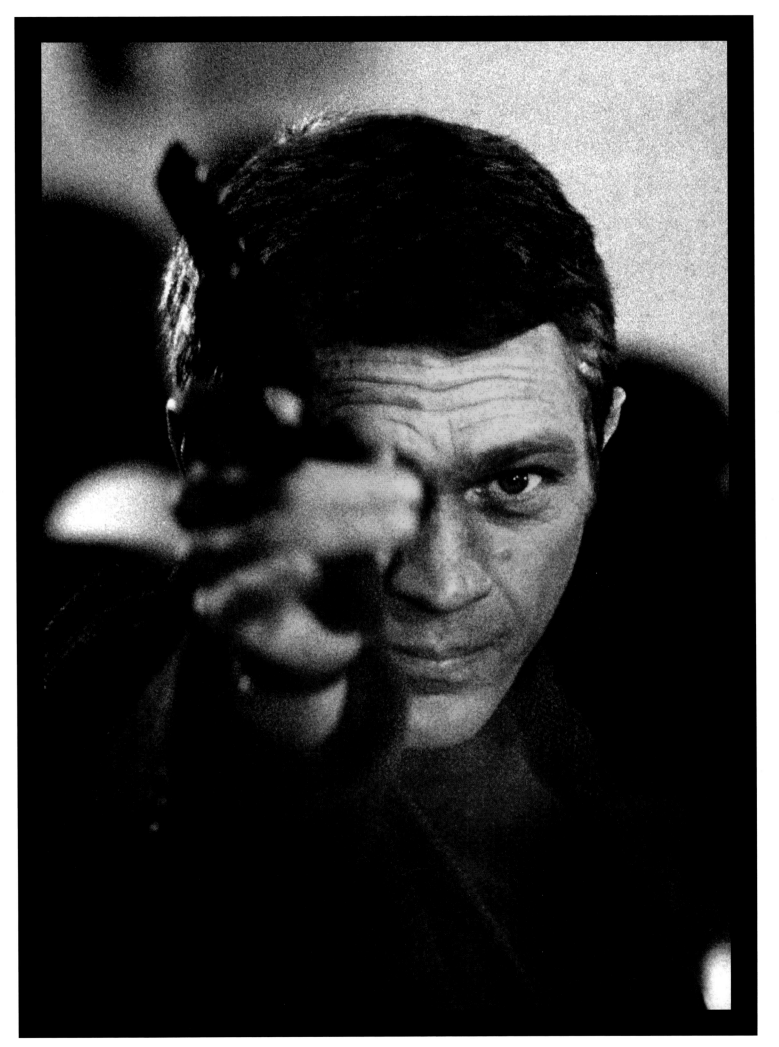

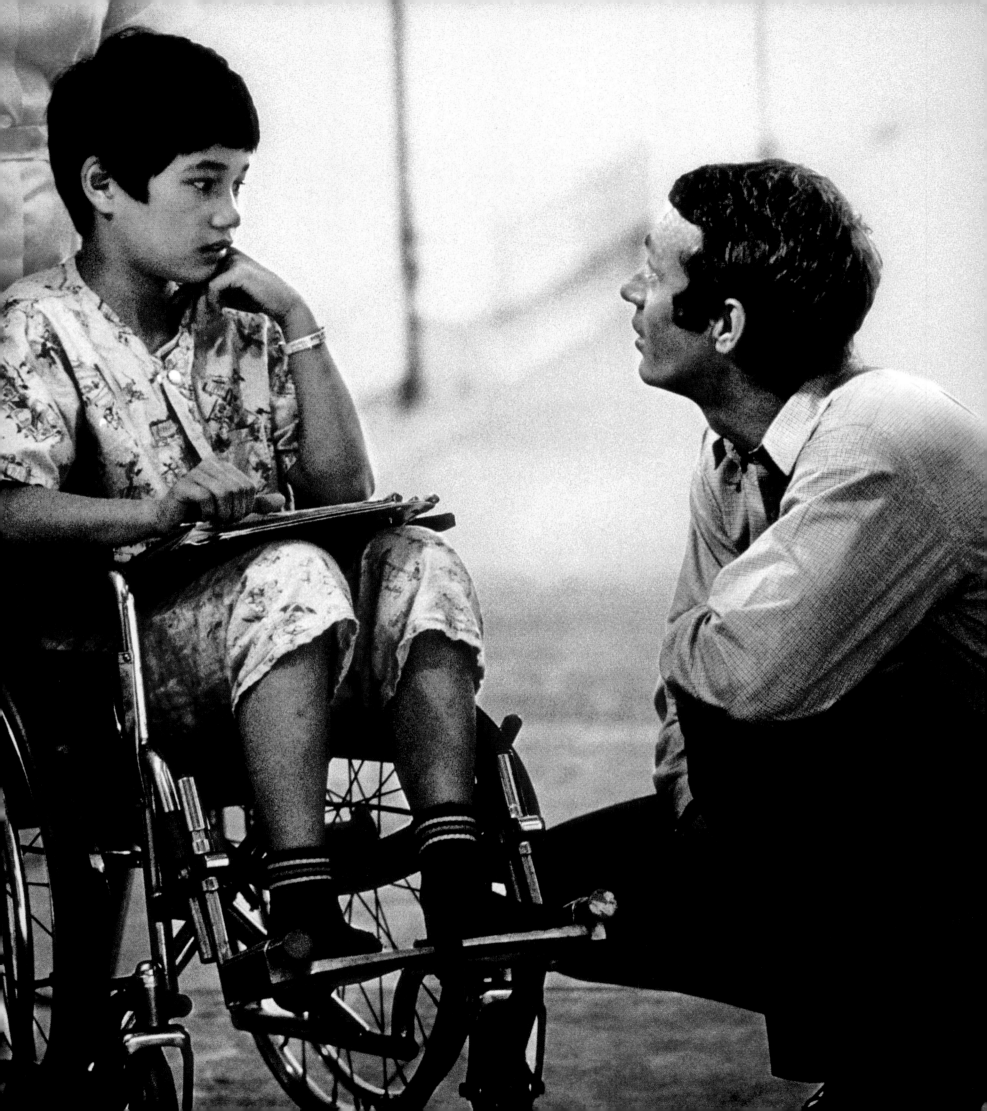

WHEN A KID DIDN'T HAVE ANY LOVE WHEN HE WAS SMALL, HE BEGINS TO WONDER IF HE'S GOOD ENOUGH. YOU KNOW IF MY MOTHER DIDN'T LOVE ME, AND I DIDN'T HAVE A FATHER, I MEAN, WELL, I GUESS I'M NOT VERY GOOD.

STEVE MCQUEEN

QUAND UN GOSSE N'A PAS ETE AIME DANS SON ENFANCE, IL SE DEMANDE S'IL VAUT QUELQUE CHOSE. MOI, MA MERE NE M'A PAS AIME ET JE N'AI PAS EU DE PERE, DONC JE PENSE VRAIMENT QUE JE NE VAUX PAS GRAND-CHOSE.

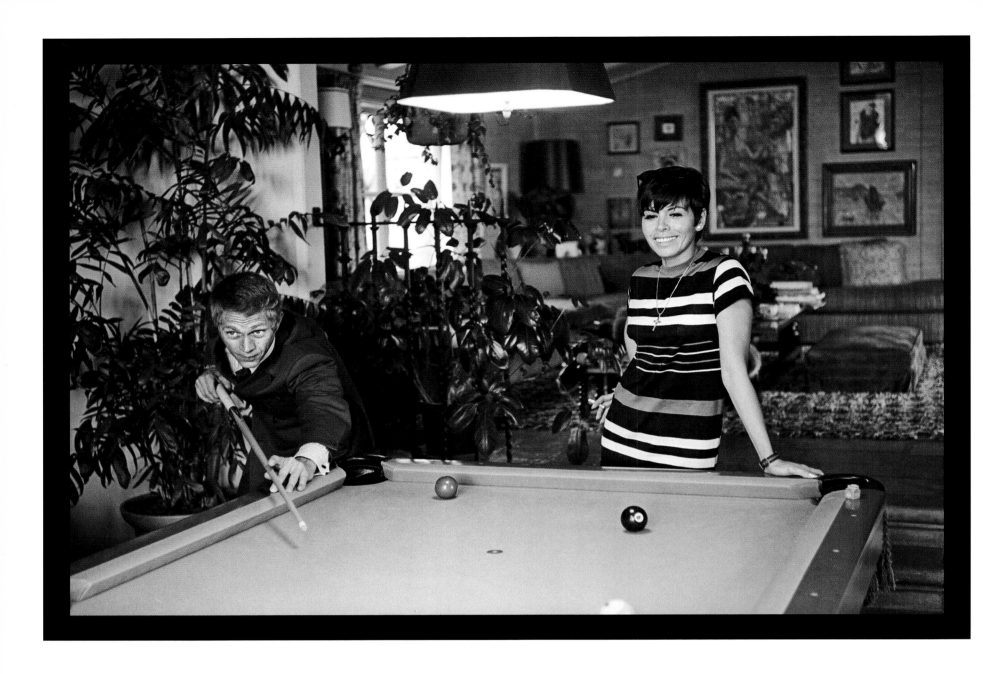

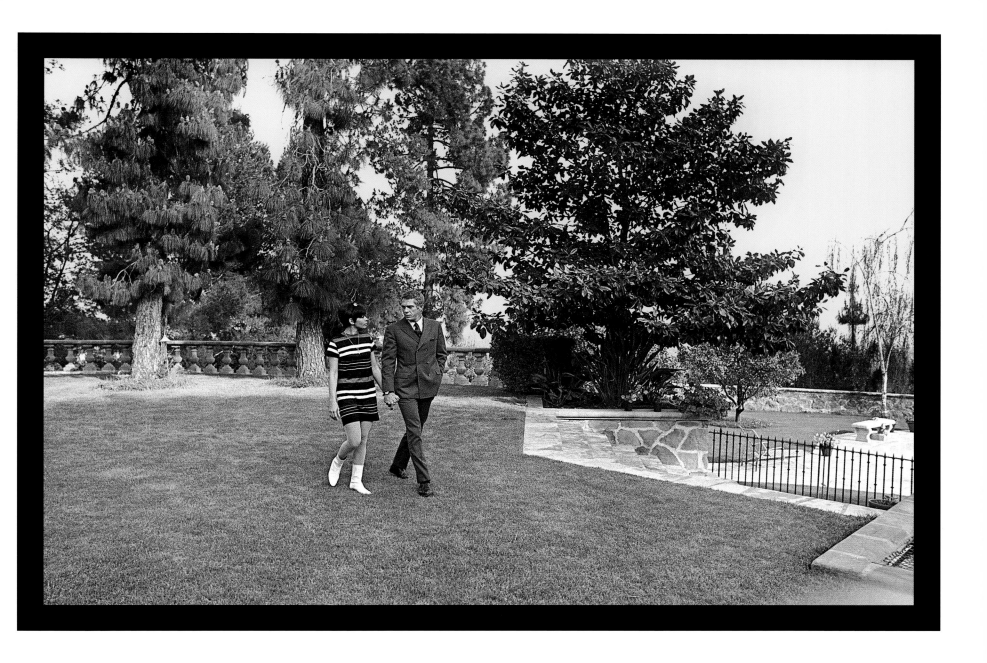

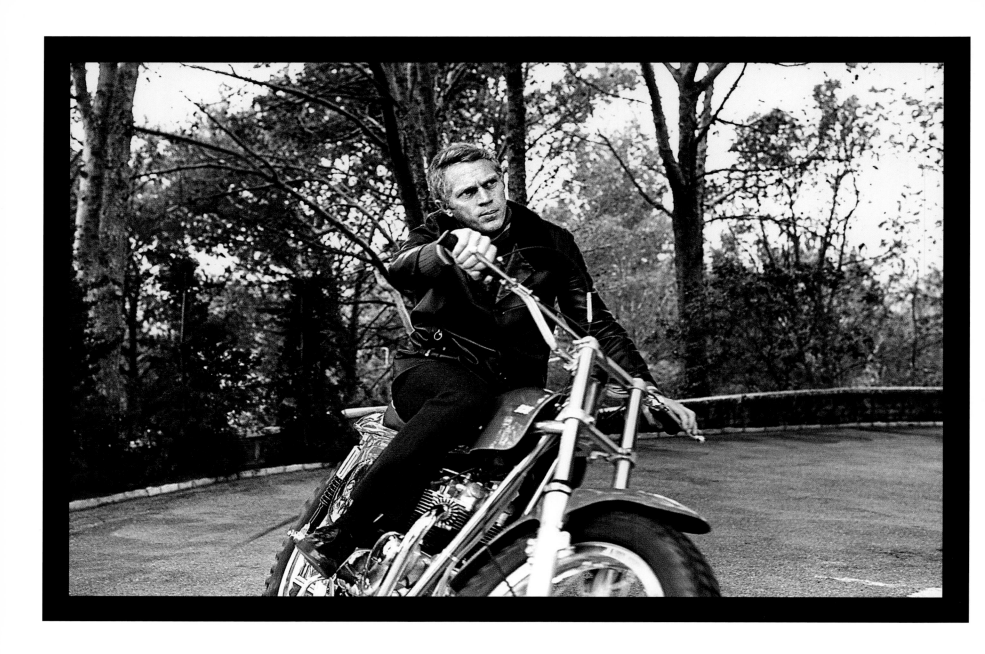

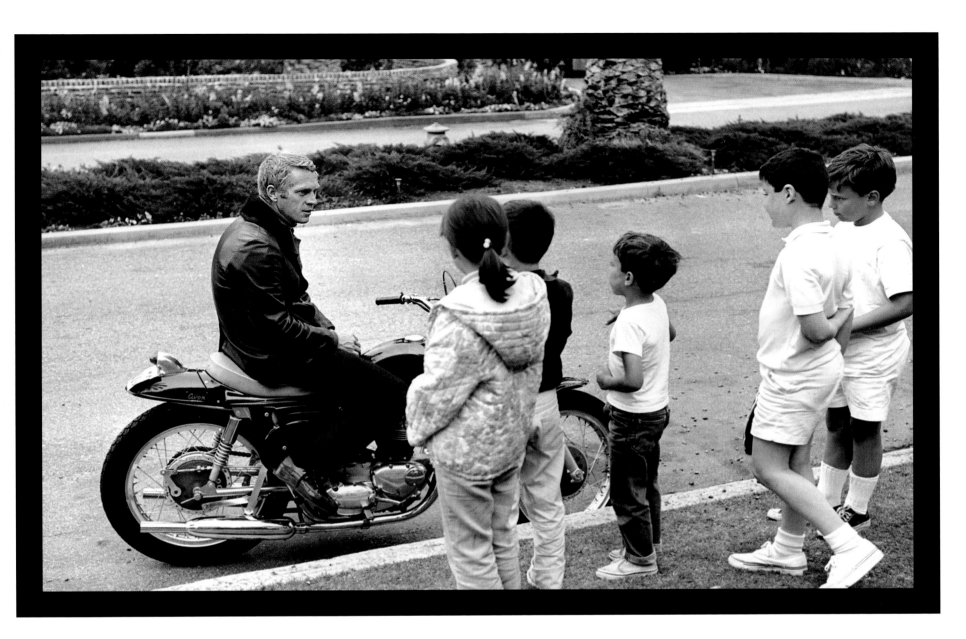

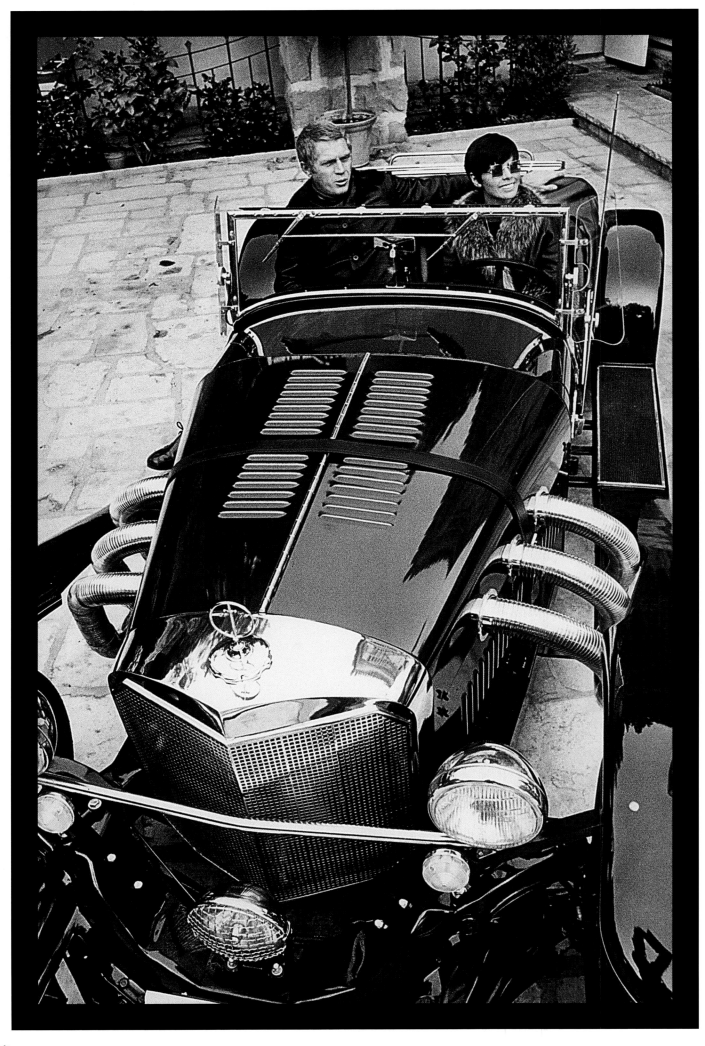

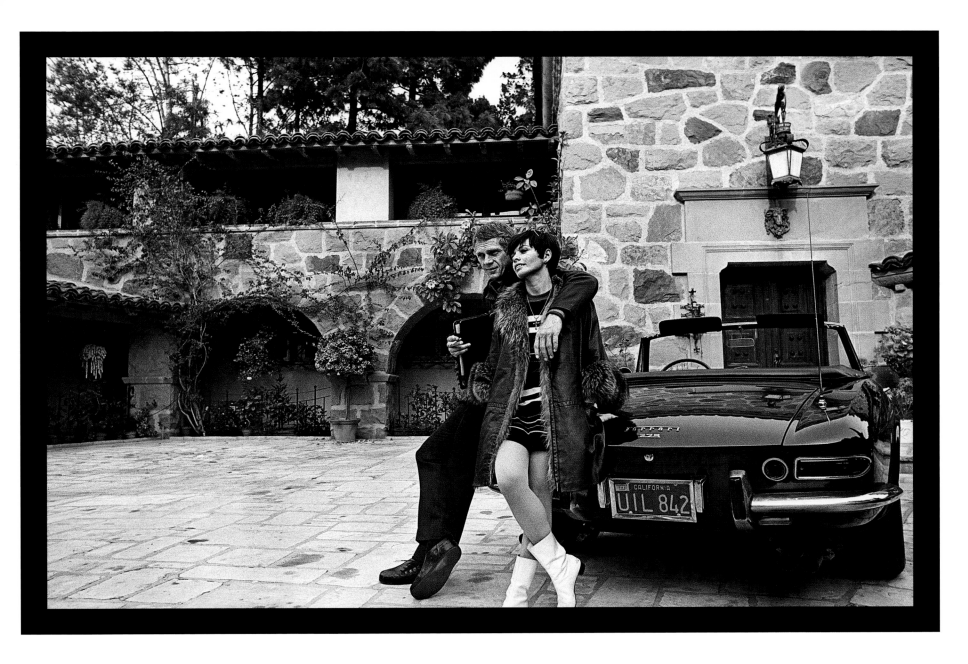

AUTO RACING HAS DIGNITY.
BUT YOU NEED
THE SAME ABSOLUTE CONCENTRATION.
YOU HAVE TO REACH INSIDE YOURSELF
AND BRING FORTH
A LOT OF BROKEN GLASS.

STEVE MCQUEEN

IL Y A DE LA DIGNITE DANS LE SPORT AUTOMOBILE.
MAIS CELA REQUIERT UNE CONCENTRATION TOTALE.
IL FAUT ALLER AU PLUS PROFOND DE SOI ET
PANSER TOUTES SES PLAIES INTERIEURES.

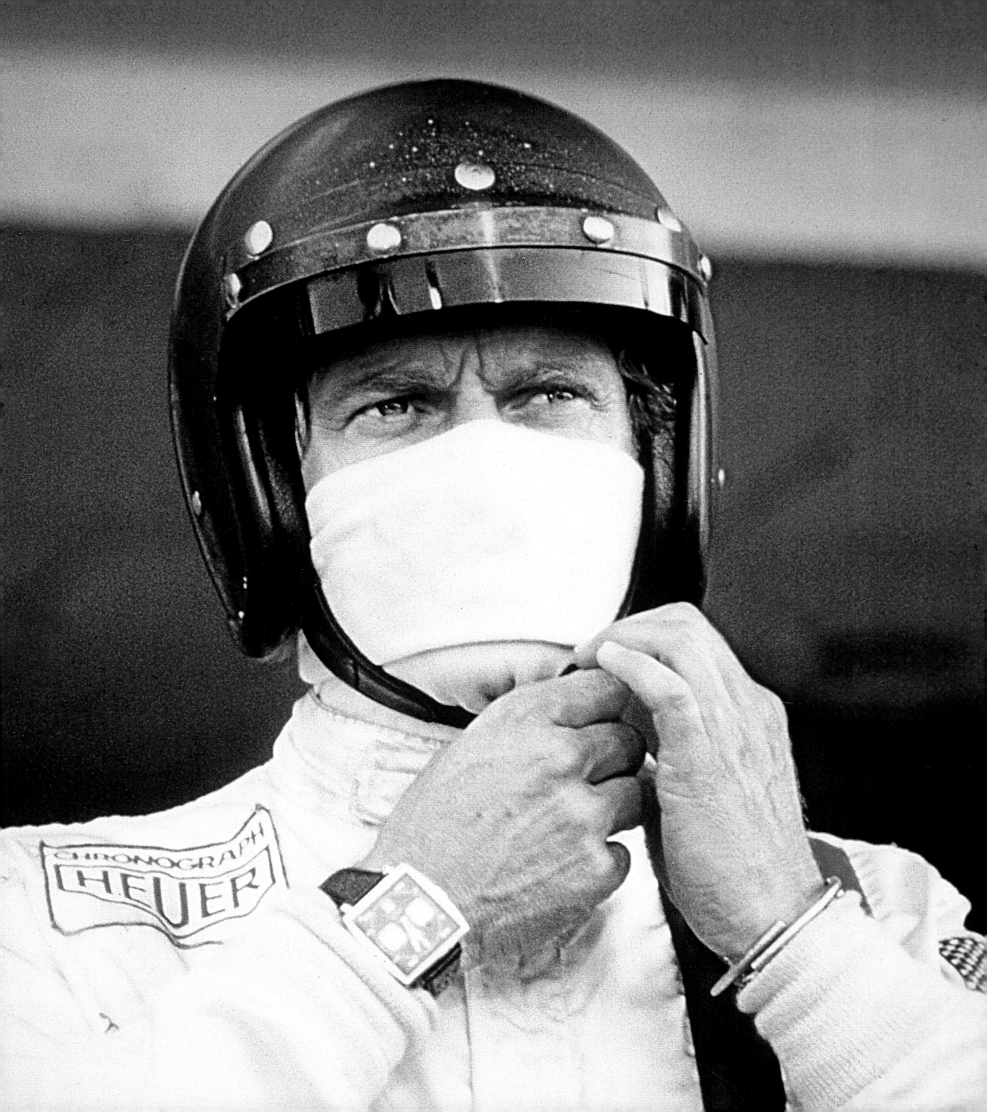

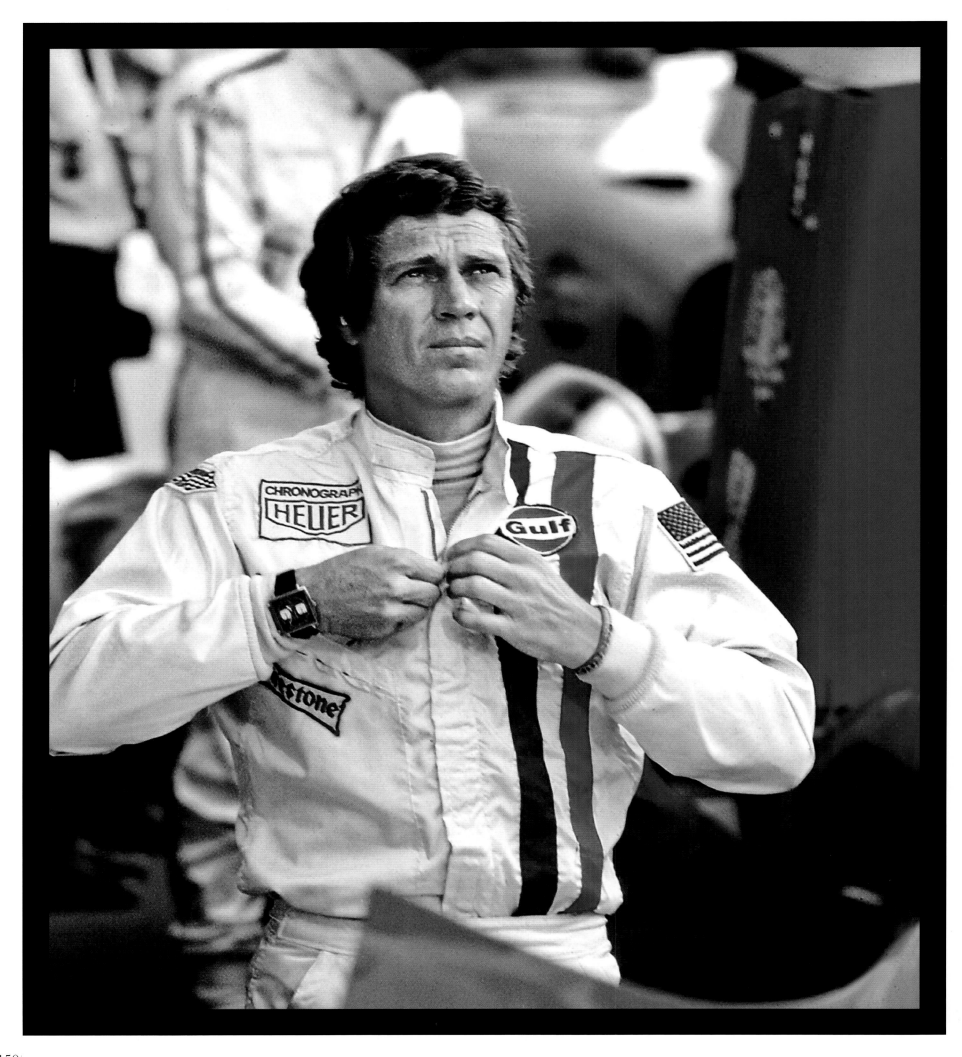

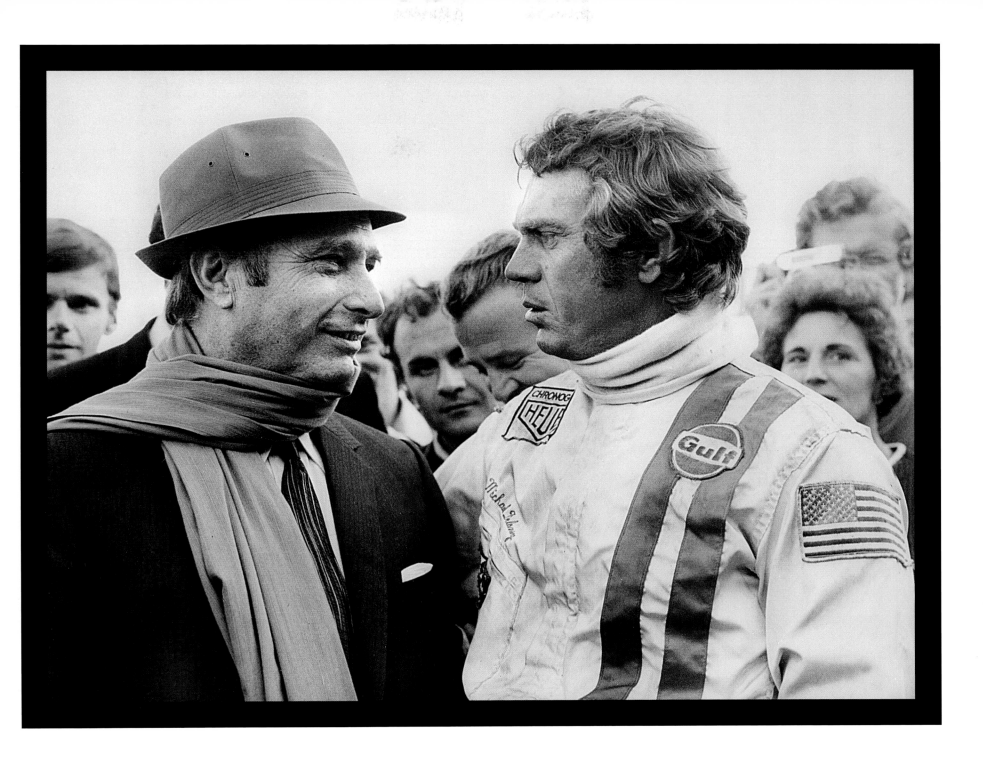

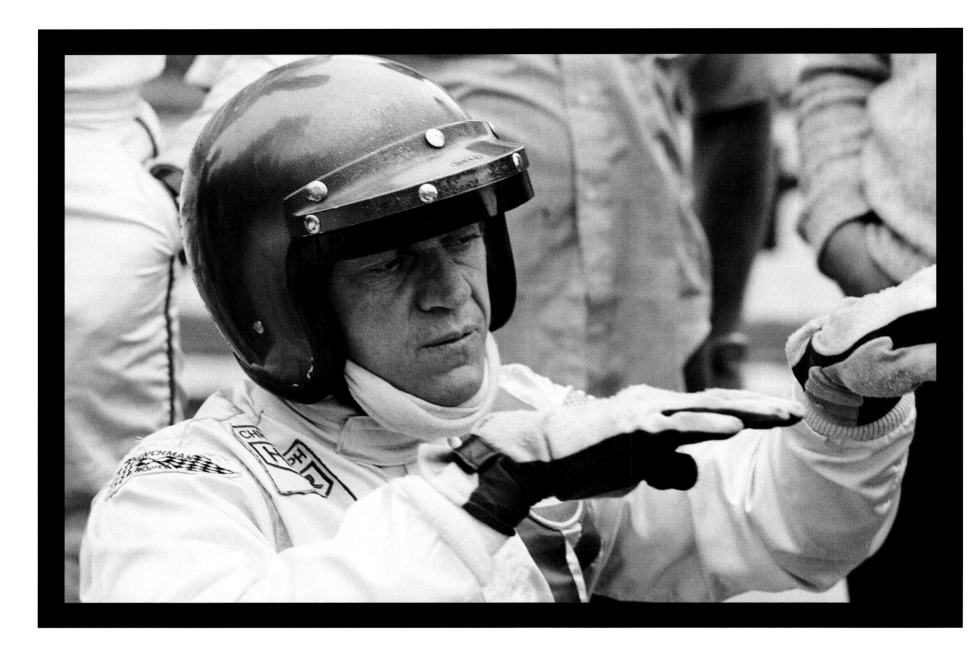

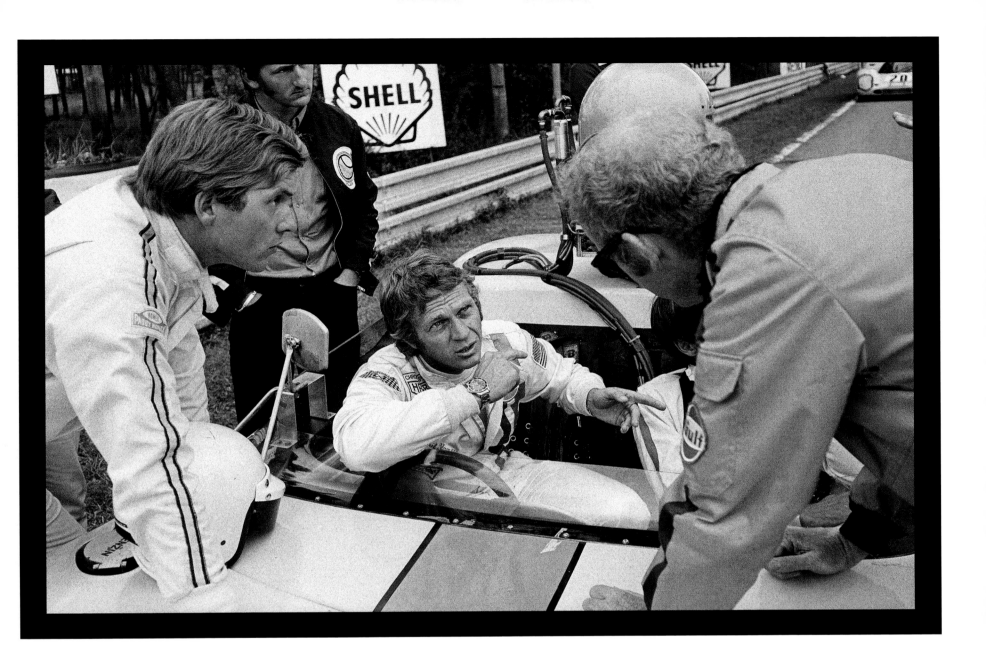

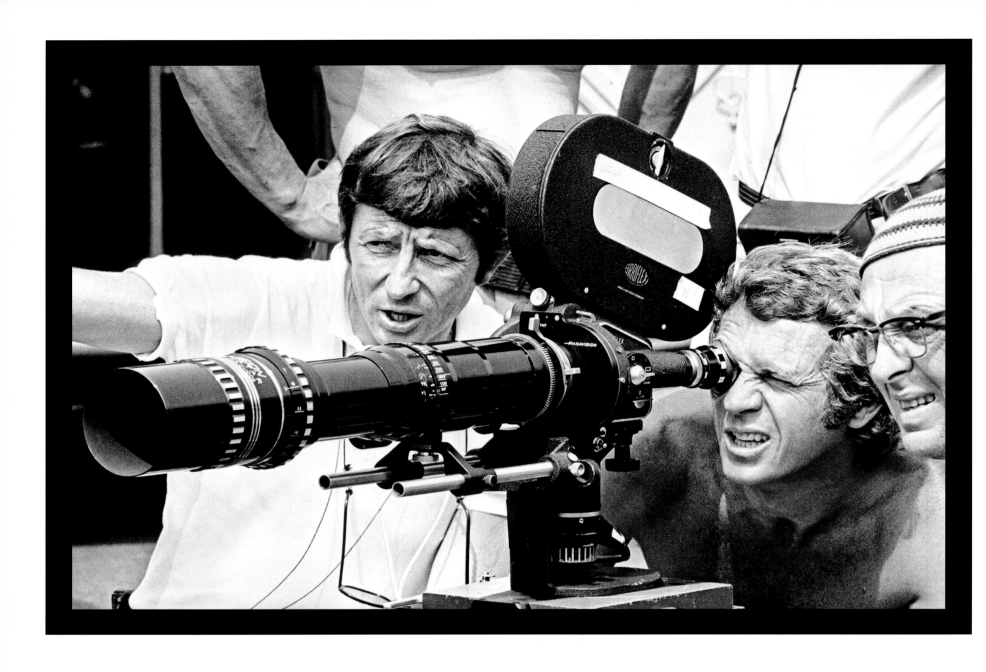

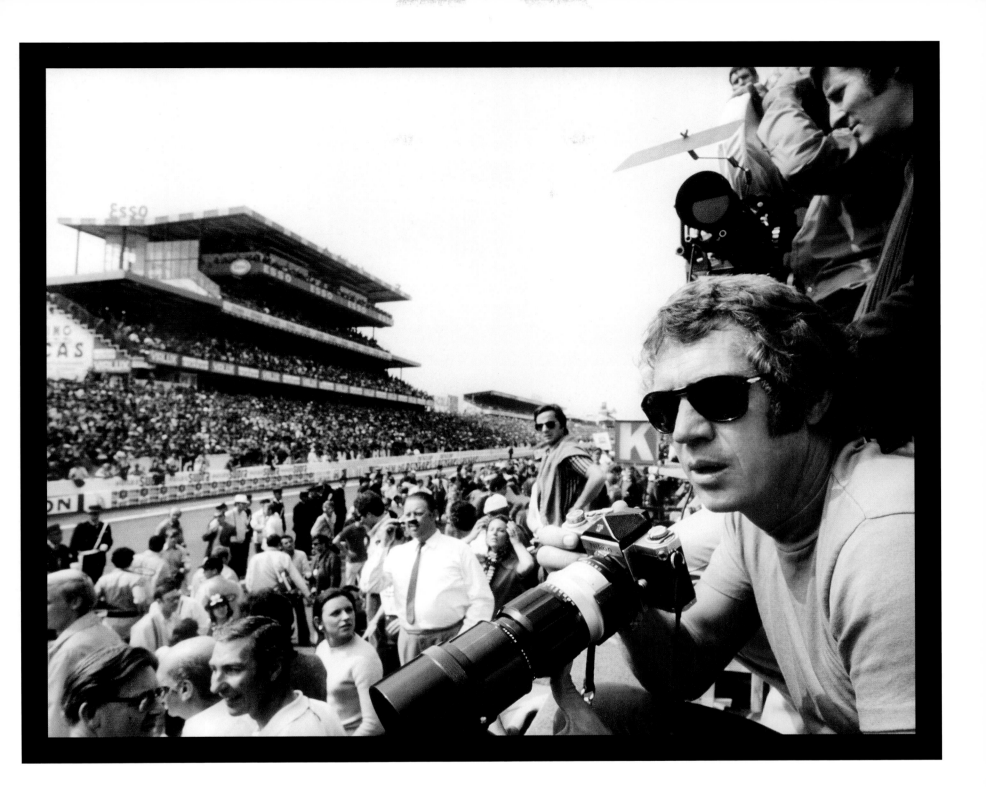

155

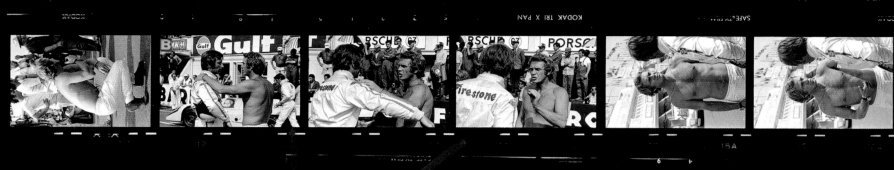

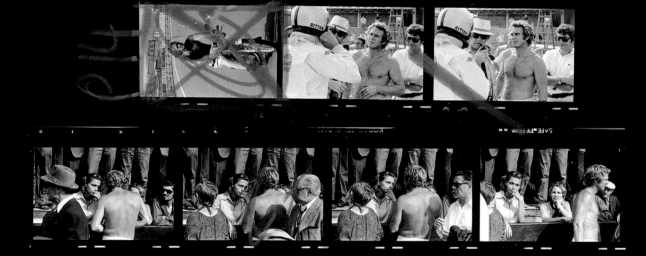

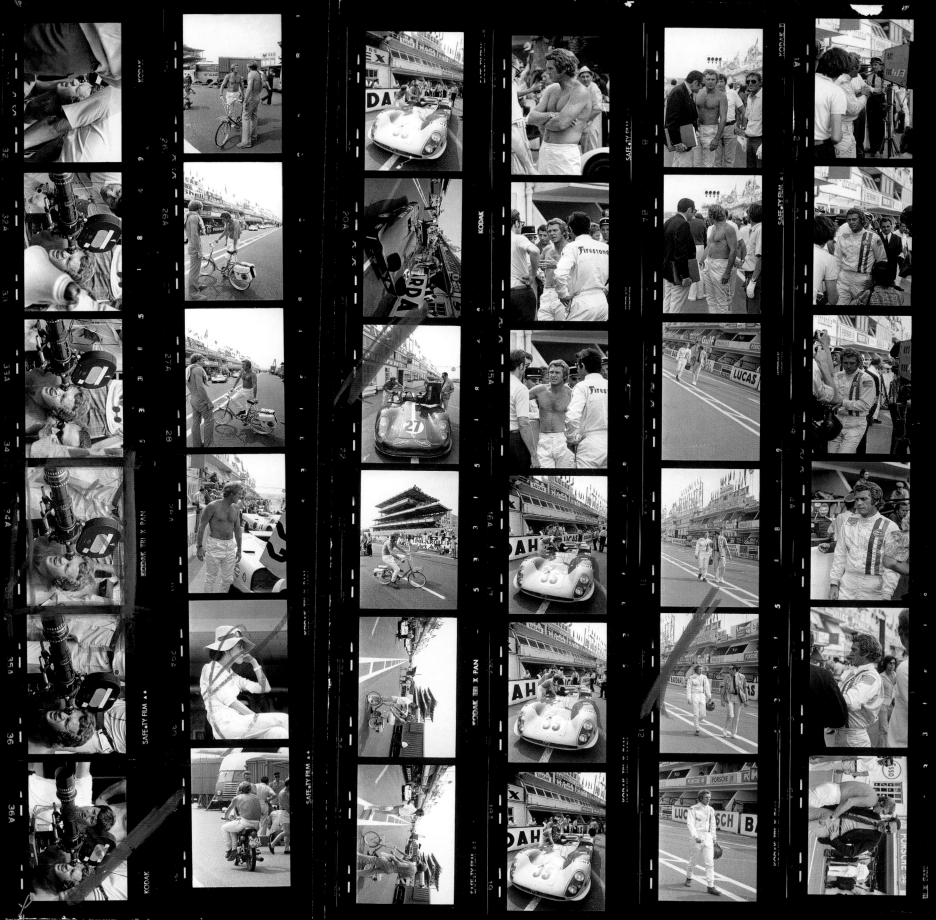

RACING IS LIFE. ANYTHING BEFORE OR AFTER IS JUST WAITING.

STEVE MCQUEEN

LA COURSE, C'EST LA VIE. AVANT ET APRES, CE N'EST QUE DE L'ATTENTE.

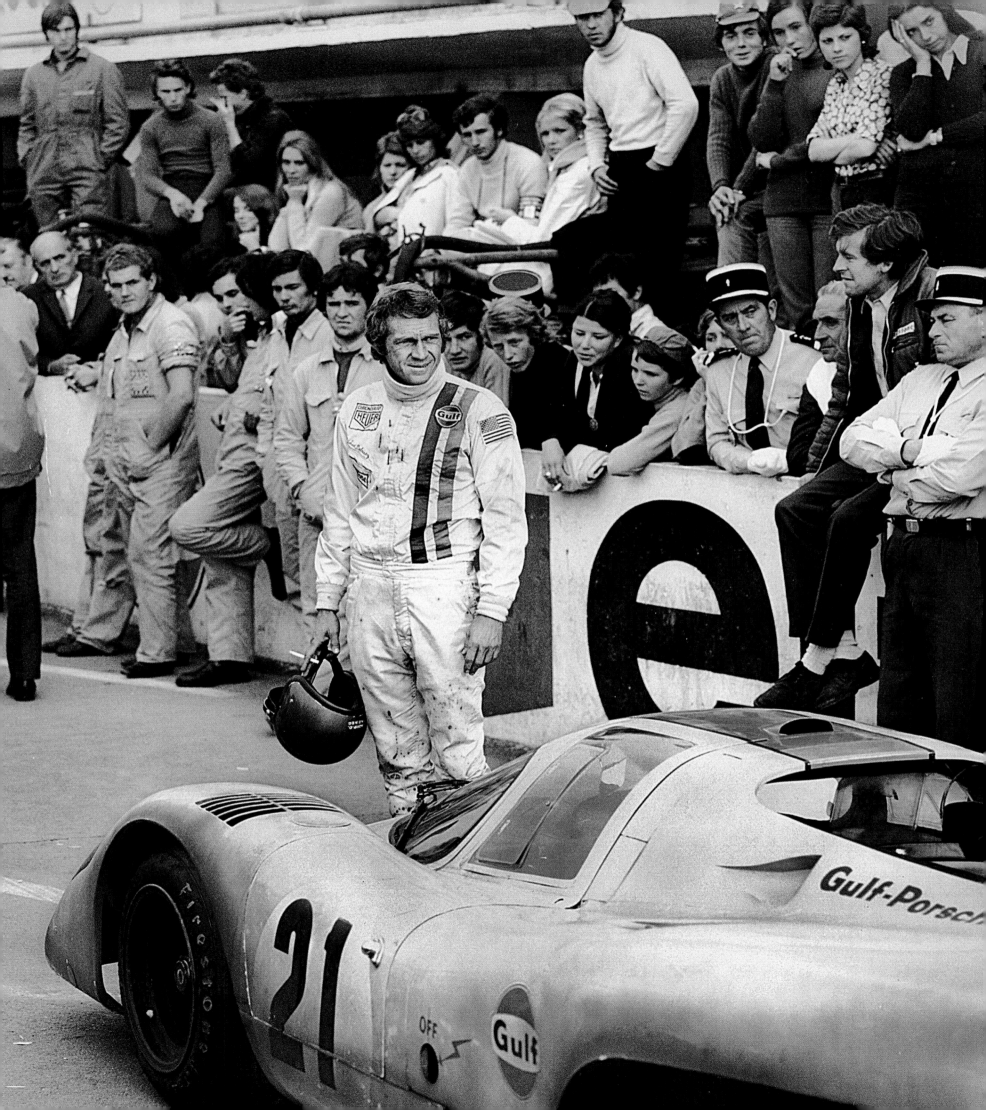

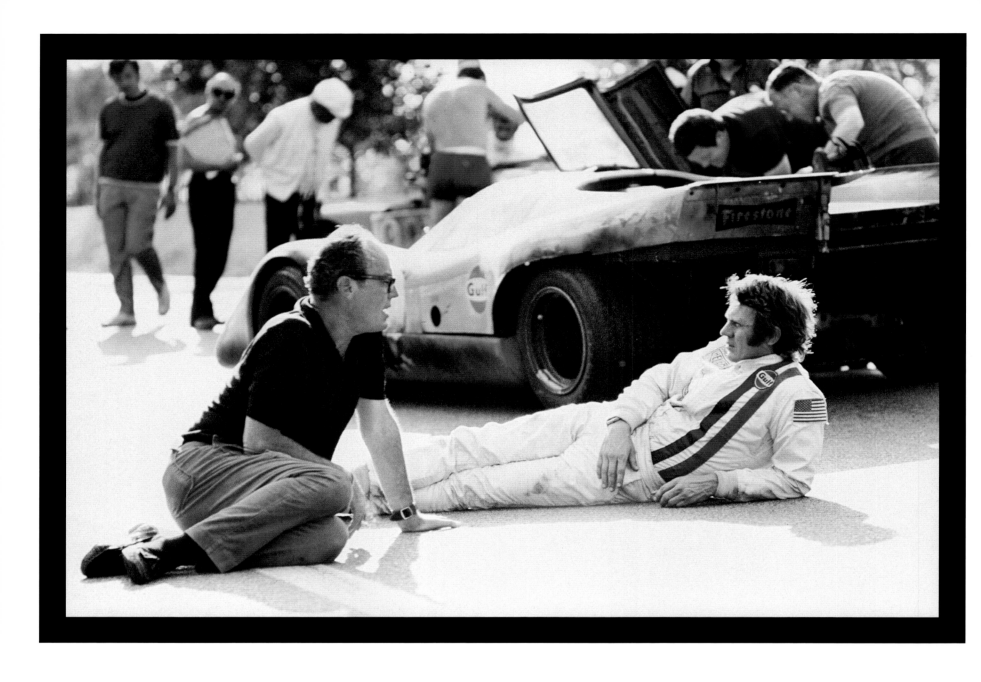

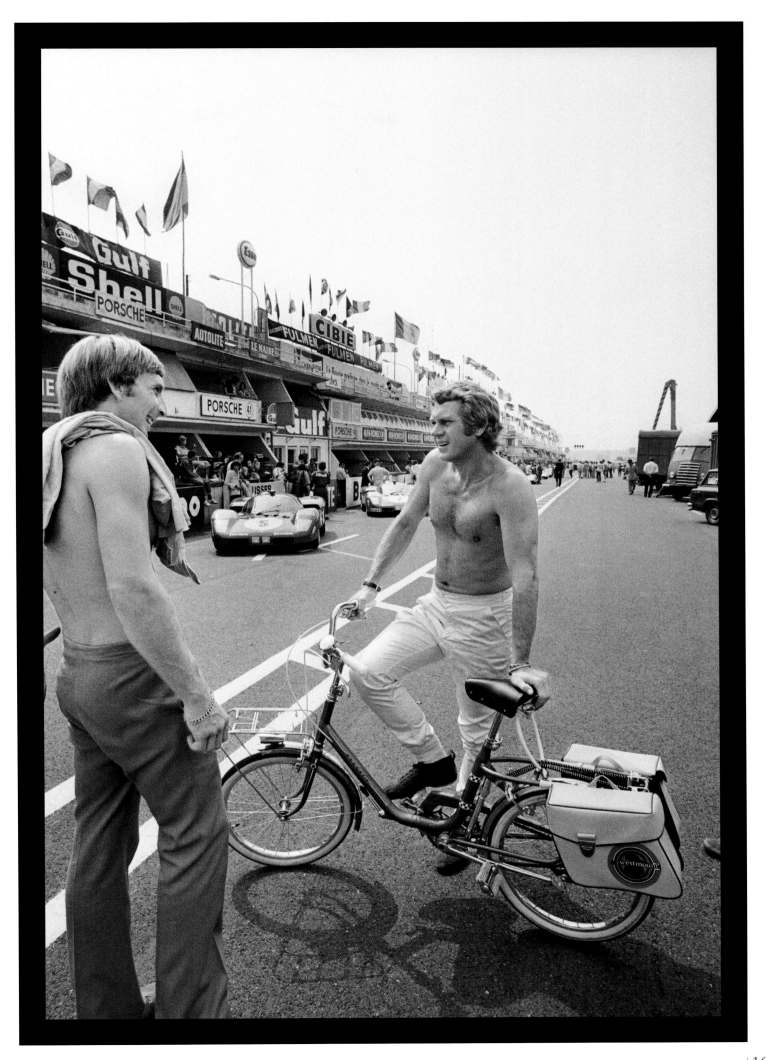

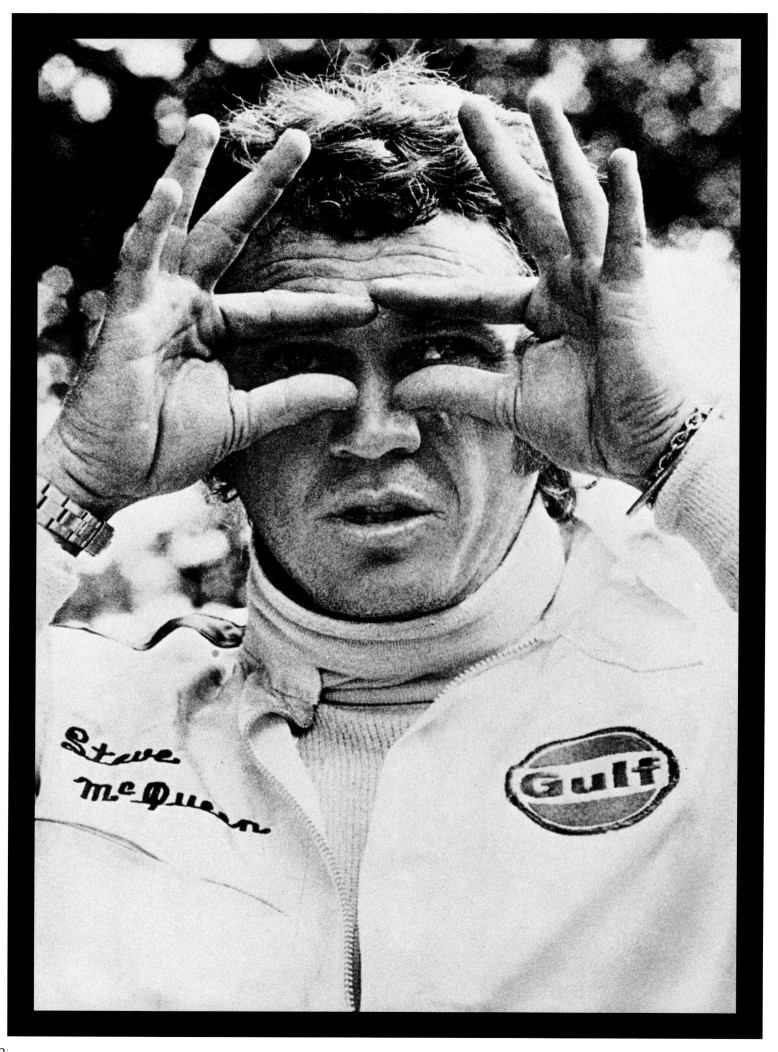

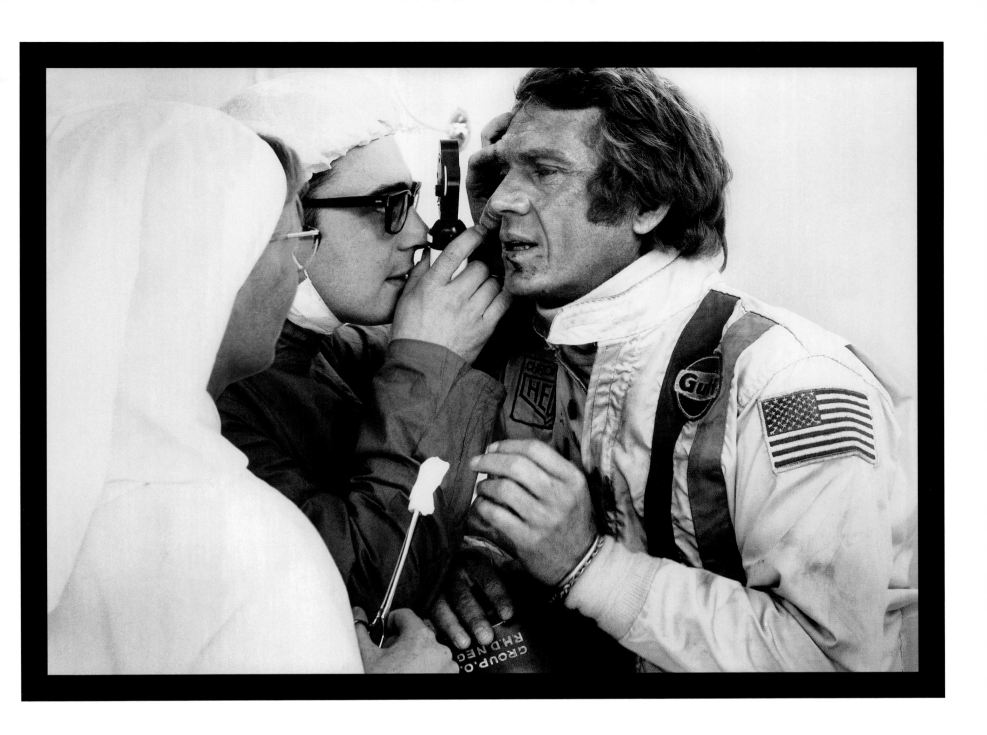

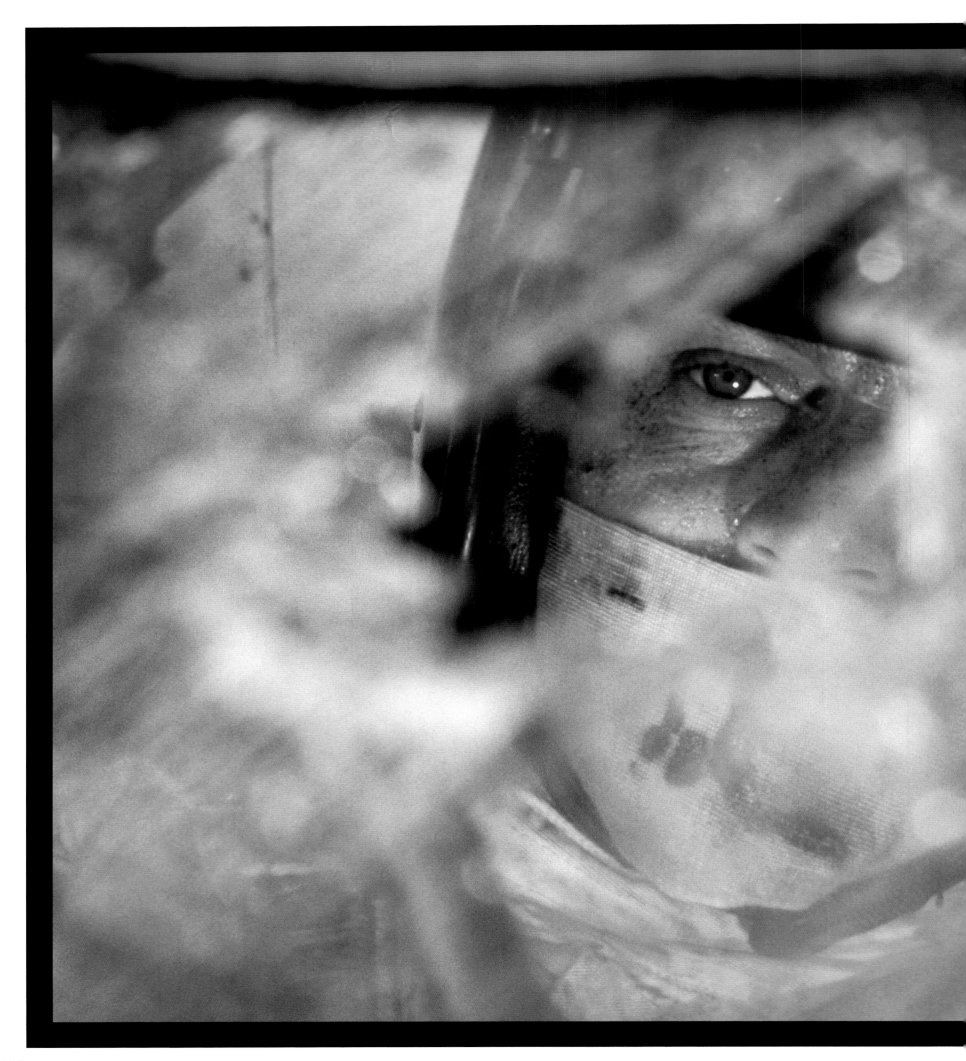

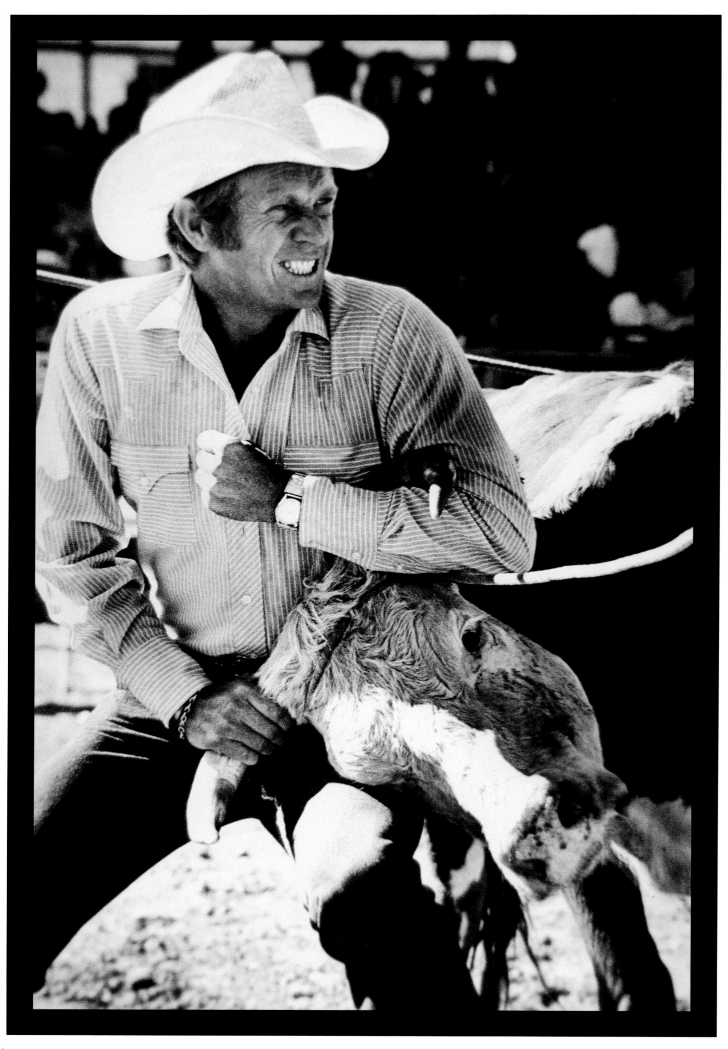

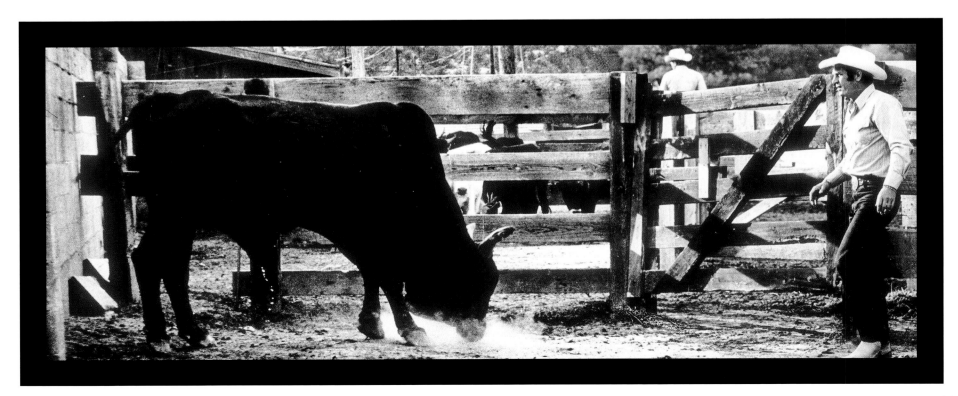

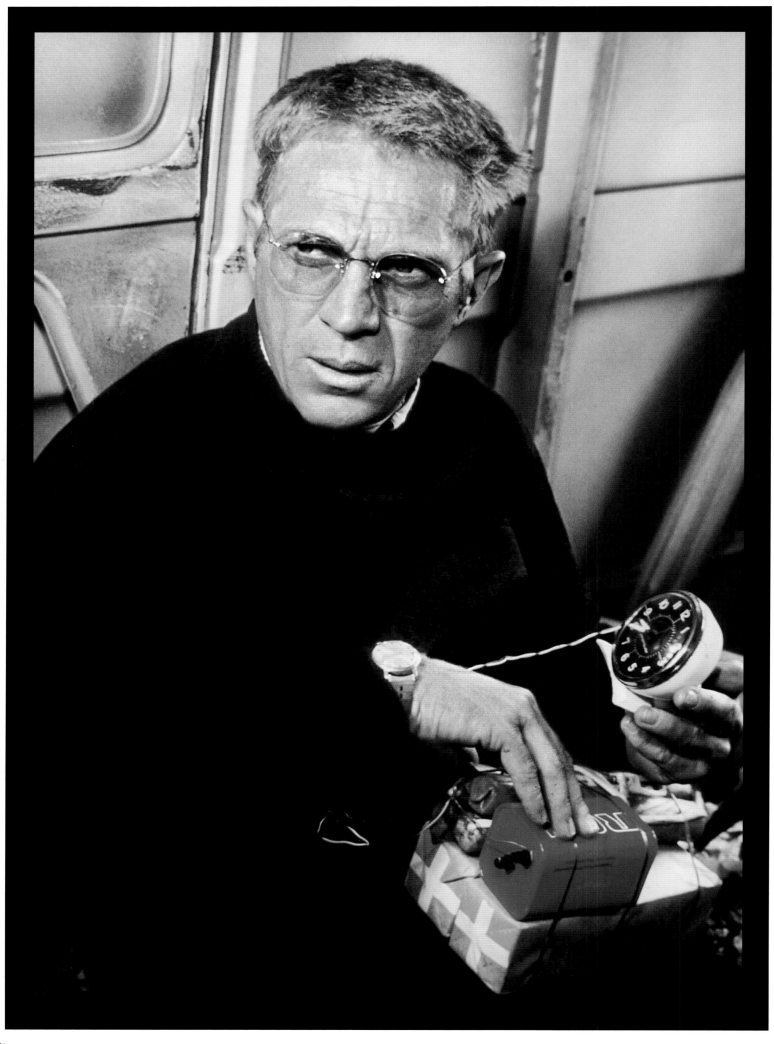

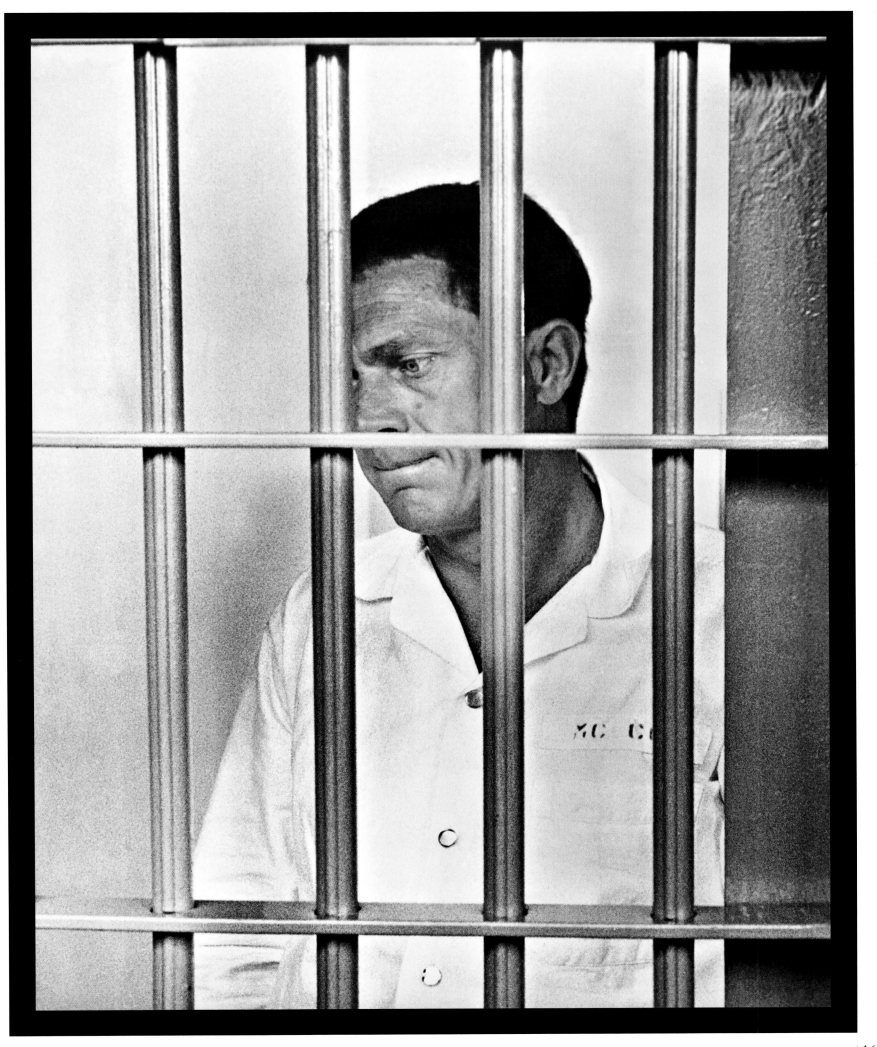

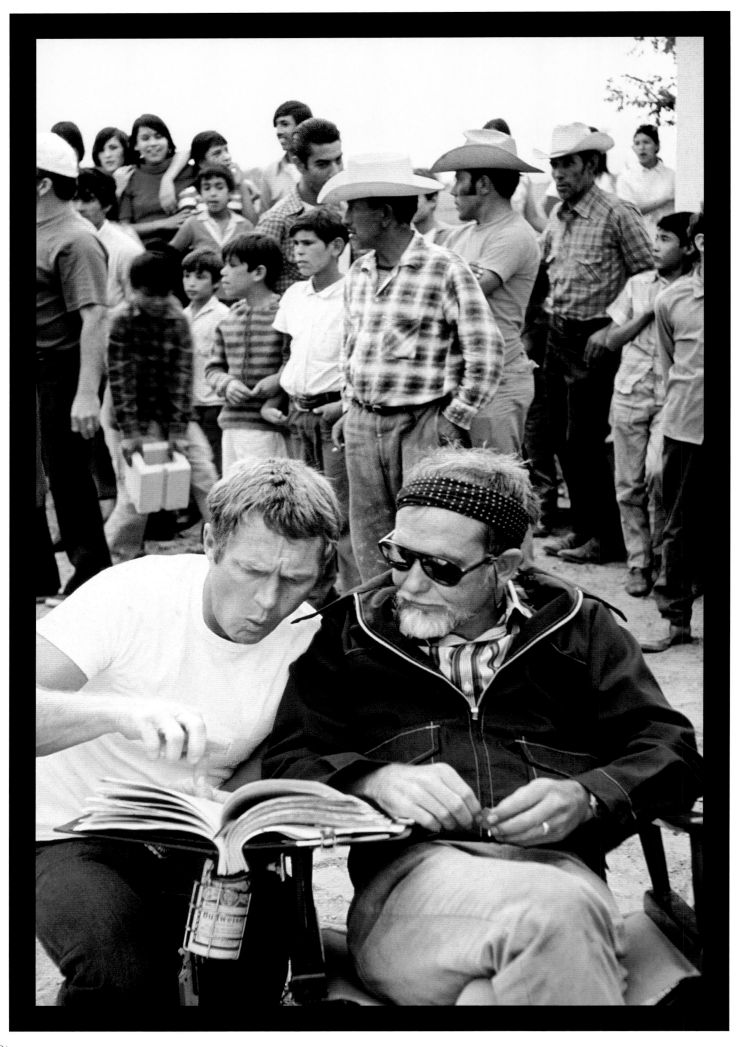

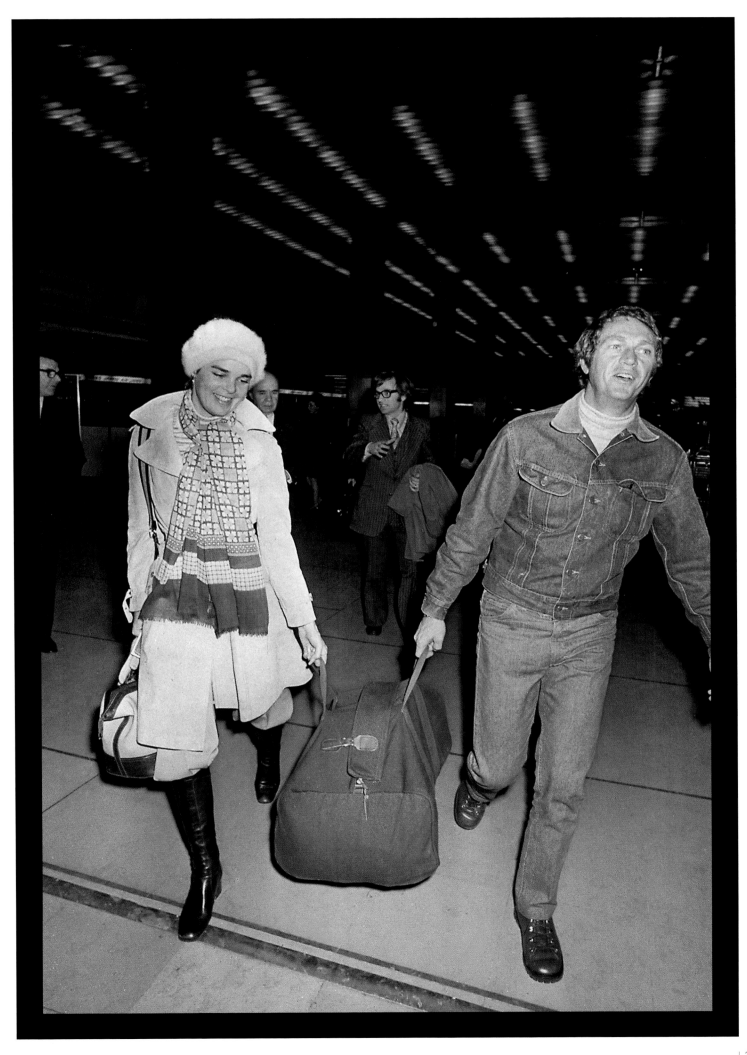

I'M OUT OF THE MIDWEST
IT WAS A GOOD PLACE
TO COME FROM
IT GIVES YOU A SENSE OF RIGHT
OR WRONG AND FAIRNESS
WHICH IS LACKING IN OUR SOCIETY

STEVE MCQUEEN

JE VIENS DU MIDWEST.
C'EST UN BON ENDROIT POUR GRANDIR,
CELA INCULQUE CE QUI EST JUSTE, CE QUI EST REGLO,
BREF CE QUI MANQUE CRUELLEMENT A NOTRE SOCIETE.

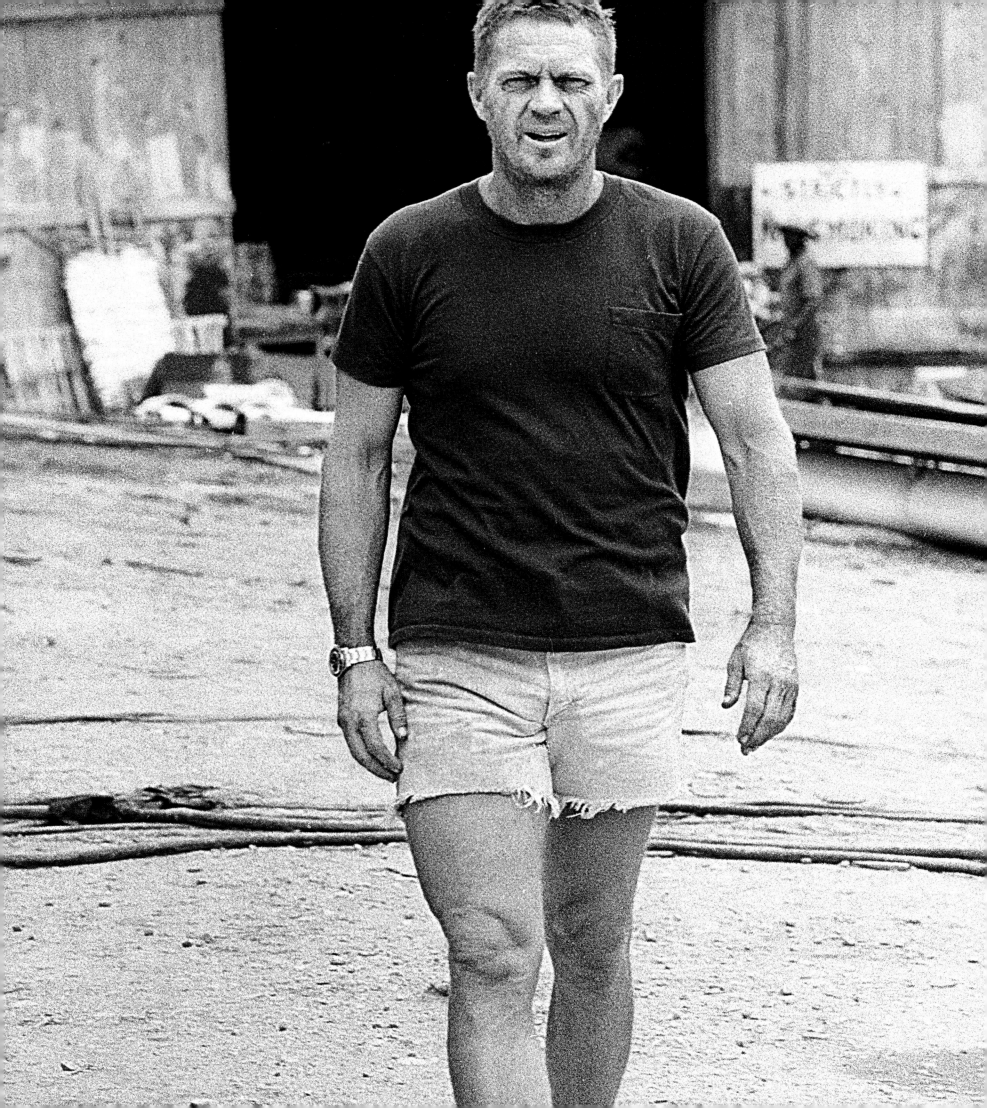

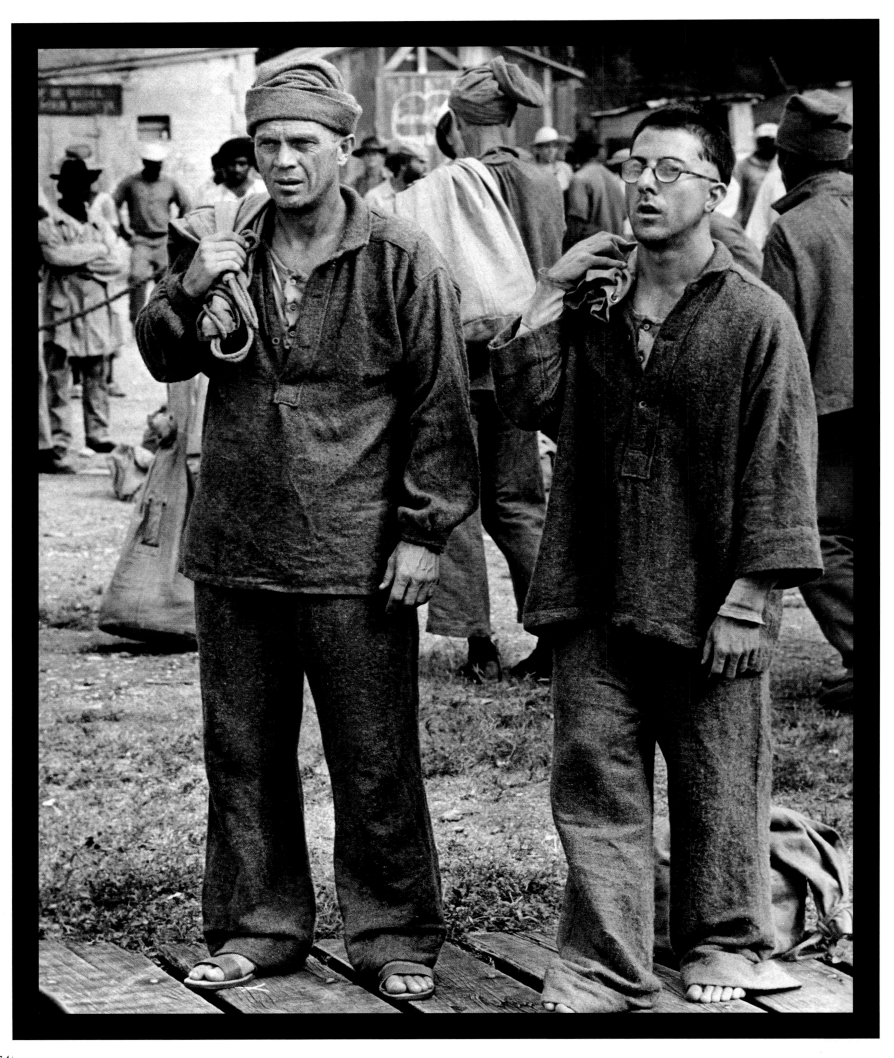

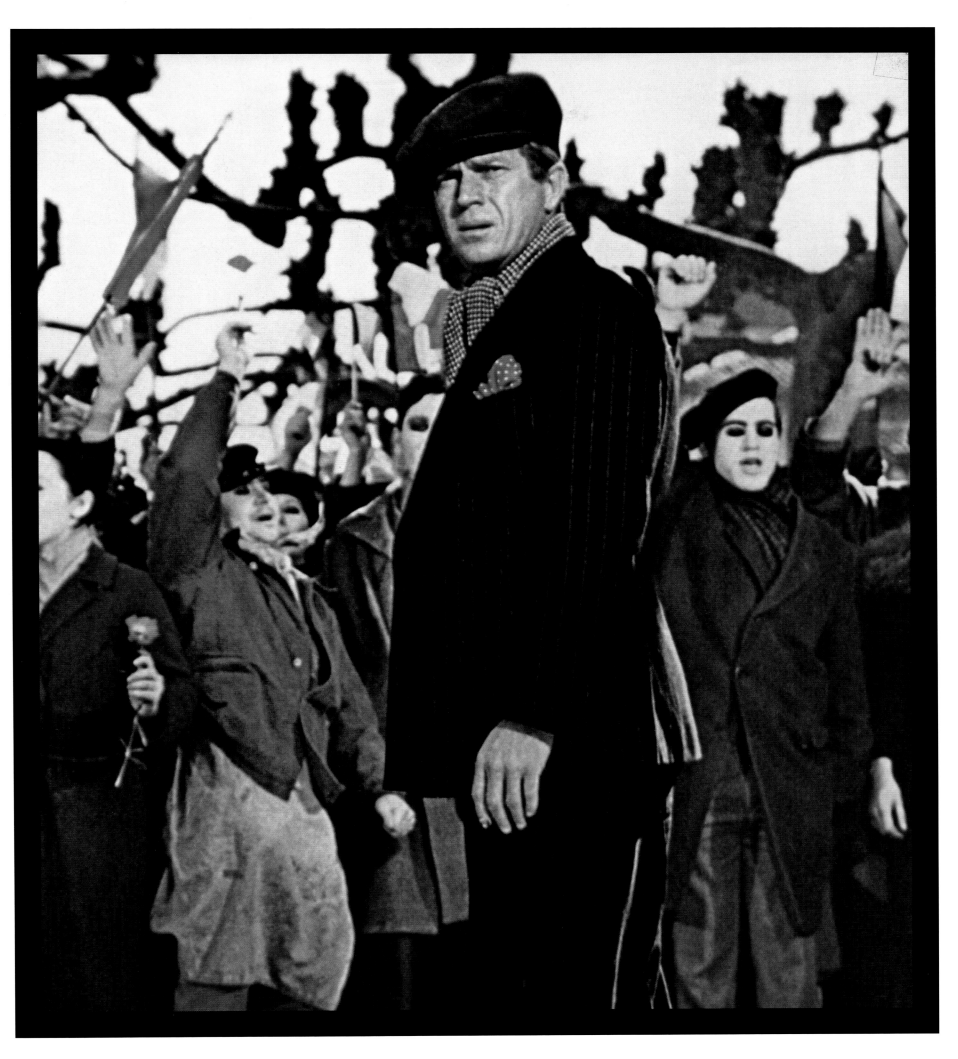

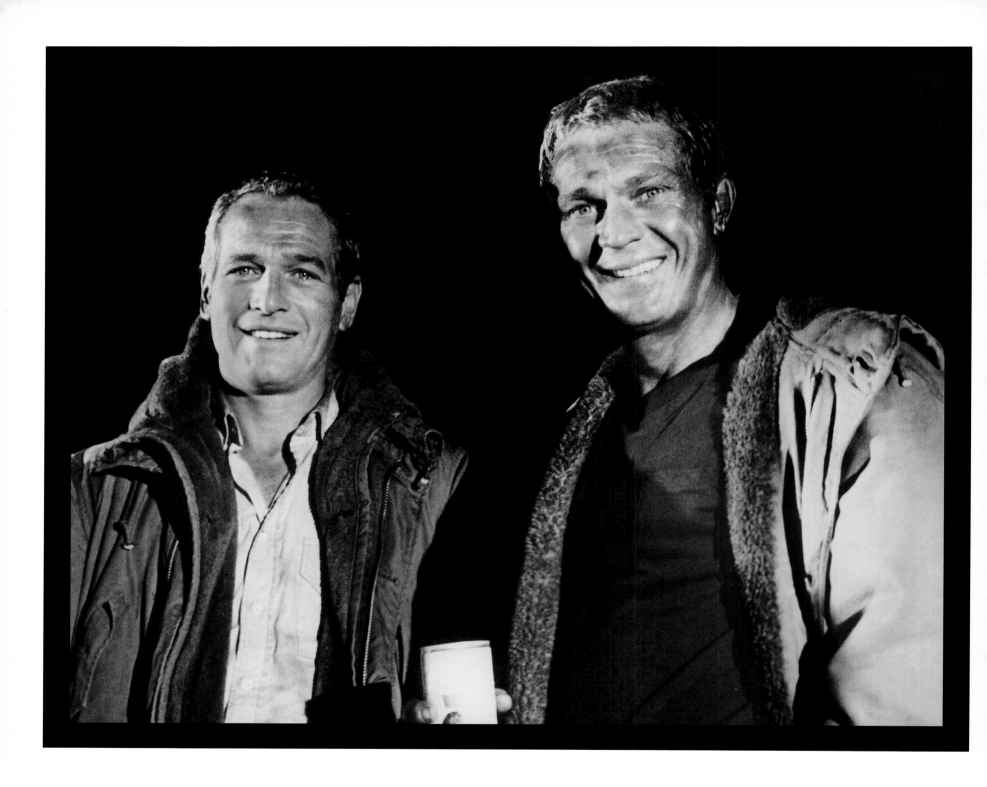

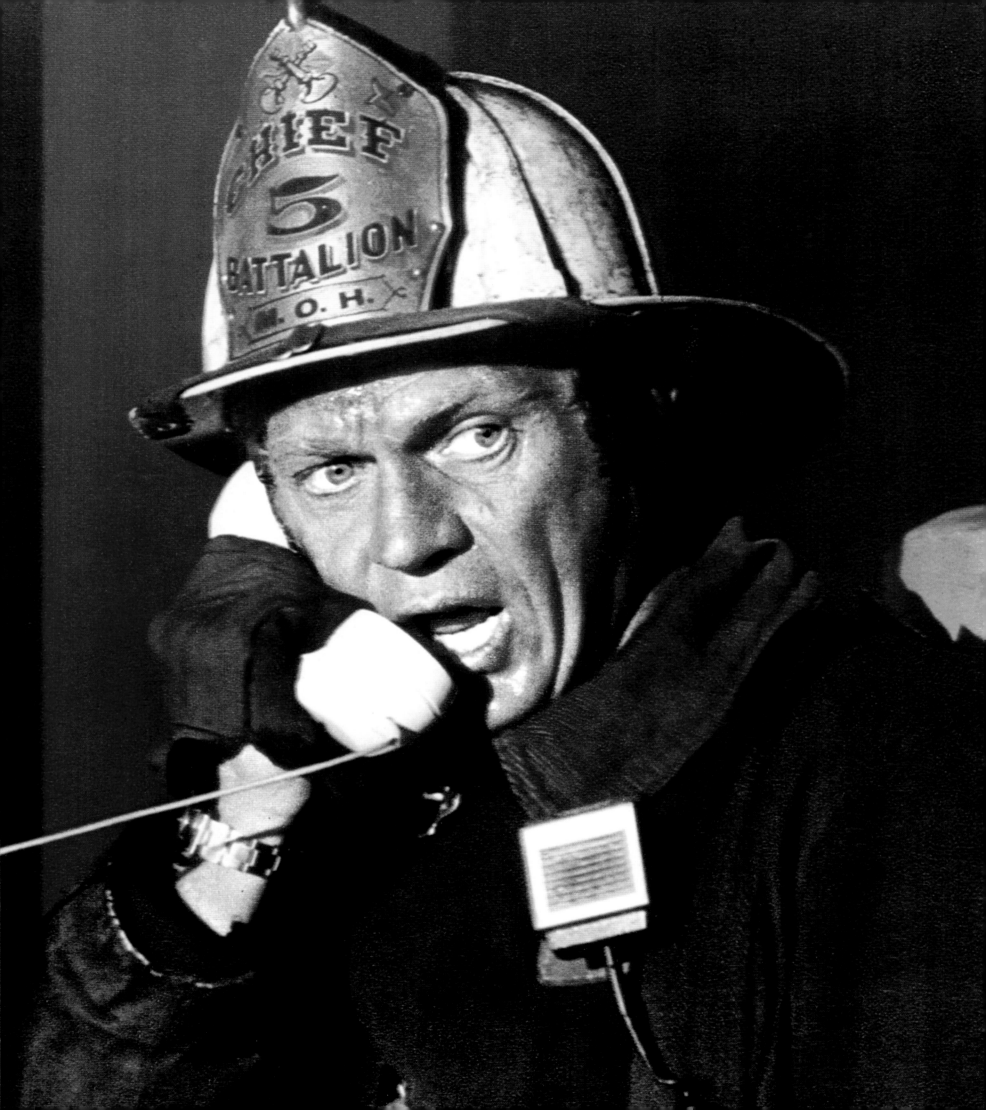

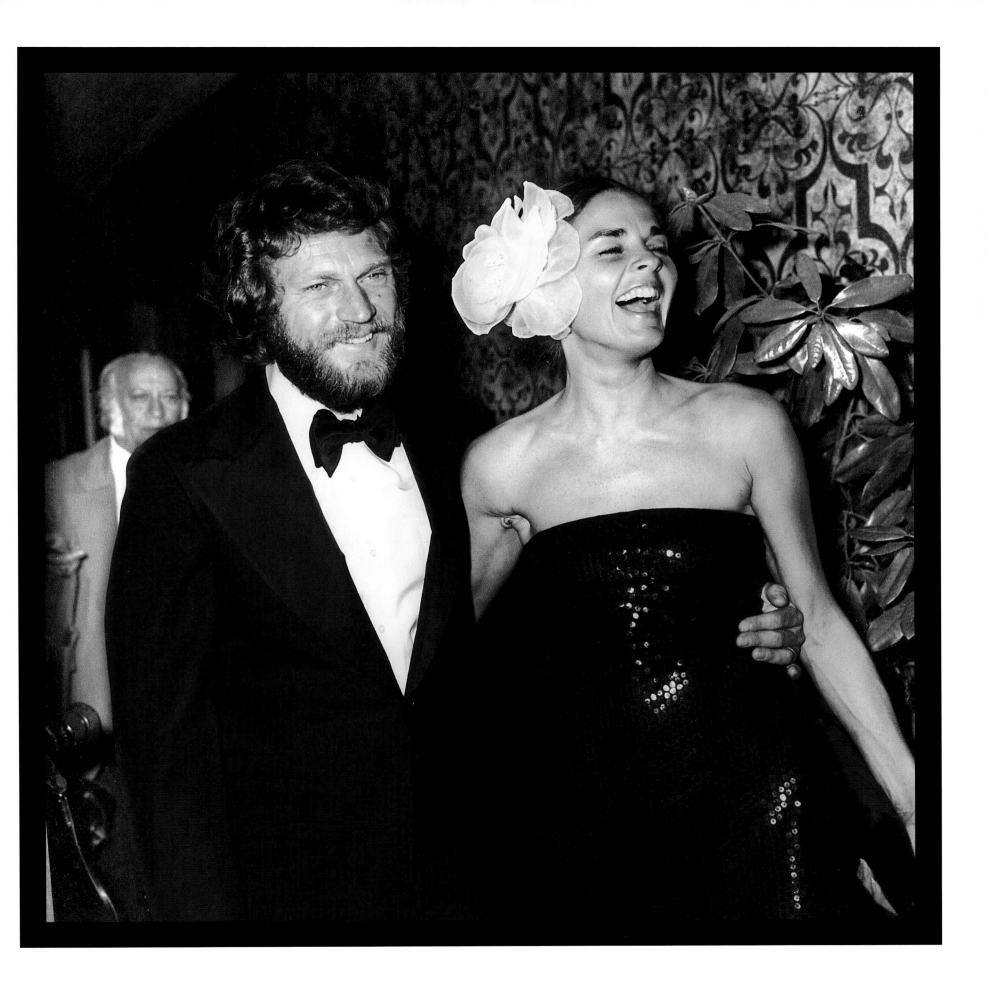

AN ACTOR IS A PUPPET,
MANIPULATED BY A DOZEN OTHER PEOPLE.

STEVE MCQUEEN

UN ACTEUR N'EST QU'UNE POUPEE MANIPULEE PAR
UNE DOUZAINE D'AUTRES PERSONNES.

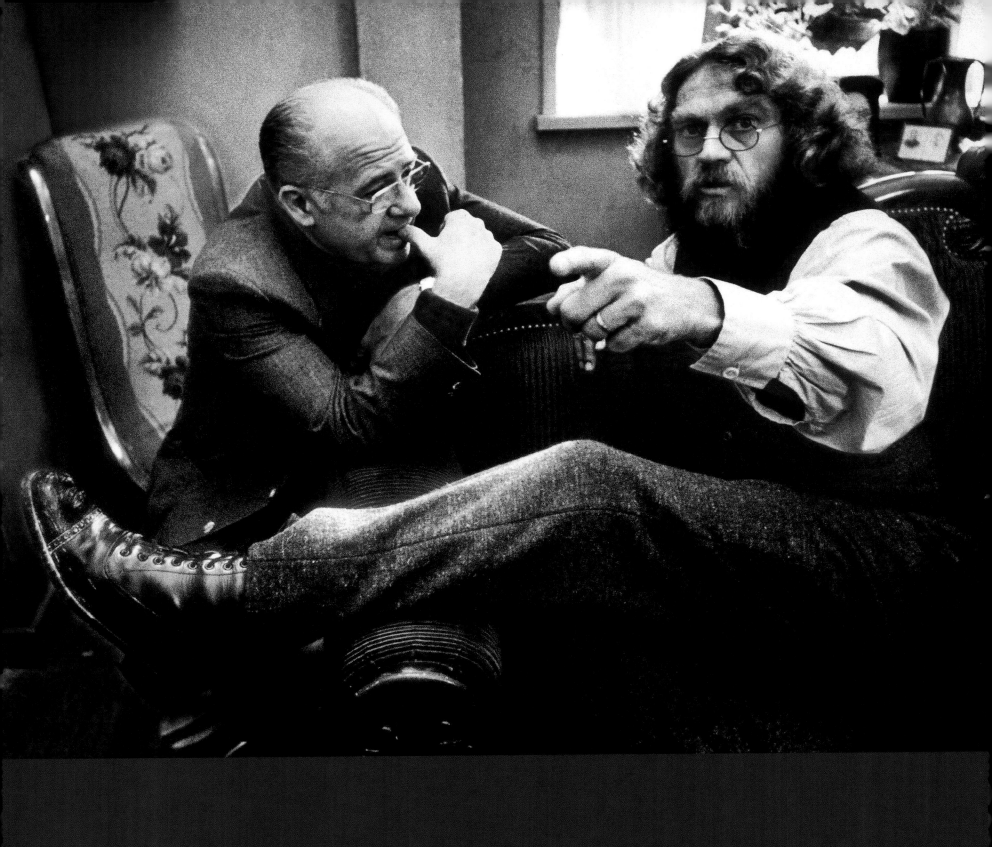

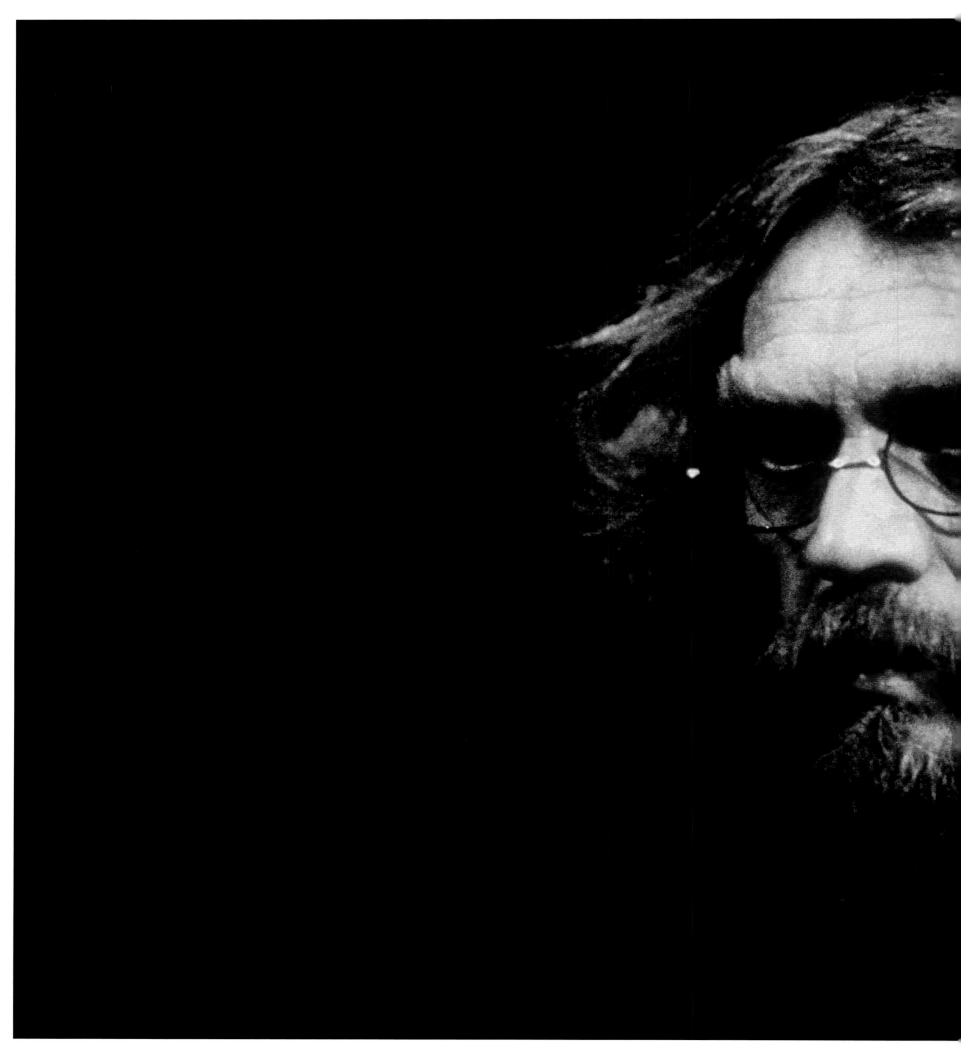

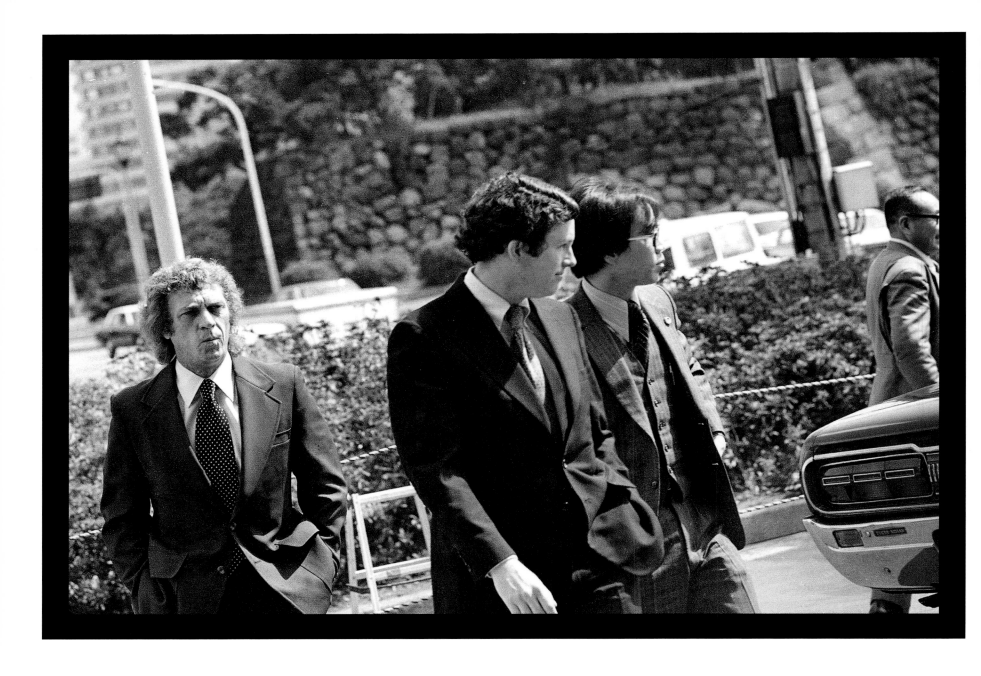

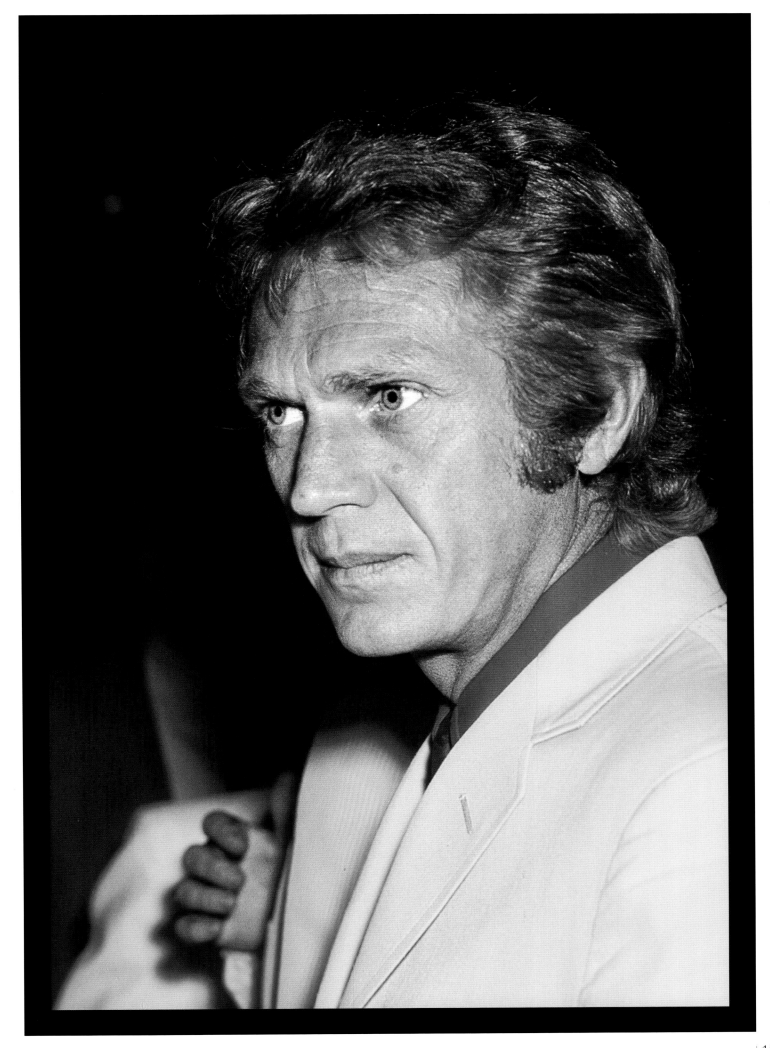

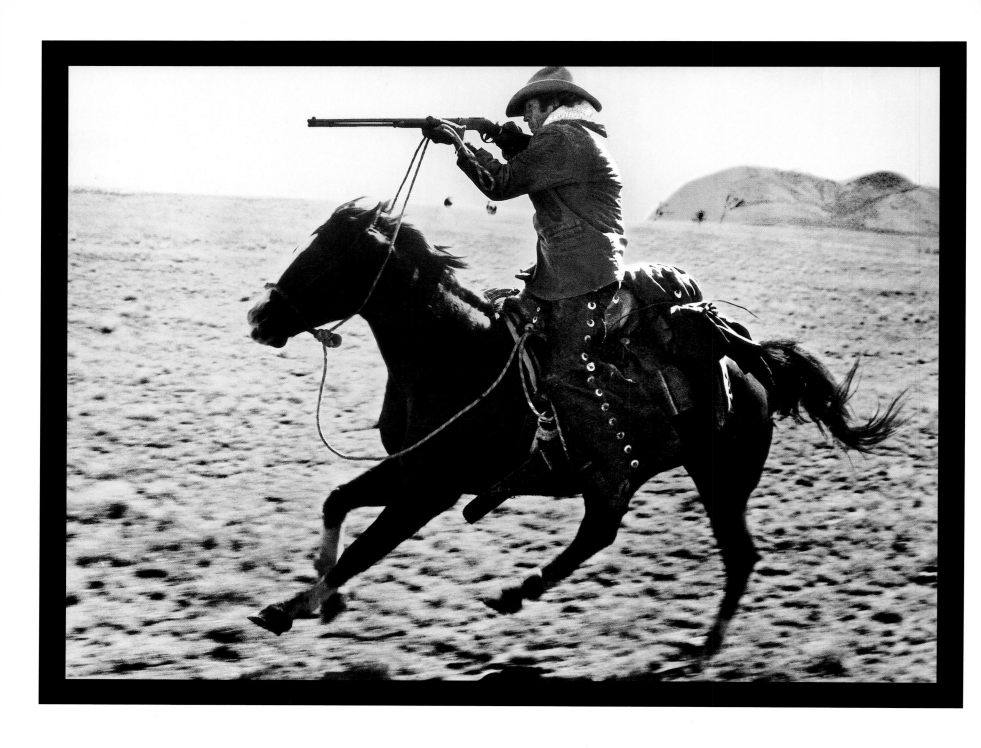

Le jour où ils voulurent
"prendre" Tom HORN,
ils n'étaient pas
assez nombreux.

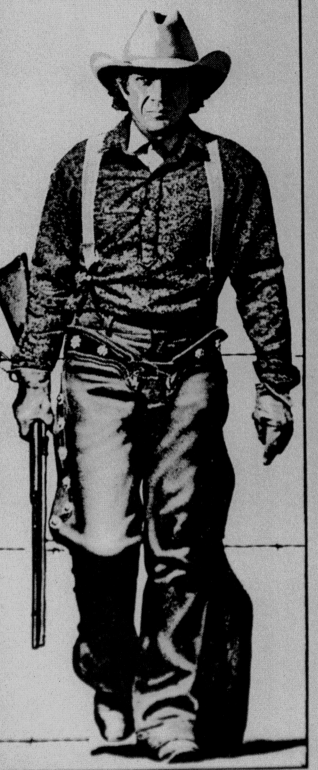

STEVE McQUEEN
DANS
TOM HORN
... Sa Véritable Histoire

First Artists présente
STEVE McQUEEN dans "TOM HORN"
Une Production de SOLAR-FRED WEINTRAUB
Musique de ERNEST GOLD
Directeur de la Photographie JOHN ALONZO A.S.C.
Producteur Exécutif STEVE McQUEEN
Scénario de THOMAS McGUANE et BUD SHRAKE
Produit par FRED WEINTRAUB
Réalisé par WILLIAM WIARD

Distribué par Warner-Columbia

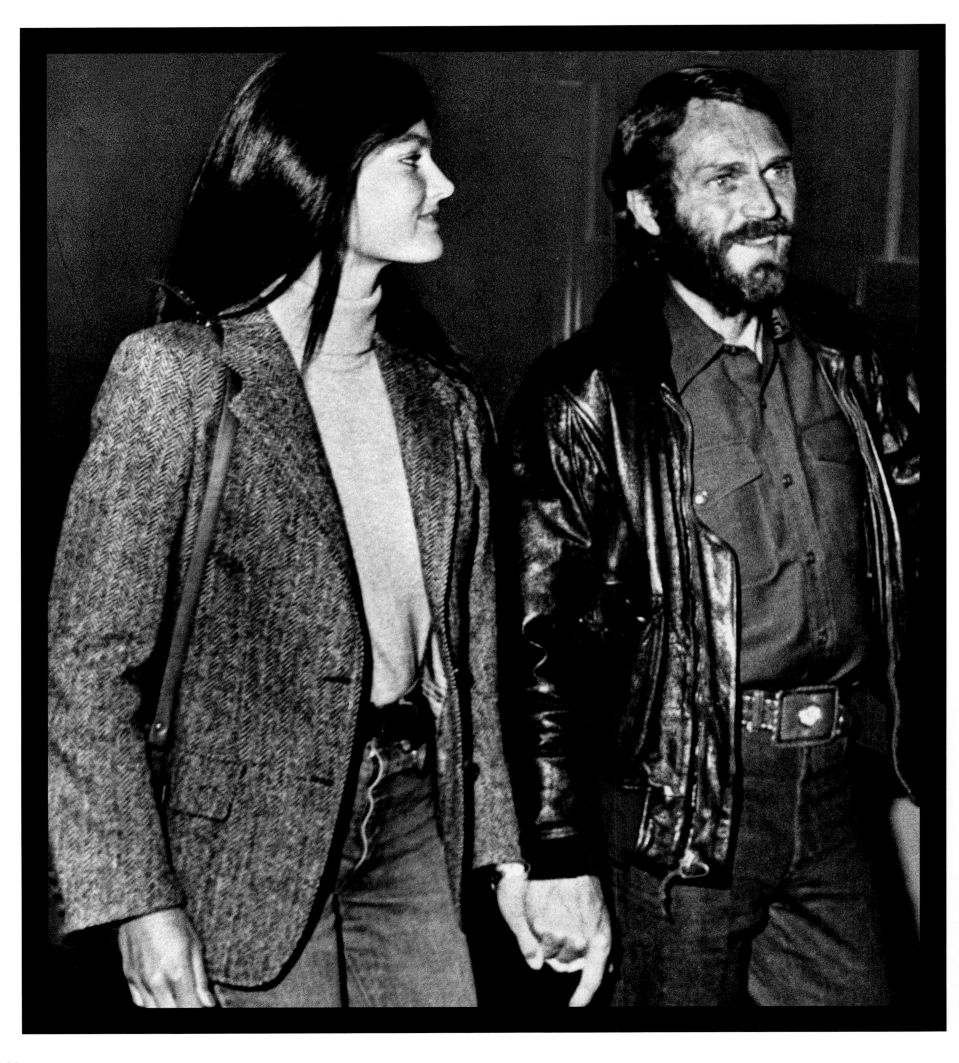

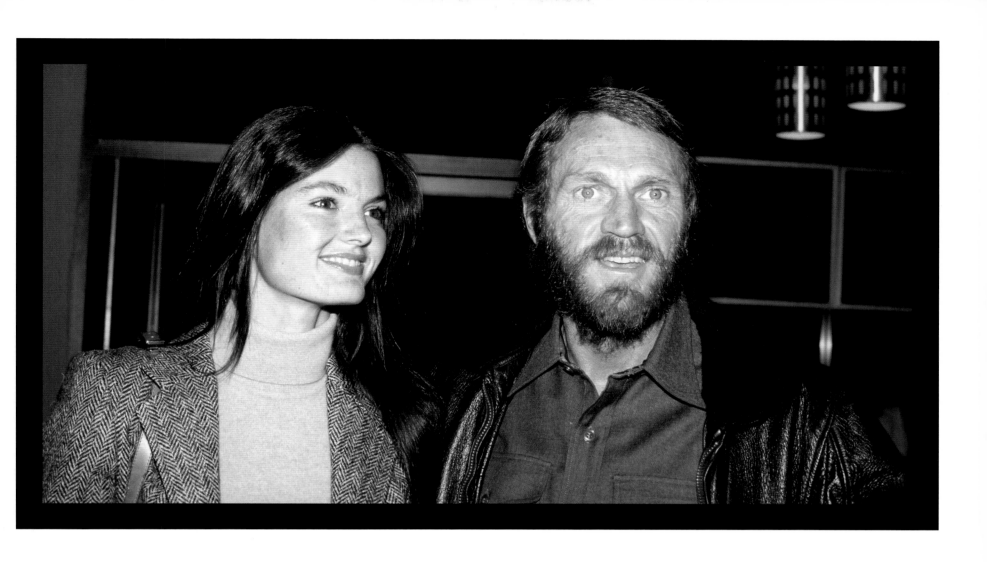

I HAD TO LEARN TO LOOK OUT FOR MYSELF WHEN I WAS A KID. I HAD NO ONE TO TALK TO. I WAS ALL ALONE. IT TAUGHT ME TO BE SELF-RELIANT.

STEVE MCQUEEN

IL A FALLU QUE J'APPRENNE A ME PROTEGER QUAND J'ETAIS GAMIN.
JE N'AVAIS PERSONNE A QUI PARLER. J'ETAIS TOUT SEUL.
CELA M'A APPRIS A ETRE AUTONOME.

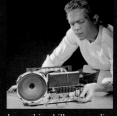

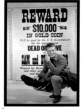

1950 | Steve McQueen shows his skill as a radio repair man.

1950 | Steve McQueen démontrant ses talents de réparateur radio. PHOTO Getty Images

1959 | Steve McQueen in *The Great St Louis Train Robbery* || February 1957 | Steve McQueen and Canadian actor, singer and writer William Shatner in an episode of the CBS series *The Defender*.

1959 | Steve McQueen dans le film *Hold Up en 120 secondes*. PHOTO Collection ChristopheL || Février 1957 | Steve McQueen et l'acteur, chanteur et écrivain canadien William Shatner dans un épisode de la série *The Defender* sur la chaîne CBS. PHOTO CBS Photo Archive/Getty Images

1958 | Steve McQueen with Stacy Graham in the cult series *Wanted: Dead or Alive*. || 1958 | Steve McQueen in *The Great St Louis Train Robbery*.

1958 | Steve McQueen en compagnie de l'actrice Stacy Graham dans la série culte *Au Nom de la Loi*. PHOTO MPTV/Photomasi || 1958 | Steve McQueen dans le film *Hold Up en 120 secondes*. PHOTO Collection ChristopheL

1959 | Steve McQueen as Josh Randall in *Wanted: Dead or Alive*, armed with his famous sawn-off Winchester.

1959 | Steve McQueen incarne Josh Randall dans *Au Nom de la Loi*, armé de sa célèbre Winchester à canon scié. PHOTO MPTV/Photomasi, PHOTO Collection ChristopheL

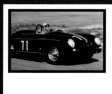

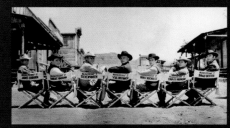

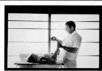

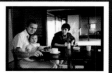

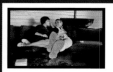

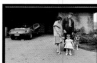

April 1959 | Steve McQueen on the Riverside Raceway at the wheel of his Porsche Speedster.

Avril 1959 | Steve McQueen sur le circuit de Riverside au volant de son Speedster Porsche. PHOTO MPTV/Photomasi

1960 | *The Magnificent Seven* directed by John Sturges. From left to right: James Coburn, Robert Vaughn, Steve McQueen, Yul Brynner, Horst Buchholz, Charles Bronson and Brad Dexter.

1960 | *Les Sept Mercenaires* du réalisateur John Sturges. De gauche à droite : James Coburn, Robert Vaughn, Steve McQueen, Yul Brynner, Horst Bucholtz, Charles Bronson et Brad Dexter. PHOTO Collection ChristopheL

1960 | Model father Steve McQueen changes his daughter Terry's diaper in their Hollywood Hills home on Solar Drive. || 1960 | Steve McQueen with his daughter Terry on his knee and his wife, Neile Adams, in their home in Hollywood Hills.

1960 | Steve McQueen en père modèle changeant les couches de sa fille Terry dans leur résidence de Hollywood Hills sur Solar Drive, 1960. || 1960 | Steve McQueen avec sa fille Terry sur les genoux et son épouse Neile au domicile familial d'Hollywood Hills. PHOTO MPTV/Photomasi

1960 | A relaxed moment for Steve McQueen and Neile at home in Hollywood Hills. || 1960 | Family man Steve McQueen with his wife Neile, daughter Terry, and dog Mike. Steve's 1957 Jaguar XK-SS is in the background.

1960 | Séance détente pour Steve McQueen et son épouse Neile dans leur maison d'Hollywood Hills. || 1960 | Steve McQueen en famille avec Neile (son épouse), Terry (sa fille), Mike (son chien) et sa Jaguar XK-SS 1957 au fond. PHOTO MPTV/Photomasi

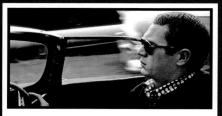

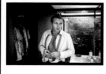

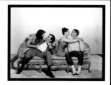

1960 | Steve McQueen at the wheel of his Jaguar XK-SS at Nichols Canyon (Hollywood).

1960 | Steve McQueen au volant de sa Jaguar XK-SS sur Nichols Canyon (Hollywood). PHOTO MPTV/Photomasi

1960 | Steve McQueen at home in Hollywood Hills.

1960 | Steve McQueen chez lui dans les collines d'Hollywood. PHOTO MPTV/Photomasi

1960 | A casual Steve McQueen in the bathroom of his Hollywood Hills home. || 1961 | Steve McQueen in *The Honeymoon Machine* with Paula Prentiss, Jim Hutton and Brigid Bazlen.

1960 | Steve McQueen dans l'intimité de la salle de bain de son domicile dans les collines d'Hollywood. || 1961 | Dans le film *Branle-bas au Casino* avec Paula Prentiss, Jim Hutton et Brigid Bazlen. PHOTO MPTV/Photomasi

1962 | Steve McQueen in Don Siegel's *Hell is for Heroes*. || October 1961 | Steve McQueen, Shirley Ann Field and Robert Wagner at Bovingdon Field while shooting Philip Leacock's *The War Lover*.

1962 | Steve McQueen dans *L'Enfer est pour les Héros* de Don Siegel. PHOTO Collection ChristopheL || Octobre 1961 | Steve McQueen, Shirley Ann Field et Robert Wagner sur l'aérodrome de Bovingdon durant le tournage de *L'Homme qui aimait la Guerre* de Philip Leacock. PHOTO Central Press/Getty Images

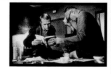

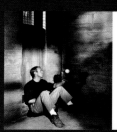

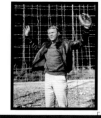

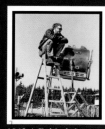

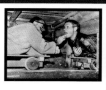

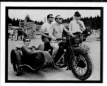

1963 | The Mirsch brothers, producers of *The Great Escape*, and Steve McQueen discussing the film. || 1963 | In an office at Goldwyn Studios, Steve McQueen and director John Sturges mull over a scene from *The Great Escape*.

1963 | Steve McQueen en discussion avec les frères Mirsch, producteurs de *La Grande Evasion*. PHOTO Time Life Pictures/Getty Images || 1963 | Dans un bureau du Goldwyn Studio, Steve McQueen et le réalisateur John Sturges s'interrogent sur une scène de *La Grande Evasion*. PHOTO MPTV/Photomasi

1963 | Steve McQueen in two classic *Great Escape* scenes.

1963 | Steve McQueen lors de célèbres scènes de *La Grande Evasion*. PHOTO MPTV/Photomasi

1963 | Behind the scenes of *The Great Escape*. Makeup man Emile Lavigne paints Steve McQueen's face for the next take.

1963 | Les coulisses du tournage de *La Grande Evasion*. Le maquilleur Emile Lavigne salit le visage de Steve McQueen pour la prise suivante. PHOTO Collection ChristopheL, PHOTO MPTV/Photomasi

1963 | Three heroes of *The Great Escape* : James Coburn (in the sidecar), Steve McQueen and James Gardner (on the motorcycle). || 1963 | Steve McQueen's escape astride the German army motorbike.

1963 | Les trois héros de *La Grande Evasion* : James Coburn (à bord du side), Steve McQueen et James Gardner (sur la moto). || 1963 | L'évasion de Steve McQueen au guidon de la moto de l'armée allemande. PHOTO Collection ChristopheL

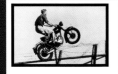 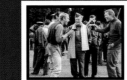 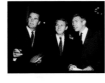 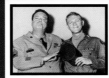 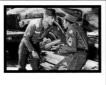 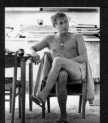

I LIVE FOR MYSELF
AND I ANSWER TO NOBODY.

1963 | McQueen's friend Bud Ekins doubled for him in the celebrated jump to Switzerland in *The Great Escape*. || 1963 | A bad landing for Steve McQueen, imprisoned in the barbed wire.

1963 | McQueen sera doublé par son ami motard Bud Edkins lors du célèbre saut pour rejoindre la Suisse dans *La Grande Evasion*. PHOTO MPTV/Photomasi || 1963 | Mauvaise réception pour Steve McQueen, prisonnier des barbelés. PHOTO Corbis

1963 | A coffee break while shooting *The Great Escape*. || 1963 | James Garner, Steve McQueen and James Coburn at the premiere of *The Great Escape*.

1963 | Pause café durant le tournage de *La Grande Evasion*. PHOTO Collection ChristopheL || 1963 | James Garner, Steve McQueen et James Coburn lors de la "Première" du film *La Grande Evasion*. PHOTO Getty Images

1963 | Steve McQueen in a new soldier's role in *Soldier in the Rain*.

1963 | Steve McQueen dans un nouveau rôle de militaire pour *La Dernière Bagarre*. PHOTO Collection ChristopheL

1963 | Steve McQueen at home, summer 1963.

1963 | Steve McQueen chez lui durant l'été 1963. PHOTO Time Life Pictures / Getty Images

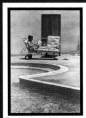 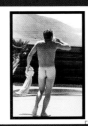 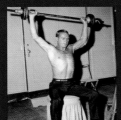 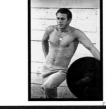 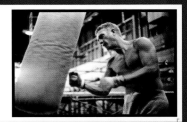

WHEN I BELIEVE IN SOMETHING, I FIGHT LIKE HELL FOR IT.

1963 | Poolside at home, far from filming, Steve McQueen enjoys some time off.

1963 | Au bord de sa piscine, loin des tournages, Steve McQueen prend le temps de vivre. PHOTO Time Life Pictures / Getty Images

1963 | Steve McQueen kept in shape for his racing pursuits, as well as for the cinema.

1963 | Steve McQueen entretenait sa forme pour le cinéma, mais également pour ses activités en sports mécaniques. PHOTO Getty Images

1963 | McQueen horsing around in the fitness room.

1963 | Pour Steve McQueen, les exercices à la salle de musculation pouvaient aussi devenir un jeu d'enfant. PHOTO Getty Images

1963 | Steve kept in shape and regularly frequented the gym during shoots, as here in Paramount Studios, in Hollywood.

1963 | Steve gardait la forme et fréquentait régulièrement la salle de gym entre les tournages, comme ici aux Studios Paramount à Hollywood. PHOTO William Claxton

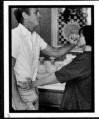 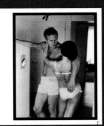 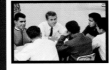 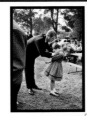 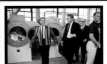 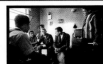

1963 | Intimate moments with his wife Neile at home in Hollywood Hills.

1963 | Instants d'intimité avec son épouse Neile dans leur résidence d'Hollywood Hills. PHOTO Getty Images

1963 Steve McQueen kissing his daughter Terry goodnight. || 1963 McQueen in his role as father, playing with his young son Chad in the family home.

1963 | Steve McQueen embrassant sa fille Terry pour lui souhaiter bonne nuit. PHOTO Time Life Pictures/Getty Images || 1963 | Les jeux d'un père avec son jeune fils Chad au domicile familial. PHOTO Getty Images

June 1963 | Steve McQueen sharing a meal with students at the *California Junior Boys Republic*, a reform school he attended himself for several months as a teenager. || June 1963 | During an outdoor lunch at the California Junior Boys Republic, Steve McQueen signs an autograph for a young admirer.

Juin 1963 | Steve McQueen partageant le repas avec de jeunes pensionnaires de l'établissement de redressement *California Junior Boys Republic* où il a lui-même séjourné plusieurs mois de son adolescence. || 1963 | Lors d'un déjeuner en plein air au *California Junior Boys Republic*, Steve McQueen signe un autographe à une jeune admiratrice. PHOTO Getty Images

June 1963 | McQueen is an amused visitor to the school laundry at the California Junior Boys Republic. || June 1963 | In the dormitory where he spent many nights himself, Steve McQueen talks about his life with the young residents.

Juin 1963 | McQueen, visiteur amusé de la laverie du *California Junior Boys Republic* || Juin 1963 | Dans le dortoir où il passa lui-même de nombreuses nuits, Steve McQueen fait partager son expérience aux jeunes délinquants. PHOTO Getty Images

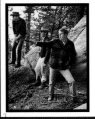 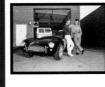 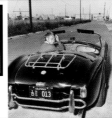 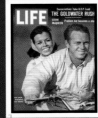 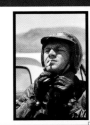

LIFE
THE GOLDWATER RUSH

June 1963 | Steve McQueen practices shooting a revolver during a hunting trip in the Sierra Madre Mountains with friends Jim Corbin and Dave Resnic. || June 1963 | Steve McQueen being shaken awake by his dog while on a hunting trip in the Sierra Madre.

Juin 1963 | Steve McQueen s'exerçant au tir au revolver lors d'une partie de chasse dans les montagnes de Sierra Madra avec ses amis Jim Corbin et Dave Resnic. || Juin 1963 | Steve McQueen tiré de son sommeil par son chien lors d'une partie de chasse en Sierra Madra. PHOTO Getty Images

1963 | At home in Los Angeles, Steve has fun with a cougar-skin rug.

1963 | Chez lui à Los Angeles, Steve s'amuse avec une peau de Cougar. PHOTO William Claxton

June 1963 | Steve McQueen with Carroll Shelby, pilot and manufacturer of the Ford AC Cobra sports cars. || June 1963 | Steve McQueen at the wheel of his new Ford AC Cobra in Los Angeles.

Juin 1963 | Steve McQueen en compagnie du pilote Carroll Shelby, également constructeur des voitures de sport Ford AC Cobra. || Juin 1963 | Steve McQueen au volant de sa nouvelle Ford AC Cobra à Los Angeles. PHOTO Sipa Press

July 12, 1963 | Steve McQueen and his wife Neile on the cover of Life. || 1963 | An enthusiast of long-distance motorbike treks, Steve McQueen prepares for the 500 miles race through California's Mojave Desert.

12 juillet 1963 | Steve McQueen en couverture de *Life* avec sa femme Neile. || 1963 | Passionné de raids à moto, Steve McQueen se prépare pour la course de 500 Miles à travers le désert de Mojave en Californie. PHOTO Getty Images

 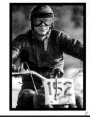

1963 | Steve McQueen at the start of the 500 miles Mojave Desert race. || 1963 | McQueen chose a Triumph to take part in this race.

1963 | Steve McQueen au départ des 500 Miles du Désert de Mojave. PHOTO William Claxton. || 1963 | C'est au guidon de motos de marque Triumph que McQueen participait à ces courses. PHOTO Getty Images

 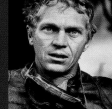

I'M NOT SURE WHETHER I'M AN ACTOR WHO RACES OR A RACER WHO ACTS.

1963 | At the end of the 500 miles Mojave Desert race, Steve McQueen shows signs of an arduous ride.

1963 | À l'arrivée des 500 Miles du Désert de Mojave, Steve McQueen porte les stigmates d'une course éprouvante. PHOTO Getty Images

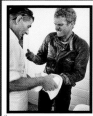 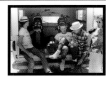

1963 | Steve McQueen having his badly blistered hands tended after the race. || 1963 | The mood after the race as Steve McQueen recounts the challenges of the course.

1963 | Steve McQueen faisant soigner ses mains meurtries d'ampoules après la course. PHOTO Getty Images || 1963 | Ambiance d'après course avec Steve McQueen relatant les difficultés de la course. PHOTO William Claxton

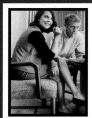 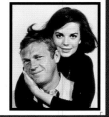

1963 | Steve McQueen with actress Nathalie Wood in *Love With The Proper Stranger*.

1963 | Steve McQueen avec l'actrice Nathalie Wood dans le film *Une certaine rencontre*. PHOTO Getty Images, PHOTO Collection ChristopheL

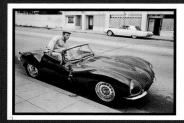

1963 | Steve McQueen behind the wheel of his Jaguar XK-SS.

1963 | Steve McQueen s'installant au volant de sa Jaguar XK-SS. PHOTO Getty Images

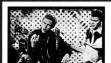 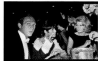

1965 | Steve McQueen in *Baby The Rain Must Fall*, directed by Robert Mulligan. || 1964 | Steve McQueen (with his wrist in a cast) with his wife Neile and Rita Hayworth at the 36th Academy Awards.

1965 | Steve McQueen dans le film *Le Sillage de la Violence* réalisé par Robert Mulligan. PHOTO Collection ChristopheL || 1964 | Steve McQueen (poignet plâtré) en compagnie de sa femme Neile et de Rita Hayworth lors de la 36e édition des *Academy Awards*. PHOTO MPTV/Photomasi

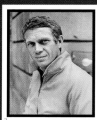 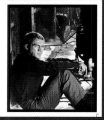

1964 | A portrait of McQueen at the age of thirty-four. || 1965 | Steve McQueen during the shooting of Norman Jewison's *The Cincinnati Kid*.

1964 | Portrait de Steve McQueen à trente-quatre ans. PHOTO William Claxton) || 1965 | Steve McQueen lors du tournage du film *Le Kid de Cincinnati* de Norman Jewison. PHOTO MPTV/Photomasi

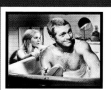 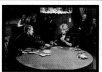

1965 | Steve McQueen and actress Tuesday Weld in a scene from *The Cincinnati Kid*. || 1965 | Steve McQueen playing poker with actress Joan Blondell in *The Cincinnati Kid*.

1965 | Steve McQueen et l'actrice Tuesday Weld dans une scène de *Le Kid de Cincinnati*. PHOTO Collection ChristopheL || 1965 | Steve McQueen lors d'une partie de poker avec l'actrice Joan Blondell dans *Le Kid de Cincinnati*. PHOTO MGM Studios/ Courtesy Getty Images

 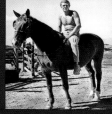

WHEN A HORSE LEARNS TO BUY MARTINIS, I'LL LEARN TO LIKE HORSES.

1966 | Steve McQueen in *Nevada Smith*, which was produced and directed by Henry Hathaway.

1966 | Steve McQueen dans le film *Nevada Smith* de Henry Hathaway. PHOTO MPTV/Photomasi

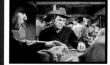 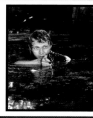

1966 | Steve McQueen involved in another poker game in *Nevada Smith*. || 1966 | Steve McQueen often got wet in his films, as in this scene from *Nevada Smith*.

1966 | Steve McQueen de nouveau autour d'une table de poker dans *Nevada Smith*. || 1966 | Steve McQueen s'est souvent mouillé dans ses films. À l'instar de cette scène dans *Nevada Smith*. PHOTO Collection ChristopheL

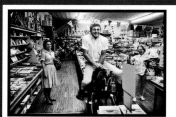

1963 | Lee Remick and Steve McQueen visiting a general store near Bay City, Texas, while shooting there. When Steve dismounted this horse, it bucked. *I never could trust a horse*, he said.

1963 | Lee Remick and Steve McQueen dans un magasin de Bay City, Texas, lors d'une séance de prises de vues. Lorsqu'il enfourcha le cheval, celui-ci se brisa. *Je ne pourrais jamais faire confiance aux chevaux*, lança-t-il. PHOTO William Claxton

1966 | Steve McQueen unwinds after completing a scene for *Nevada Smith*. || 1966 | Steve McQueen during the shooting of *Nevada Smith*.

1966 | Steve McQueen se détend après la fin d'une scène de *Nevada Smith* || 1966 | Steve McQueen lors du tournage de *Nevada Smith*. PHOTO Roger-Viollet, PHOTO Collection ChristopheL

IT WAS ALL VERY PLEASANT JUST LYING IN THE SUN AND WATCHING THE GIRLS GO BY, BUT ONE DAY I SUDDENLY FELT BORED WITH HANGING AROUND AND WENT AND JOINED THE MARINES.

1966 | Steve McQueen reconnects with Robert Wise in *The Sand Pebbles*.

1966 | Steve McQueen retrouve le réalisateur Robert Wise dans *La Canonnière du Yang-Tse*. PHOTO MPTV/Photomasi

1966 | Steve McQueen in *The Sand Pebbles*.

1966 | Steve McQueen dans *La Canonnière du Yang-Tse*. PHOTO MPTV/Photomasi

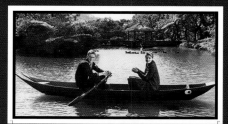

1966 | Steve McQueen and actress Candice Bergen in Robert Wise's film *The Sand Pebbles*.

1966 | Steve McQueen et l'actrice Candice Bergen dans *La Canonnièredu Yang-Tse* de Robert Wise. PHOTO Collection ChristopheL

1966 | Steve McQueen aboard the Yangtze River Patrol gunboat in *The Sand Pebbles*. || 1966 | Steve McQueen and Richard Attenborough with the actress and French novelist Marayat Andriane (author of *Emmanuelle*) in a scene from *The Sand Pebbles*.

1966 | Steve McQueen à bord de *La Canonnière du Yang-Tse*. PHOTO MPTV/Photomasi || 1966 | McQueen et Richard Attenborough avec l'actrice et romancière française Marayat Andriane (auteur d'*Emmanuelle*) dans une scène de *La Canonnière du Yang-Tse*. PHOTO Collection ChristopheL

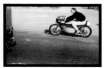
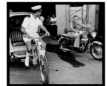
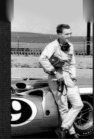

IT'S ONLY WHEN I'M GOING FAST,
IN A RACING CAR OR BIKE,
THAT I REALLY RELAX.

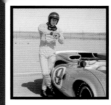

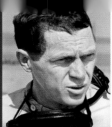
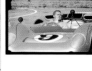

1966 | Lacking a Triumph, McQueen rides a Suzuki during the filming of *The Sand Pebbles*. || 1966 | During a break from shooting *The Sand Pebbles*, McQueen and Richard Crenna organize a race around the studio.

1966 | A défaut de Triumph, McQueen conduit une Suzuki lors du tournage de *La Canonnière du Yang-Tse*. PHOTO MPTV/Photomasi || 1966 | Lors d'une pause sur le tournage de *La Canonnière du Yang-Tse*, McQueen et Richard Crenna organisent une course autour du studio. PHOTO Corbis

1966 | Steve McQueen on the Riverside Raceway in California.
1966 | Steve McQueen sur le circuit de Riverside en Californie. PHOTO MPTV/Photomasi

1966 | It is about time for Steve McQueen to take the wheel of his Lola and hit the Riverside Raceway in California.
1966 | C'est bientôt l'heure pour Steve McQueen de prendre le volant de sa Lola sur la piste de Riverside (Californie). PHOTO MPTV/Photomasi

1966 | Steve McQueen never stopped pushing limits on the racetrack.
1966 | Avec la course automobile, McQueen poussait sans cesse ses limites. PHOTO MPTV/Photomasi

STARDOM EQUALS FREEDOM.
IT'S THE ONLY
EQUATION THAT MATTERS.

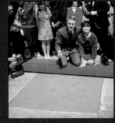

ACTING'S A GOOD RACKET.
AND LETS FACE IT,
YOU CAN'T BEAT IT
FOR THE BREAD.

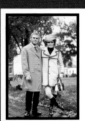

1966 | Steve McQueen and his wife Neile making hand and footprints in front of Mann's Chinese Theater on Hollywood Boulevard.
1966 | Steve McQueen et son épouse Neile lors de la prise d'empreinte de mains et de pieds devant le Mann's Chinese Theater sur Hollywood Boulevard. PHOTO MPTV/Photomasi

April 1967 | Steve McQueen and his wife Neile at the Academy Awards.
Avril 1967 | Steve McQueen et sa femme Neile lors de la Cérémonie des Awards. PHOTO Corbis, PHOTO MPTV/Photomasi

1968 | Steve McQueen in Norman Jewison's *The Thomas Crown Affair*.
1968 | Steve McQueen dans *L'Affaire Thomas Crown* de Norman Jewison. PHOTO MPTV/Photomasi

1968 | Steve McQueen and Faye Dunaway in *The Thomas Crown Affair*. || 1968 | Steve McQueen in Norman Jewison's *The Thomas Crown Affair*.
1968 | Steve McQueen et Faye Dunaway dans *L'Affaire Thomas Crown*. || 1968 | Steve McQueen dans *L'Affaire Thomas Crown* de Norman Jewison. PHOTO MPTV/Photomasi

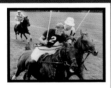
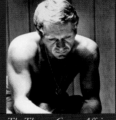

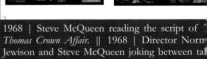

I REALLY DON'T LIKE TO ACT.
AT THE BEGINNING, BACK IN '51,
I HAD TO FORCE
MYSELF TO STICK WITH IT.
I WAS REAL UNCOMFORTABLE,
REAL UNCOMFORTABLE.

1968 | Steve McQueen and Faye Dunaway posing in front of *The Thomas Crown Affair* Rolls Royce. || 1968 | Steve McQueen was keen on polo in *The Thomas Crown Affair*.
1968 | Steve McQueen et Faye Dunaway posant devant la Rolls-Royce de *L'Affaire Thomas Crown*. || 1968 | Steve McQueen s'adonnant au polo dans *L'Affaire Thomas Crown*. PHOTO MPTV/Photomasi

1968 | Faye Dunaway and Steve McQueen as the director, Norman Jewison, prepares a close-up of the two stars.
1968 | Faye Dunaway et Steve McQueen avec le réalisateur Norman Jewison préparant un gros plan sur ses deux acteurs. PHOTO Getty Images

1968 | Steve McQueen in *The Thomas Crown Affair*.
1968 | Steve McQueen dans *L'Affaire Thomas Crown*. PHOTO Collection ChristopheL

1968 | Steve McQueen reading the script of *The Thomas Crown Affair*. || 1968 | Director Norman Jewison and Steve McQueen joking between takes of *The Thomas Crown Affair*.
1968 | Steve McQueen en train de lire le script de *L'Affaire Thomas Crown*. || 1968 | Le réalisateur Norman Jewison et Steve McQueen plaisantant entre deux prises de *L'Affaire Thomas Crown*. PHOTO MPTV/Photomasi

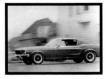
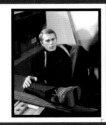
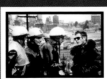
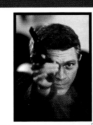
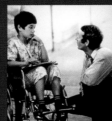

WHEN A KID DIDN'T HAVE ANY
LOVE WHEN HE WAS SMALL,
HE BEGINS TO WONDER
IF HE'S GOOD ENOUGH.
YOU KNOW IF MY MOTHER DIDN'T LOVE ME,
AND I DIDN'T HAVE A FATHER,
I MEAN, WELL, I GUESS
I'M NOT VERY GOOD.

1968 | Steve McQueen at the wheel of his Ford Mustang WP in the film *Bullitt* by Peter Yates. || 1968 | Steve McQueen in his role as Police Lieutenant Frank Bullitt.
1968 | Steve McQueen au volant de sa Ford Mustang GT dans le film *Bullitt* de Peter Yates. PHOTO MPTV/Photomasi || 1968 | Steve McQueen in-

1968 | Steve McQueen and San Francisco motor-cyclists in *Bullitt*. || 1968 | Gun in hand, Steve McQueen in *Bullitt*.
1968 | Steve McQueen et les motards de San Francisco dans *Bullitt*. || 1968 | Steve McQueen arme au poing dans *Bullitt*. PHOTO MPTV/Photomasi

1968 | Steve McQueen in Peter Yates' *Bullitt*.
1968 | Steve McQueen dans *Bullitt* de Peter Yates. PHOTO MPTV/Photomasi

1969 | Close-up of Steve McQueen's eyes.
1969 | Gros plan sur les yeux de Steve McQueen. PHOTO Getty Images

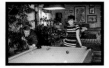

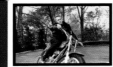
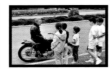

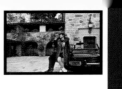

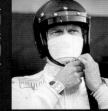

AUTO RACING HAS DIGNITY. **BUT YOU NEED** THE SAME ABSOLUTE CONCENTRATION. YOU HAVE TO REACH INSIDE YOURSELF **AND BRING FORTH** A LOT OF BROKEN GLASS.

1970 | Steve McQueen and his wife Neile in their Beverly Hills home.

1970 | Steve McQueen et son épouse Neile dans leur domicile de Beverly Hills. PHOTO MPTV/Photomasi

1970 | Passionate about motorbikes, Steve McQueen had a collection that included over two hundred machines. || 1970 | Steve McQueen on his motorbike with some children from his area in California.

1970 | Passionné de motos, Steve McQueen possédait une collection de plus de deux cent machines. || 1970 | Steve McQueen sur sa moto en compagnie des enfants de son quartier en Californie. PHOTO MPTV/Photomasi

1970 | Steve McQueen and his wife Neile in their Excalibur. || 1970 | Steve McQueen with Neile and their Ferrari 275 GTS.

1970 | Steve McQueen et son épouse Neile à bord de leur Excalibur. || 1970 | Steve McQueen avec Neile et leur Ferrari 275 GTS. PHOTO MPTV/Photomasi

1971 | In the film *Le Mans*, Steve McQueen wears the celebrated Tag Heuer *Monaco* chronograph.

1971 | Dans le film *Le Mans*, Steve McQueen porte la célèbre montre Tag Heuer modèle chronograph *Monaco*. PHOTO Rue des Archives

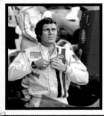
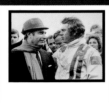
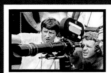
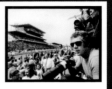

1971 | Steve McQueen, alias Michael Delaney, in Lee H. Katzin's *Le Mans*. || 1970 | McQueen with Juan Manuel Fangio during the filming of *Le Mans*. The Argentine was a former Formula 1 world champion.

1971 | Steve McQueen, alias Michael Delaney, dans le film *Le Mans* de Lee H. Katzin. PHOTO TAG Heuer || 1970 | McQueen en compagnie de Juan Manuel Fangio, l'ancien champion du monde argentin de Formule 1 lors du tournage du film *Le Mans*. PHOTO AFP

1970 | Steve McQueen preparing the racing scenes in *Le Mans* with his colleagues.

1970 | McQueen en train de préparer les scènes de course avec ses collaborateurs pour le film *Le Mans* PHOTO DPPI

1970 | Steve McQueen during the shooting of *Le Mans*.

1970 | Steve McQueen lors du tournage et des phases de repérage du film *Le Mans*. PHOTO Raymond Depardon / Magnum Photos, PHOTO MPTV/Photomasi

1970 | Stills from the filming of *Le Mans*, directed by Lee H. Katzin

1970 | Rushes sur le tournage du film *Le Mans* de Lee H. Katzin. PHOTO Raymond Depardon / Magnum Photo

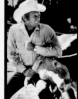

RACING IS LIFE. ANYTHING BEFORE OR AFTER IS JUST WAITING.

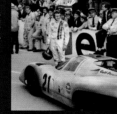

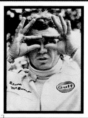

1971 | Steve McQueen beside his Porsche 917 in a scene from *Le Mans*.

1971 | McQueen à côté de sa Porsche 917 lors d'une scène du film *Le Mans*. PHOTO MPTV/Photomasi

1970 | Steve McQueen in discussion with various members of the film crew. On the right, McQueen with Derek Bell, a British racing driver and adviser for *Le Mans*.

1970 | En discussion avec différents membres de l'équipe de tournage. A droite, avec le Britannique Derek Bell, pilote et conseiller sur le film *Le Mans*. PHOTO Collection ChristopheL, PHOTO Raymond Depardon / Magnum Photos

1971 | In motor racing, the line of sight is critical. || 1971 | Nursing sequence in the racetrack sick bay after the accident scene in *Le Mans*.

1971 | En course automobile, la vue, c'est la vie. PHOTO Roger-Viollet || 1971 | Scène de soins dans l'infirmerie du circuit après l'accident dans le film *Le Mans*. PHOTO Collection ChristopheL

1971 | The accident scene in the film *Le Mans*. After being unconscious for a moment, McQueen was pulled from the driver's seat of his Porsche.

1971 | Scène de l'accident dans le film *Le Mans*. Un instant inconscient, McQueen va finalement s'extraire de l'habitacle de sa Porsche. PHOTO MPTV/Photomasi

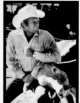

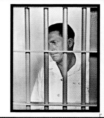
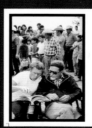

I'M OUT OF THE MIDWEST. IT WAS A GOOD PLACE TO COME FROM. IT GIVES YOU A SENSE OF RIGHT OR WRONG AND FAIRNESS, WHICH IS LACKING IN OUR SOCIETY.

1972 | Steve McQueen, rodeo specialist, in *Junior Bonner* by Sam Peckinpah.

1972 | Steve McQueen, spécialiste du rodéo, dans le film *Junior Bonnier, le dernier bagarreur* de Sam

1972 | Steve McQueen in two scenes from *The Getaway*, directed by Sam Peckinpah.

1972 | Steve McQueen dans deux scènes du film *Guet Apens* de Sam Peckinpah. PHOTO Collection

1972 | Steve McQueen conferring with director Sam Peckinpah over the script of *The Getaway*. || February 1973 | Steve McQueen arriving at the Orly Airport in Paris, France, with his new wife, actress Ali MacGraw

1973 | Steve McQueen during the shooting of *Papillon*, produced by Franklin J. Schaffner.

1973 | Steve McQueen pendant le tournage de *Papillon* réalisé par Franklin J. Schaffner. PHOTO Ro

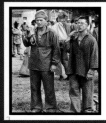 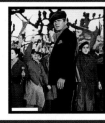 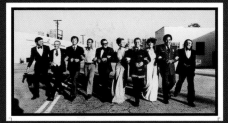 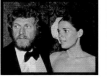 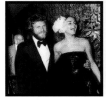

1973 | Steve McQueen and Dustin Hoffman in *Papillon*. || 1973 | Steve McQueen in Franklin J. Schaffner's *Papillon*.

1973 | Steve McQueen et Dustin Hoffman dans *Papillon*. PHOTO MPTV/Photomasi || 1973 | Steve McQueen dans *Papillon* de Franklin J. Schaffner. PHOTO Collection ChristopheL

1974 | Paul Newman and Steve McQueen in *The Towering Inferno* by Irwin Al and John Guillermin. || 1974 | Steve McQueen in the role of Chief Michael O'Hallorhan, of the San Francisco firefighters.

1974 | Paul Newman et Steve McQueen dans le film *La Tour Infernale* de Irwin Allen et John Guillermin. || 1974 | Steve McQueen dans le rôle de Michael O'Hallorhan, chef des pompiers de San Francisco. PHOTO Collection ChristopheL

1974 | Group photo of the principal actors in *The Towering Inferno*. From left to right: Robert Wagner, Fred Astaire, Richard Chamberlain, Paul Newman, William Holden, Faye Dunaway, Steve McQueen, Jennifer Jones, O.J. Simpson and Robert Vaughn.

1974 | Photo de groupe des principaux acteurs de *La Tour Infernale*. De g à d : Robert Wagner, Fred Astaire, Richard Chamberlain, Paul Newman, William Holden, Faye Dunaway, Steve McQueen, Jennifer Jones, O.J. Simpson et Robert Vaughn. PHOTO MPTV/ Photomasi

March 1974 | Steve McQueen and his wife Ali MacGraw in Hollywood's Century Plaza Hotel during a ceremony in which the American Film Institute awarded actor James Cagney the Life Achievement Award.

Mars 1974 | Steve McQueen et sa femme Ali MacGraw au Century Plaza Hotel d'Hollywood lors de la Cérémonie de l'American Film Institute récompensant l'acteur James Cagney avec un *Life Achievement Award*. PHOTO Collection ChristopheL. PHOTO Getty Images

 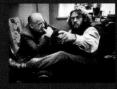

AN ACTOR IS A PUPPET, MANIPULATED BY A DOZEN OTHER PEOPLE.

1977 | Steve McQueen with George Schaefer, director of *An Enemy of the People*.

1977 | Steve McQueen avec George Schaefer, le réalisateur de *Un Ennemi du Peuple*. PHOTO MPTV/ Photomasi

1977 | Steve McQueen in *An Enemy of the People*.

1977 | Steve McQueen dans *Un Ennemi du Peuple*. PHOTO MPTV/Photomasi

 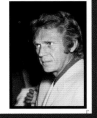 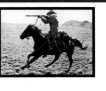 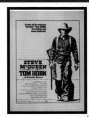

April 1978 | Steve McQueen in Tokyo, Japan, to testify in a lawsuit against four Japanese companies who used his photo without permission. || 1978 | Portrait of Steve McQueen at forty-eight.

Avril 1978 | Steve McQueen à Tokyo pour témoigner dans un procès contre quatre sociétés japonaises ayant utilisé son image sans permission. PHOTO AP/Sipa Press || 1978 | Portrait de Steve McQueen à quarante-huit ans. PHOTO Ron Galella

1980 | Steve McQueen in *Tom Horn*, one of his last films.

1980 | Steve McQueen dans *Tom Horn*, l'un de ses derniers films. PHOTO Collection ChristopheL

I HAD TO LEARN TO LOOK OUT FOR MYSELF WHEN I WAS A KID. I HAD NO ONE TO TALK TO. I WAS ALL ALONE. IT TAUGHT ME TO BE SELF-RELIANT.

TAG Heuer is proud to have made possible the creation of this extraordinary book. Steve McQueen is more than an actor, he is a mythic icon, an enduring symbol of grace and elegance. Through his passion for car racing and his unforgettable performance in the film *Le Mans*, this legendary figure has come to embody sporting glamour. More than anything, his indomitable thirst for life continues to move us, which is why he is the longstanding ambassador of TAG Heuer's *Monaco* collection.